Sources of Inspiration
for ceramics and the applied arts

CAROLYN GENDERS

A & C BLACK
LONDON

Dedication

To my husband Steve for his help on the computer
and unfailing support.

I would like to thank all the potters who have so generously
contributed to this book. Many thanks also to Steve Hawksley,
Howard Cole, Erica Just, Simon Arnold, Ann Frith and
Colin M. Baxter for photographic source material.

First published in Great Britain 2002
A&C Black Publishers Limited
37 Soho Square
London W1D 3QZ
www.acblack.com

This paperback edition 2004

ISBN-10: 0–7136–7098–3
ISBN-13: 978–0–7136–7098–1

738 GEN
3 weeks
F 27684

Front cover illustrations: 'Grafitti' bowl by Carolyn Genders. Photo by Mike Fearey.
 Reflections, photo by Steve Hawksley.
Frontispiece: Detail of Indian material.

Cover design: Sutchinda Thompson.
Design: Penny and Tony Mills.

Note: unless stated otherwise, all artwork and photographs by Carolyn Genders.

Printed and bound in Turin, Italy by G. Canale & C. S. p.a.

Contents

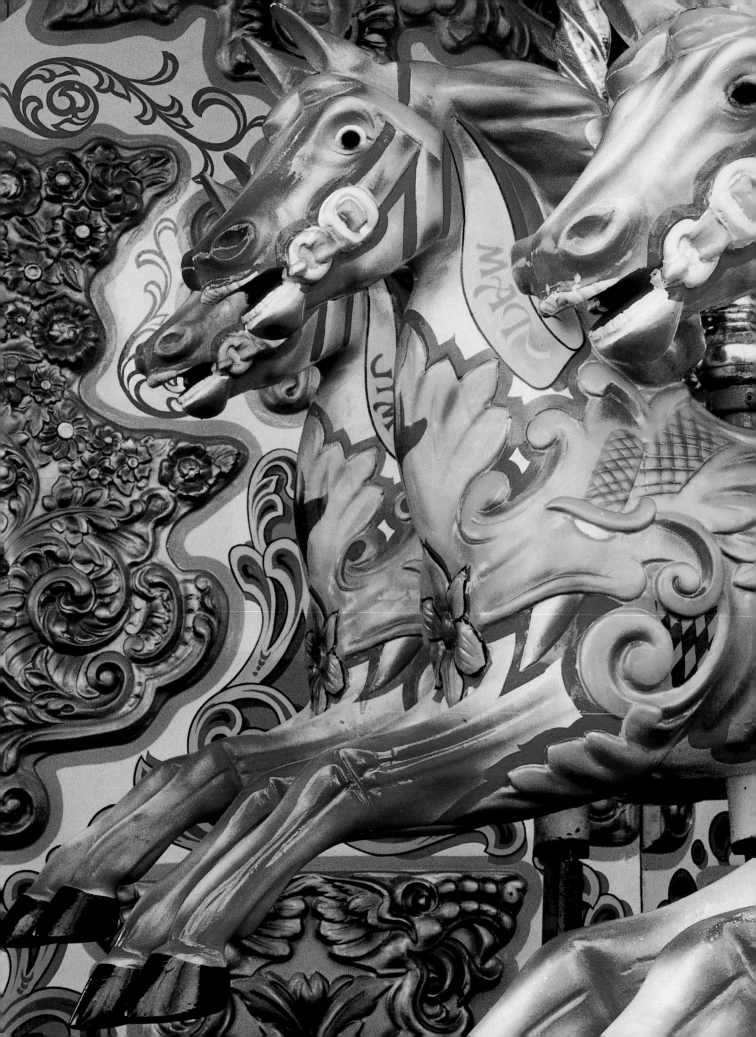

Introduction

T HE WONDERFUL thing about clay is that it is possible to make vessels and sculpture so diverse in form and finish that it is sometimes hard to remember that they were all made from the same material. Having caught the 'clay bug', the choices are many:

- What clay? terracotta, crank, porcelain?
- What technique? Coiling, slabbing, throwing?
- What firing? Raku, earthenware, stoneware?

The list goes on and on.

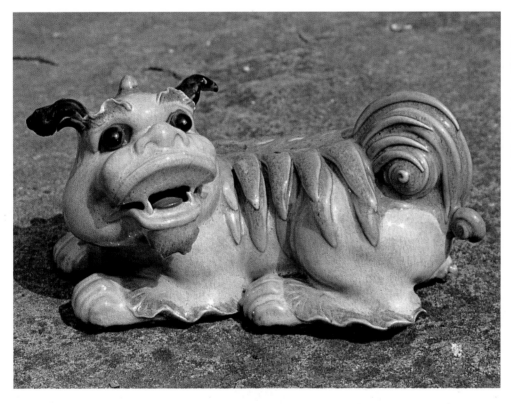

LEFT Chinese Lion.
ABOVE Rough Textured Bowl, 47cm width, 1994, by Carolyn Genders.
OPPOSITE PAGE Fairground Horses.
Photo by Steve Hawksley.

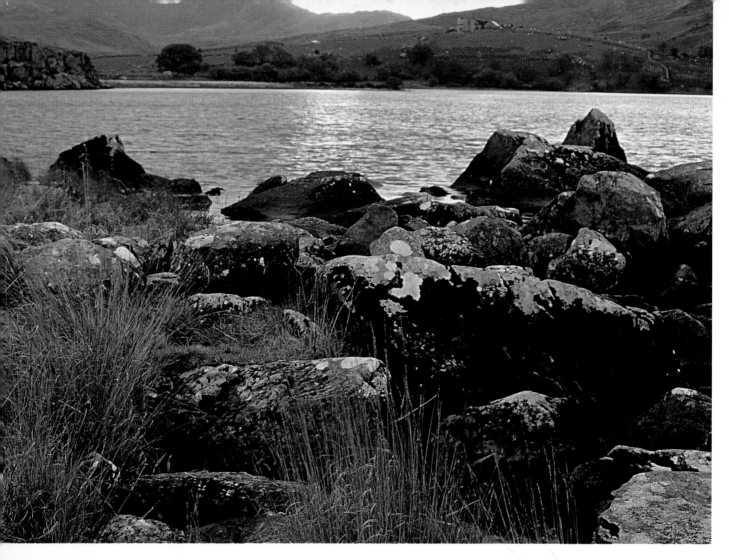

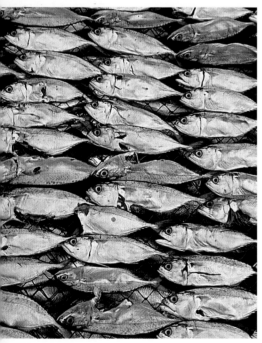

TOP Sunset.
 Photograph by Howard Cole.
ABOVE Fish drying, Thailand.
 Photograph by Simon Arnold.

Many competent makers who have acquired the basic skills and techniques say that they lack ideas but often they have not had the chance or taken the time to unlock their imagination by really looking and seeing what is around them. It is easy to get carried away by the feel of the clay, the excitement of mastering new skills and the mystery of firing when in fact, the most vital consideration is the 'idea' and making work that has individuality and a personal voice. To do this requires inspiration.

For some ceramists, manipulating the clay, reacting to the material and the way it handles is the entire stimulus they need. Others, like myself, find inspiration in a diverse variety of sources: plant and animal life, rocks, machines and the paintings and the sculpture of other artists to mention but a few.

In this book I hope to encourage a new way of seeing and a different approach to developing thematic ideas for the making of ceramics. I will introduce some easily found source materials and illustrate how I translate them into designs for form and decoration. I hope that the reader will share the enjoyment and excitement that I find in the richness of colour and pattern of the simplest object.

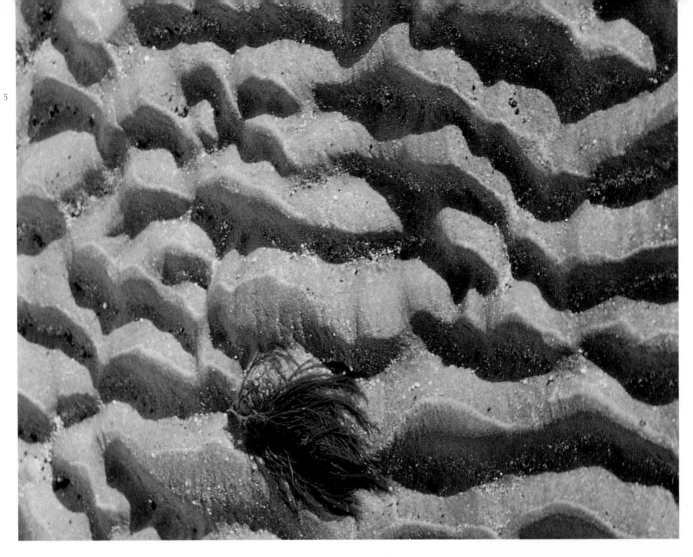

For me, making ceramics is a journey on which I take continuous decisions. Each pot, while important in its own right, is another step on the path to creating work of beauty and presence. Developing ideas for form, surface or colour is a playful experience, an elaborate doodling that I can immerse myself in, letting my imagination run free. I usually carry a sketchbook with me, sketching things that catch my eye – sand patterns on the beach or the arrangement of stones in a wall – creating a visual diary. When I am back in my studio I look at these sketches and if there is something that captivates my imagination I develop the idea, making exploratory studies that may lead to new work. Often these remain in the sketchbook, but sometimes an idea germinates in my mind surfacing years later. There are inexhaustible themes that recur time and again as I find that there are many ways to explore them

ABOVE Sunlit sand, Lee-on-Solent.
 Photograph by Colin M. Baxter.
RIGHT Harbour wall.
 Photograph by Colin M. Baxter.

Apples, oil painting by Carolyn Genders.

– as work progresses I think of a new approach or angle. I am not technically-led, believing technique should follow idea.

I feel that drawing is the key to all artwork, whether ceramic or one of the other disciplines. Drawing has taught me to judge proportions, understand tone and strengths of light and shade. Observational drawing keeps me fresh and aware of different ways of approaching a subject. Those who draw learn to look and *see.* Drawing is a great way of generating ideas rapidly; it helps sort out ideas and develop form. Many ceramists use drawing as a tool with which to move away from the original source, developing the kernel of an idea that they may instinctively feel is there.

Studying the paintings of artists and painting oneself can be a real help to a ceramist interested in surface and decoration. Learning how to handle a brush and make marks, creating mood with different thicknesses of paint, and experimenting with colour in two dimensions, the ceramist is less likely to feel daunted when facing the blank three-dimensional canvas of the clay surface. Many ceramists resist drawing and painting and miss out on a great pleasure!

Although working from life is always preferable this is not always possible. Building up a store of images for future reference

using sketchbooks, paintings, photos, postcards and found objects means that the artist will never be short of inspiration. Searching for an elusive surface quality or glaze colour, that pebble collected from the beach on a cold wintry day might be just the inspiration needed. I, in common with many potters, have a collection of shells, pebbles, bits of decorated old tiles and anything else that catches my eye, on the windowsill in my studio. I chose them for form, texture or colour, and I am surprised at how often, when I look back at work I have made, I see surface texture or marks that must have been influenced by one of 'my treasures'. I think that this collecting of source materials unconsciously sharpens my critical judgement and is an important part of my creativity.

All ceramists are interested in the three-dimensional, otherwise they would be designers or pattern makers. Looking at the work of ceramists, one gets a glimpse of how creative minds work and different approaches and ways of working in three dimensions are revealed. Frequently one sees that the source of inspiration is not something monumental and impressive but a tiny patch of rust on a pipe or the shape of a cloud. The ideas that stimulate enduring themes of work often develop from a series of scribbles on a scrap of paper.

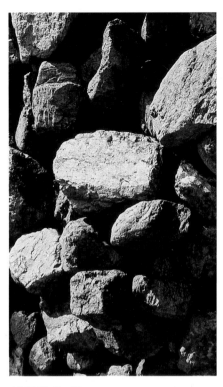

ABOVE Coal heap.
Photograph by Steve Hawksley.
BELOW Rusting machinery.
Photograph by Steve Hawksley.

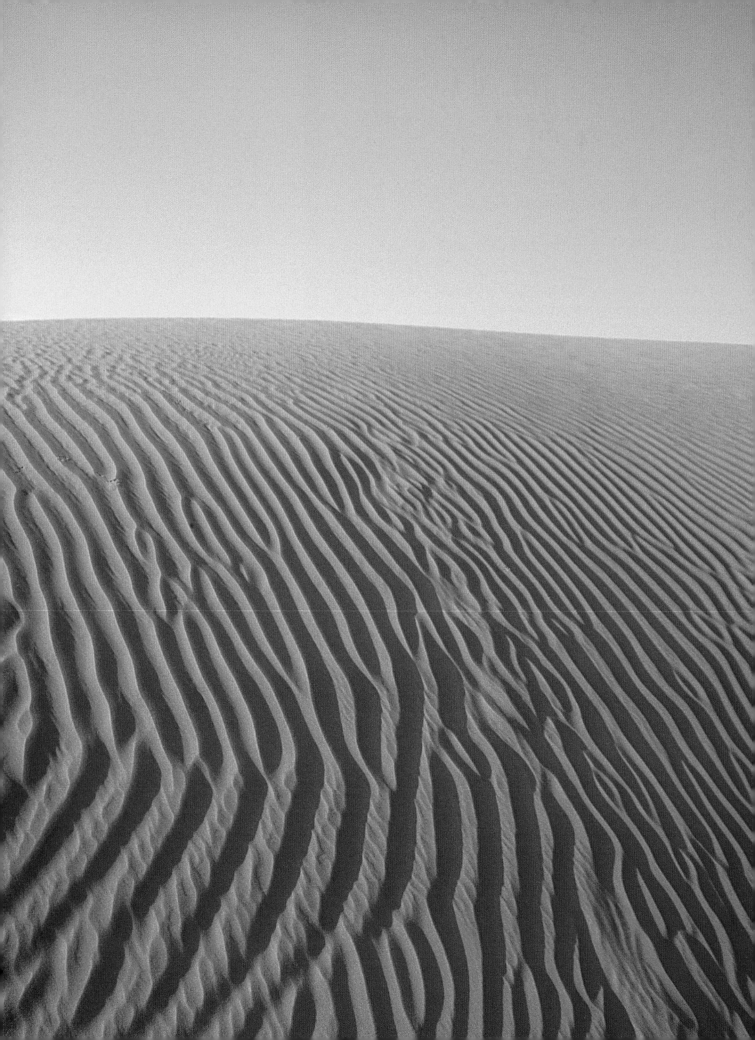

Many ceramists come from a background of Fine Art and Sculpture. Some, such as Eric Mellon and John Maltby, experienced a classical education that taught them the principles of composition, perspective and anatomy as well as varied uses of different media. For others, mixing with painters and sculptors while at art college expanded their artistic horizons – the different disciplines having different concerns – finding that the influence of a Fine Art approach rubbed off on their subsequent work.

I have been intrigued to discover that although the work of the ceramists featured in this book is totally distinctive and immediately identifiable as theirs, and theirs alone, there are common sources of inspiration and cross-references that link them. It may be as simple as a shared admiration of a certain painter's work or a similar philosophy or approach to the creative process. Some work from direct observation, some from drawings in their sketchbooks and some from impressions and images stored in their memory years before. Often, the source of inspiration may be the same but the final outcome is unique.

Although I have linked ceramists to chapter themes this is by no means meant to be a definitive categorising as it is rare that a ceramist has only one source of inspiration. For instance, Peter Lane, whilst well known for his atmospheric landscape inspired pieces, also makes intricately carved porcelain bowls inspired by plants.

It is this diverse variety of influences and sources that enriches a potter's work, indeed different sources excite the imagination in different ways adding repertoire to the visual memory.

OPPOSITE PAGE Thar Desert
sand dunes, Rajasthan.
Photograph by Simon Arnold.

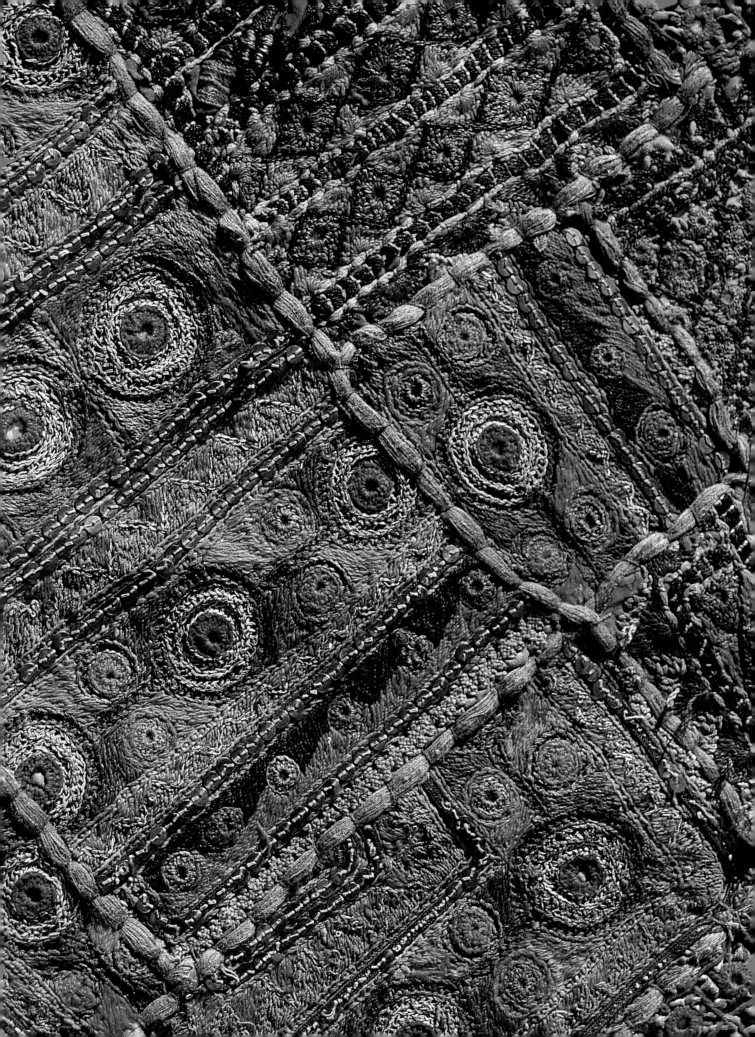

CHAPTER ONE

Pattern and colour

PATTERN AND colour are all around us. Although pattern is often 'out of fashion', it never completely goes away and throughout the centuries and cultures, man has created it: medieval tiled floors, 17th century dress fabrics, African baskets and, in Britain in the 20th century, the designs of Art Deco, the psychedelic sixties and Liberty materials. Pattern and colour add excitement to mundane objects and humdrum lives. Creating pattern and using colour is a great pleasure, and though pattern is not always obviously associated with ceramics, many pots and plates have been decorated. Islamic pots are rich in pattern and decoration, as is English slipware.

Artisan potters developed their patterns instinctively, inspired by what they saw around them, their skill gained through repetition. Many patterns look simple but in reality, the boldness and rhythm of the line are much harder to achieve and come from absolute control of the brush or tool.

One of the challenges of using pattern on three-dimensional form is that of marrying or emphasising the relationship of interior to exterior and the association that exists between them. Different approaches are possible, for instance, using a single colour to reinforce the impact of the form and accentuate the exterior or using pattern to complement or contrast with the exterior in order to attract the viewer's attention.

Sources of inspiration can be found in the simplest things and are easily adapted for ceramics. The starting point might be a piece of material, the markings of a shell or even a paragraph of script, carved in stone. Ancient craftsmen, instinctively attuned to the possibilities of pattern, transformed everyday

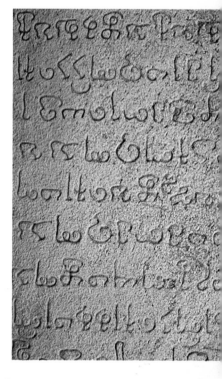

ABOVE Tamil script at temple, India.
Photograph by Simon Arnold.
OPPOSITE PAGE Indian material.

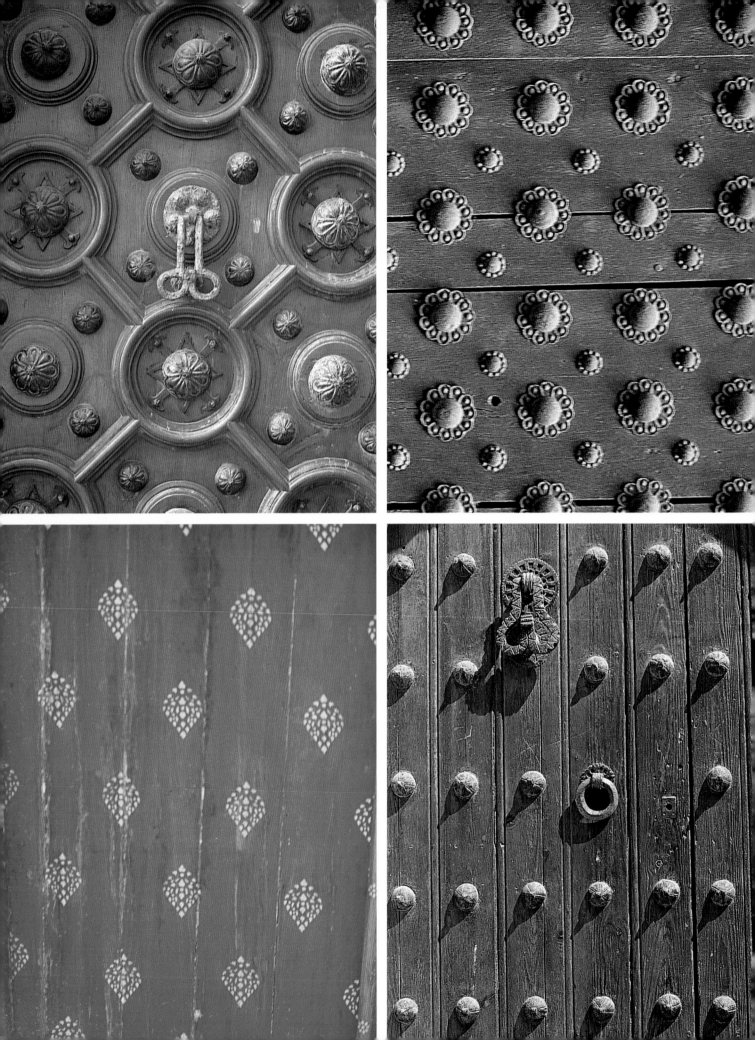

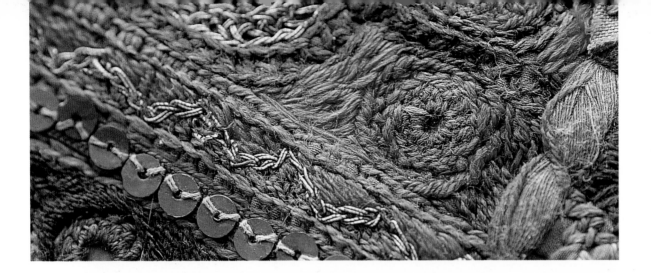

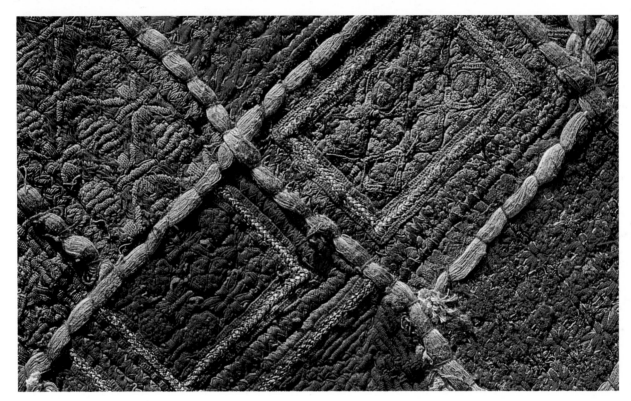

objects into something much more. The four doors shown opposite illustrate imaginative execution of embellishment created with nails. Function and pattern working together, the passing of time adds patina and texture enriching the surface. This evidence of wear and tear is something that attracts many contemporary makers who recreate similar surfaces in their work.

Pieces of material are a rich source of inspiration for pattern. We can learn so much from studying the different weaves and stitches that make up a pattern and so many materials have wonderful colours and textures that could be the start of interesting ceramic themes. These Indian cushions shown above, sewn together from scraps of embroidered materials, were made by people who use anything they have to hand – sequins, beads, even conch shells. Their unselfconscious response to materials and spontaneity in making, unconcerned with technique, gives their work an almost sculptural quality.

ABOVE Indian cushions.
OPPOSITE PAGE
(CLOCKWISE FROM LEFT TO RIGHT):
Church door, Sitges, Spain.
Door, Spain.
Door, India.
Photograph by Ann Frith.
Door, Spain.

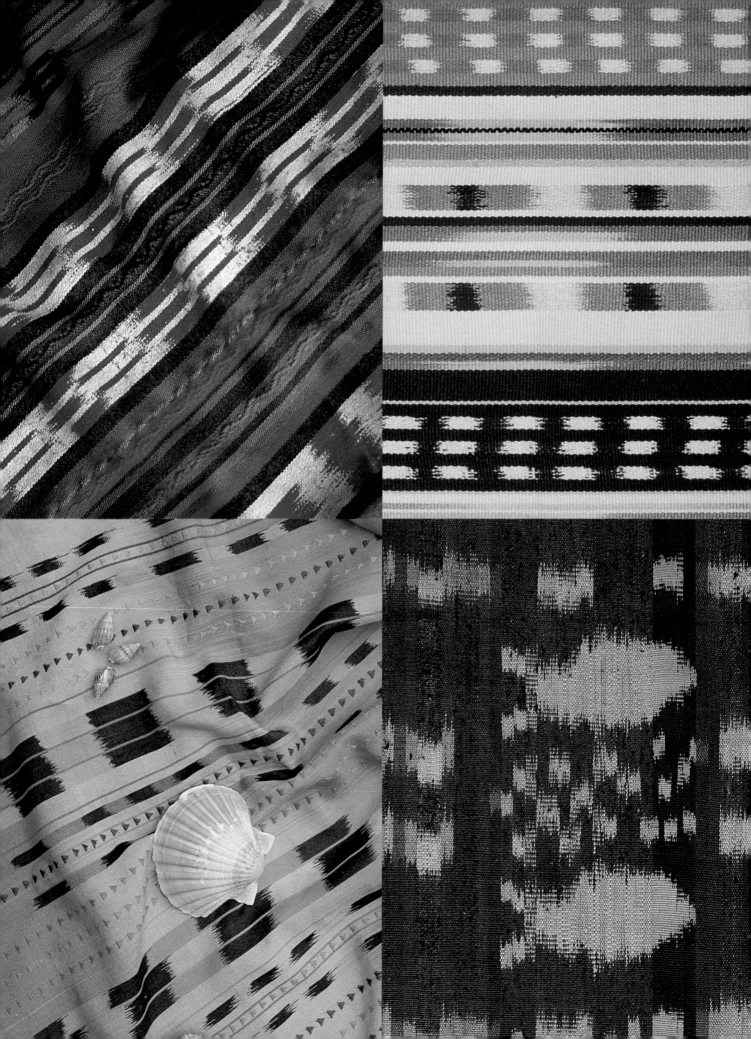

Erica Just weaves exuberantly coloured and intricate Ikats that refer to the traditional Indonesian technique. Erica travels the world looking not only at materials, but scouring beaches for unusual shells and natural objects that inspire her next piece of work. She uses colour sensitively to accentuate and emphasise pattern and weave and to convey mood. Looking at a piece of her material loosely draped, the folds add a new dimension, breaking up the line of the image and pattern, suggesting linear designs, adaptable to the three dimensions of ceramic, that could be painted, incised or inlaid onto the surface of a pot.

Arrangements of fruit in a market, such as these in the market in Barcelona create their own pattern. Beans, carefully arranged into piles, or limes, glistening in their boxes, can be turned into repeat abstract patterns.

OPPOSITE PAGE
Worsted wool and silk Ikat throw, 42 x 72in., by Erica Just.
Chintz Silk Ikat dyed wall piece, 1988, by Erica Just.
Hand-woven silk Ikat by Erica Just.
Fish 2 silk Ikat hand dyed woven, 16 x 24in., by Erica Just.

TOP Runner Beans, Barcelona.
ABOVE Limes, Barcelona.

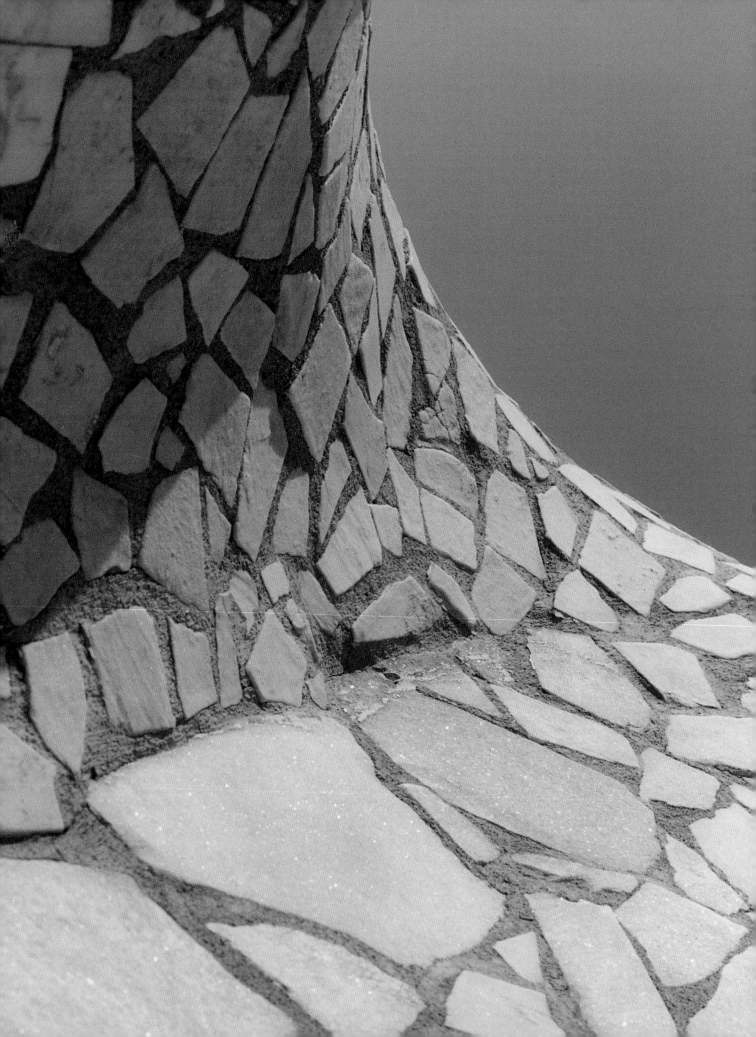

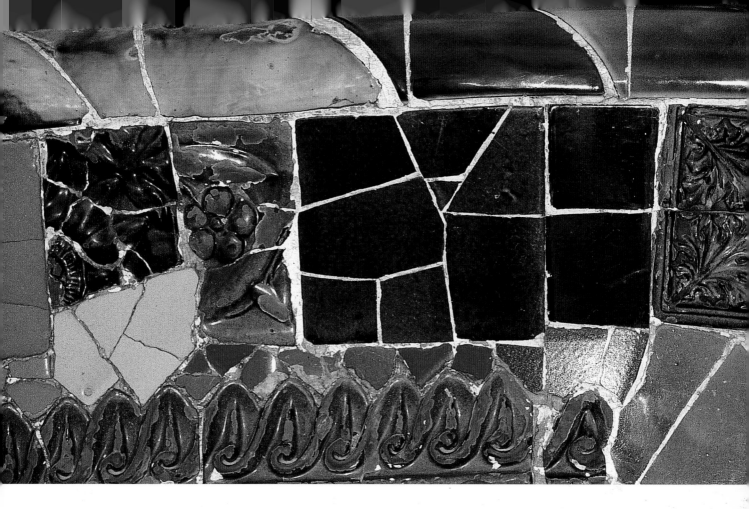

Barcelona is a fantastic city where it is impossible to escape the influence of Gaudi. The organic facades of his buildings and the unfinished cathedral The Sagrada Familia dominate the city but Gaudi also paid attention to small detail. The mosaics in the Parc Guell are free and lively arrangements of the colourful shards of china found all over Spain. Like patchwork, which is a hotchpotch of pattern and colour, the grout or the stitching provides structure and from this chaos comes harmony.

I find inspiration in the mosaic-covered pillar from the roof of the Guell Palace. The contrast of the blue, blue sky with the crystalline texture of the shards of mosaic and the curve of the pillar framing the sky make a dramatic impact. Looking carefully at the shape of an individual piece of tile immediately suggested forms that lend themselves to slab pots, coil pots and abstract constructions. Attracted by one or two shapes particularly, I imagined them in three dimensions. Sketching to manipulate the form, by emphasising curves or indentations and moving naturally away from the original shape, new forms appeared. Decoration and surface evolved in a similar way, when I explored the individual shapes, linking them with line and colour which stimulated my imagination. Whole themes of work can develop from a simple image.

ABOVE Details of mosaic bench – Parc Guell, Gaudi, Barcelona.
OPPOSITE PAGE Detail, mosaic pillar – roof of Palau Guell, Gaudi, Barcelona.
OVERLEAF Exploring and developing ideas for form, surface and decoration from the source image.

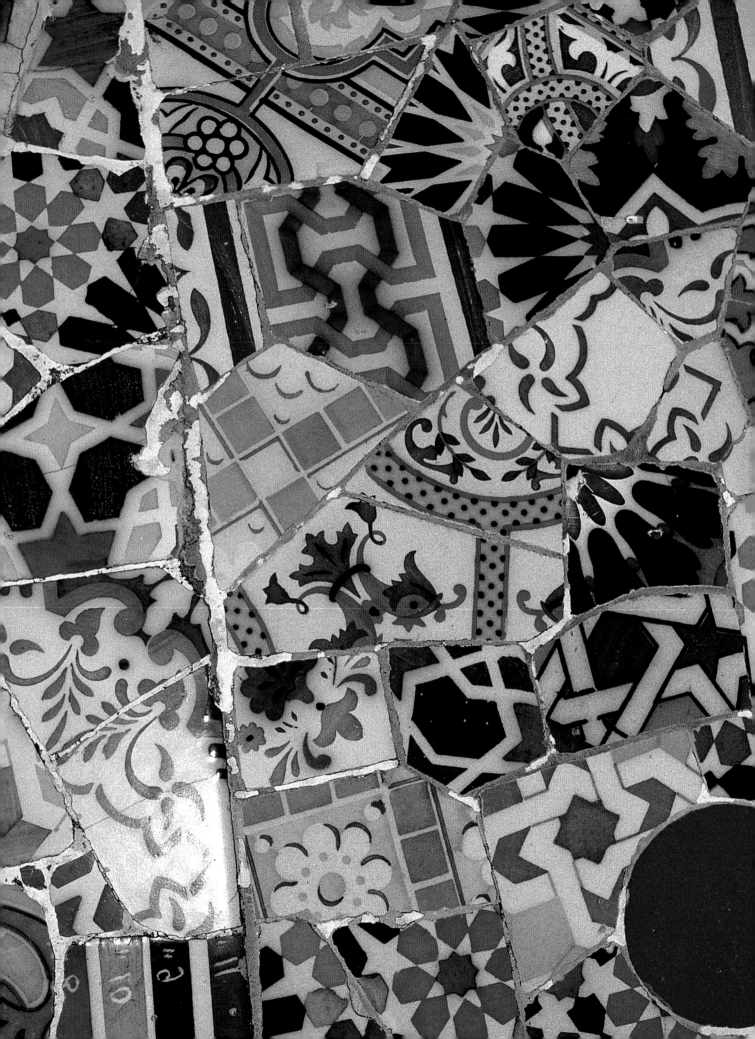

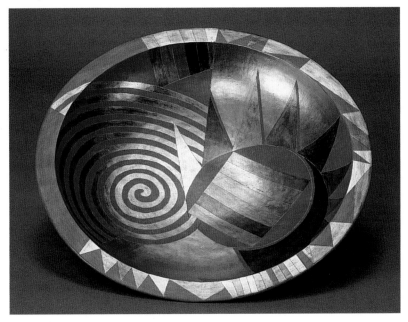

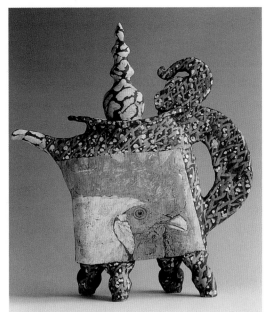

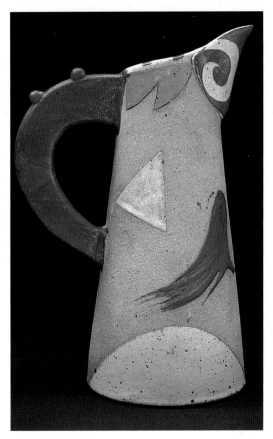

Ceramists use pattern and colour in different ways. Sandy Brown and David Miller create patterns on their work with freely expressive, lively brushstrokes, sweeping colour confidently over the surface of vessels. Carolinda Tolstoy has a more controlled approach, using repeat patterning in gold lustre over vibrant pink and turquoise glazes, to produce a modern expression of ancient cultural themes. Judy Trim's magically decorated lustred bowls are patterned with geometric compositions that have echoes, amongst others, of Egyptian pattern and kaleidoscopic reflections and sometimes incorporate stylised motifs such as radiating stars and suns, inspired by ancient cultures.

In contrast, John Mullin, whose work is based on animals, uses stylised camouflage markings as a patterned background to the central figurative theme. Jill Fanshawe-Kato, best known for her pots decorated with stylised birds, also abstracts pattern from a figurative source for decoration of jugs and bowls, exploring the relationship of marks to form. One side of the jug shown right is abstract and the other figurative. The brushstrokes are a direct response to the bold blue handle – adding colour on the body.

I use pattern, enjoying changing scale and colour to see how the emphasis alters on different three-dimensional shapes and how colour and pattern can be used to exaggerate or minimise part of a form.

TOP LEFT *Red Spiral*, lustred bowl, 38cm diameter, by Judy Trim.
TOP RIGHT *Rooster vessel* by John Mullin.
ABOVE *Abstract Jug*, by Jill Fanshawe-Kato.
OPPOSITE PAGE Detail of mosaic bench, Parc Guell, Gaudi, Barcelona.

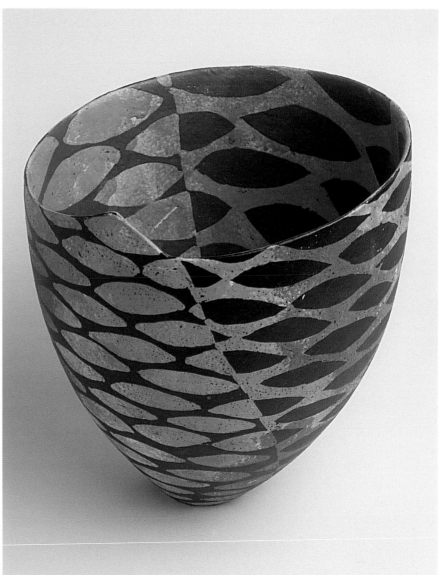

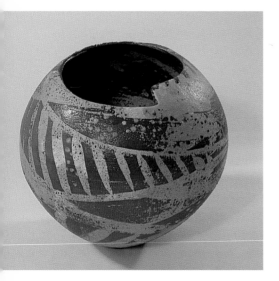

TOP LEFT Pencil studies; developing
ideas for surface treatment of
abstract vessel, by Carolyn Genders.
ABOVE RIGHT Abstract vessel, 1999,
37cm high, by Carolyn Genders.
ABOVE Multi-coloured vessel, 1998, by
Carolyn Genders.

When creating surface design on the vessel above, my intention was to explore the visual impact of the enlarged scale of pattern on the interior and to create a contrast to the exterior. Also, by reversing the pattern at certain points I created an optical illusion. The choice of colour was influenced by an original source study of winter trees silhouetted against a dusk sky.

The decorated surface of this coil pot (above left) expresses my enjoyment in using colour and painterly brushstrokes as a direct response to the rhythm of the form. It is easy to think of pattern as lightweight and frivolous but to develop pattern that draws the eye requires thought. Many patterns are deceptively simple but to achieve the effect involves a lot of work.

So many objects around us have pattern but so often we do not see them. Without them our everyday life would be duller.

Sandy Brown

Sandy Brown's inspiration comes from within herself and from her life and experiences. There are several strands to her work, each fulfilling a different need. Possibly best known for her exuberantly coloured and decorated tableware, she also makes sculptures and paints.

In 1969 she went to Japan and worked for three years at the Daisei pottery in Mashiko. This was an important time for Sandy as learning through observation and experience, rather than by formal training, she absorbed the free and dynamic approach of the Daisei potters, as illustrated by this dish (right).

On her return to England in 1973, Sandy says she 'just doodled' on her own dishes, playing and feeling free to do whatever she wanted. She did not 'think' in terms of planning in advance but worked intuitively. Working in this way over the next twenty years or so, Sandy has developed a language of painting and of throwing that complement each other, creating harmony.

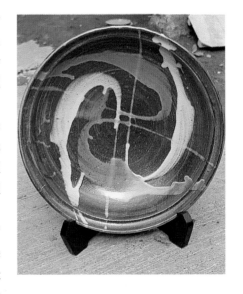

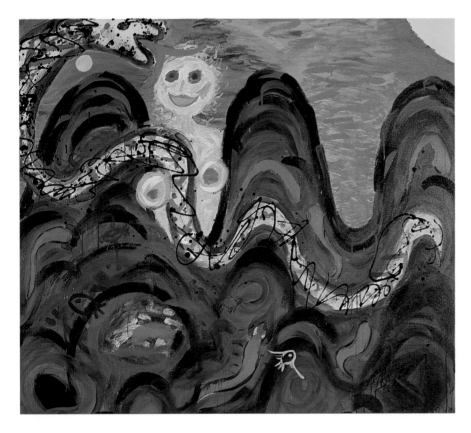

ABOVE Dish by potters at Daisei Pottery, Mashiko, Japan.
LEFT *Befriending the Serpent*, acrylic painting, 1999, by Sandy Brown.

Sandy writes, 'I love ritual in daily life. I love art in daily life. I love using pots and making pots for food'. This sums up her inspiration for her tableware. Functional pieces are either traditional English forms that Sandy associates with her grandmother, or are influenced by her time in Japan. In Japan, any pot that can hold food or liquid is considered functional. However, equally important for the Japanese cook is the aesthetic consideration, instinctively combining the colours and textures of both the food and the pot. Understanding this was Sandy's original inspiration and from Japan she brought back the ability to be very free with forms, handling the clay and the painting of the piece; and yet, the pieces still remain functional.

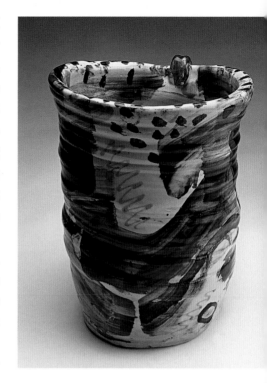

Her sculptural pieces develop in a similar way to the tableware, through playing with the clay. However, Sandy stresses that when she does drawings they are not preliminary works for ceramics. They are drawings in themselves. Neither are the ceramics preliminary works for the drawing. Most of the time, one piece leads to the next. Working fast she loses herself in her work allowing things to occur spontaneously, guided by intuition. Accidents happen but are seen as opportunities; cracks are obviously filled in, bits are added, textures made. Sandy says, 'the piece has a life full of adventures, just as I have done in my own life'.

Another strand of great importance to Sandy is her sculpture, particularly the figures she makes to find out something about herself: 'Warm-up exercises' working eyes closed for half an hour, keeps her creativity fit. She never plans or draws, just puts her hands in the clay, lets go and sees what comes. Over the years she has been on a narrative journey which is evident in her figures.

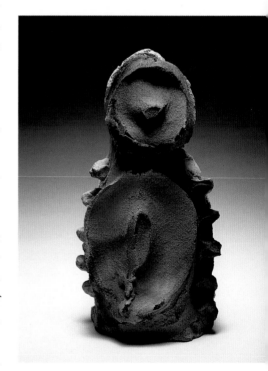

On reflection, whilst acknowledging that most of her source material comes from within herself, Sandy has become aware that external visual influences also affect her work. She lives on an estuary with one of the highest tidal differences in the world. As the water rushes out of the estuary at low tide it leaves just sand and ribbons of water. Marks reminiscent of these have made their way onto her recent work.

Much of the vitality of Sandy's work comes from her spontaneous and intuitive way of making but without the knowledge of her materials and her art that many years of making brings, her work would have less vitality and impact.

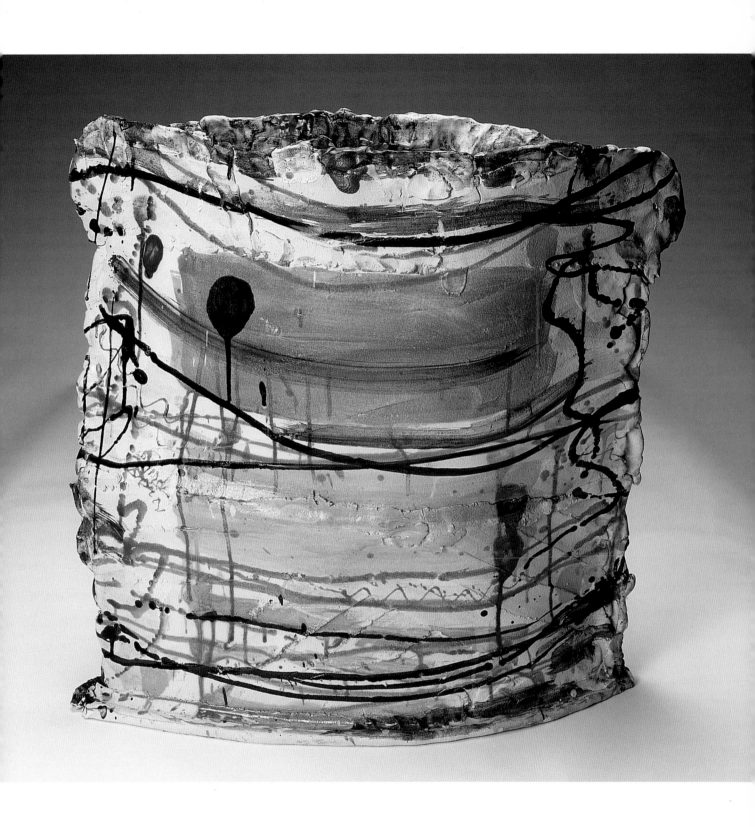

ABOVE Standing form, white clay, coloured glazes, 2000, by Sandy Brown.
OPPOSITE PAGE, TOP Softly thrown pot, 1999, by Sandy Brown.
OPPOSITE PAGE, BELOW *Woman*, smoked in sawdust, 2000, by Sandy Brown.

David Miller

David Miller's work is lively and exuberant, the colours of his pots reflecting the colours and light of the Midi, where he now lives.

In 1980 he had moved to France and was searching for a balance between making a living and artistic expression. Wanting to move away from the Leach style pots of his time in England coincided with meeting the potter, Robert Montaudouin whose work, although part of the slip tradition of the Midi was freer and more expressive. This slipware tradition appealed to David but he chose to move away from old methods and work in a new way using different materials and brighter colours.

Using his photographs of fruit and trees as source materials, David started to paint slip spontaneously onto his pots, unconcerned by technique. For him this was a new experience, as he had not painted before. At college he had always drawn and used bits of colour, rubbing, scratching and sticking onto the paper to create two-dimensional images. Choosing to paint

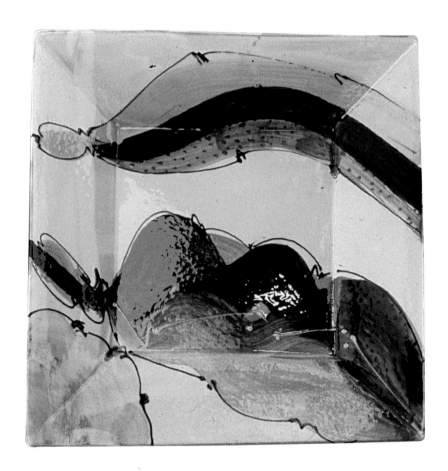

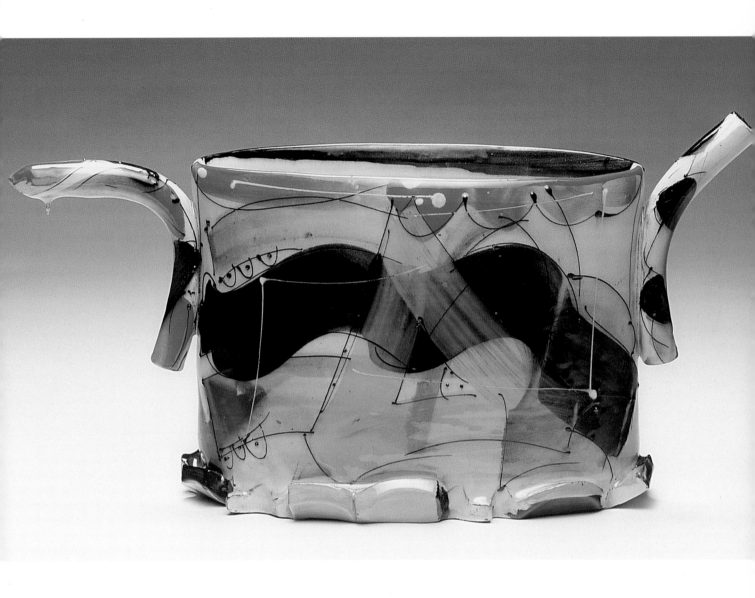

ABOVE Oval bath vessel, 2000, by David Miller.
OPPOSITE PAGE Plate decoration influenced by fruit, by David Miller.

directly onto the pots he learnt to handle brushes and translate his ideas onto the clay. Using a square brush he painted a banana onto the clay with an expansive left to right movement. This was the start of his present work. His everyday, more functional work is gestural – free brushwork and lively colour complementing the forms of the vessels, jugs and bowls.

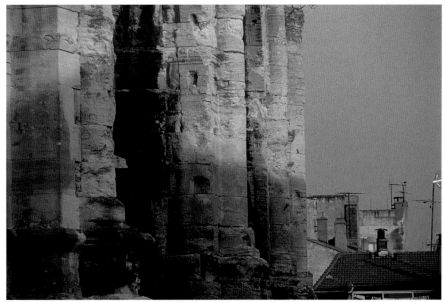

ABOVE Low temperature salt vessel, late
 1980s, by David Miller.
ABOVE RIGHT The Arena, Arles, France.
BELOW Sketch for vessel by
 David Miller.

David feels that his sculptural training has given him an insight into what looks good three-dimensionally, and looking at his one-off sculptural pieces it is evident that the relationship between form and brushwork is vital. Marks are thoughtful and considered, sometimes reflecting, sometimes challenging the form. On these pieces he often starts with sombre colours working his brush across the surface adding layers of different colours. He says that he chooses colours that work together and is still discovering new combinations.

David does not seek conscious inspiration but he is aware that most of his work is influenced by living in France, its atmosphere, people and light. His early Raku pieces of the late 1980s are people orientated, the form mirroring the expressiveness of French gestures, and many of his forms reflect the architecture of nearby Arles.

Development of ideas for forms and marks comes from drawing. The drawing stage is important, both as a springboard for new work but also because David enjoys it very much. He finds drawing liberating and allows his ideas to run free. He says that from time to time he needs to take a scrap of paper and sketch rapidly enjoying the fact that there is no mess and no technical consideration. Ideas come together and begin to relate to each other. Drawing things that could not possibly be made adds a new dimension because when he starts to make he allows the clay to take over. David finds that as his ideas develop he needs more technique to express them and he has to invent ways to overcome difficulties.

For David, creativity is a playful thing and to be enjoyed. He is serious about his work but thinks it is important not to take oneself

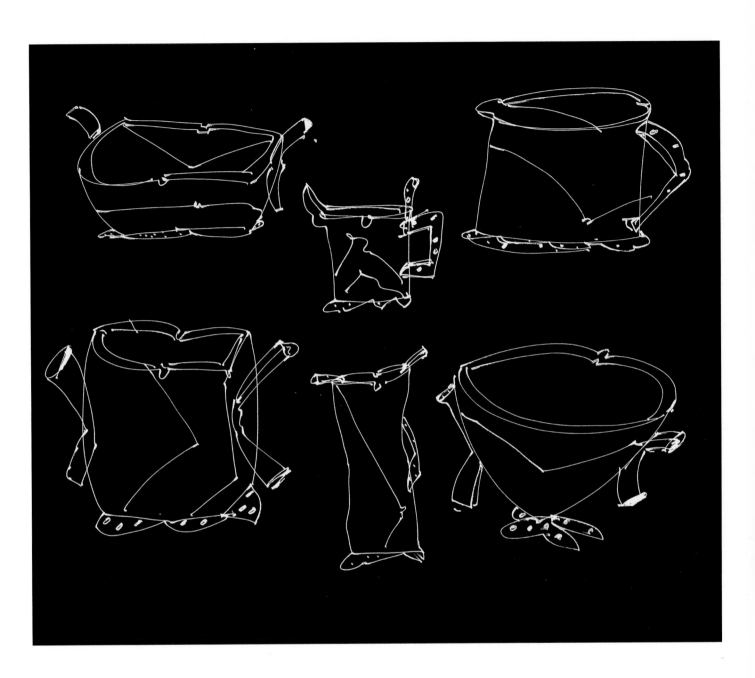

too seriously. In retrospect he realises, that with his art school background and relaxed and humorous approach, he has changed the direction of French slipware.

For me, David manages to combine painterly decoration with inventive form. His lively work, so full of wit and humour is a reflection of himself.

Sketches for vessels, 2000, by David Miller.

Carolinda Tolstoy

Although English by birth and upbringing, it is perhaps because of Carolinda Tolstoy's Greek ancestors that she is instinctively attracted to the arts and crafts of the Middle East and Morocco. Carolinda has travelled extensively through Iran, Turkey, Russia and Greece, amongst others, absorbing the influences of different countries whose artistic traditions are linked by a shared history of pattern and colour.

These are the sources of inspiration for her own work and the patterns and colours of her stylised decoration and Islamic inspired ceramic pieces are her own interpretation of the arts of other countries.

Discovering the work of Persia in a book, subsequent visits to Iran deepened her knowledge and understanding of Persian art and culture. She is particularly drawn to the Safavid Period (AD 1500–1600), whose artists were the Shah's court painters. This time can best be described as the 'Renaissance of Persia'. Much of the decorative work from the Safavid period was itself inspired by silk made by the Armenian silk traders. It is the richness of the borders and the backgrounds of the illuminations, and the exotic colour – fluid gold, turquoise blue and vivid pink – found in clouds and carpets that first inspired Carolinda. These are the colours that she continues to use in her work.

OPPOSITE PAGE *Arabesque*, bowl by Carolinda Tolstoy.

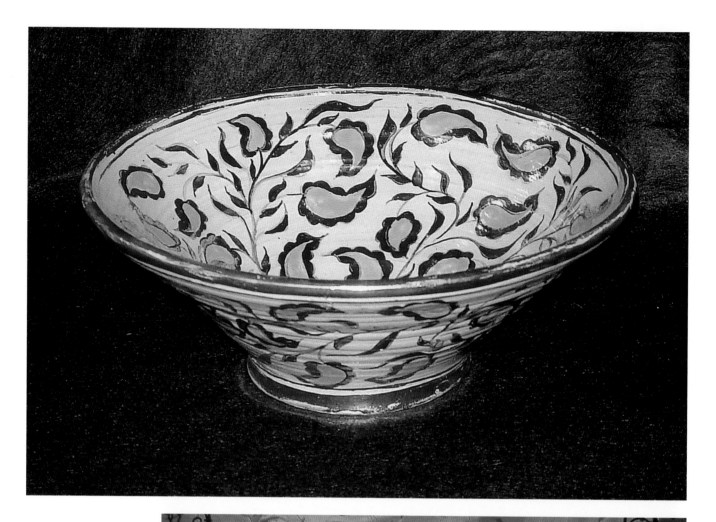

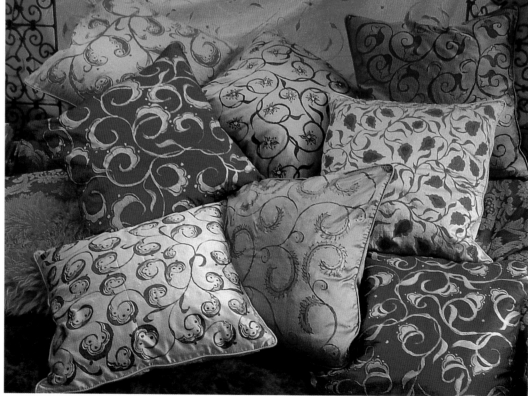

ABOVE Bowl – surface decoration is an interpretation of the tear design used on cashmere shawls in India. By Carolinda Tolstoy.

RIGHT Decorated cushions by Carolinda Tolstoy.

On her travels she sketches things that touch her visually and emotionally – landscape in Tunisia, textiles in Morocco or architectural mouldings in Greece. These sketches are her 'aide-memoires', jogging her memory when she returns to her studio in London. Ideas are adapted, moving away from the original, developing spontaneously over months, even years, into ceramic form and decoration and textile decoration. Carolinda rarely refers to her sketches once in the studio. It is enough that she did them and she relies on memory to evoke the essence that she seeks to capture.

Reluctant to question or analyse, Carolinda is nevertheless aware of the importance of her observations. She says that she is very much affected by her environment. She feels at her most creative and ideas come in quick succession when she is in Greece, where she spent many summers in her childhood. England is where ideas are realised and made.

Carolinda feels that it is important to keep artistically active wherever she is, so away from the studio she keeps her mind on design and her hand practising brushwork by decorating textiles, shoes, even walls. Moving from one medium to another allows her to develop a versatility of design. She enjoys the immediacy of colour that paint provides in contrast to the restrictions of the ceramic palette and technique.

Carolinda is unusual in that, subconsciously, she has immersed herself in the art of other cultures. In no way copying what she has seen, her work is very much an individual interpretation of all that she has absorbed: an amalgam of Middle Eastern traditions and modern methods and philosophies. As Carolinda says of her work, 'I am totally absorbed and fascinated uniquely'.

CHAPTER 2

Architecture and geometry

ARCHITECTURE and geometry seem to me to go together. Geometry deals with all three dimensions of space and architecture with spatial awareness. Few buildings are totally organic, most rely on a knowledge of geometry, and visually at least, geometry adds strength and a sense of balance and proportion. This is an important consideration in ceramics and I find that studying buildings and structural spaces sharpens my awareness of proportion, which in turn informs my ceramic decisions.

I have always enjoyed looking at architecture, not least because buildings define a country. The material, scale and solidity of buildings give a lot of information about social customs, fashion and the economy of a region or country. Driving through France I am acutely aware that when I see the distinctive clay tiled roofs I am in the south of the country and New York is instantly recognisable by its skyline.

Gaudi was as much an artist as an architect and his work has a personal style that is distinctive and instantly recognisable. To me, he is the human face of architecture and I am attracted to his organic edifices and visual play. His attention to detail and delight in decoration appeals greatly, and when I was at college his work was a major source of inspiration for me.

Inspiration from architecture can take many forms. An entire building might be the beginning of a whole body of work but so might the detailing on a flight of steps or an apartment block whose balconies are covered with blinds.

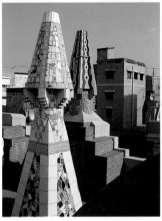

TOP Brighton Railway Station, Sussex, UK.
ABOVE Palau Guell, Gaudi Barcelona.
OPPOSITE PAGE Detail, Gaudi Building, Barcelona.

33

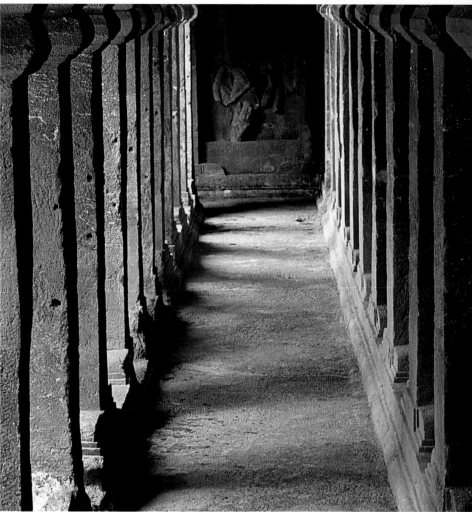

ABOVE Observational sketches by
Carolyn Genders.
ABOVE RIGHT Cloister of pillers.

Photograph by Ann Frith.

The beauty of a view, building or object initially captivates me
but as I look more searchingly I am likely to stumble upon a
seemingly insignificant mark, surface or shadow that will become my
'source of inspiration'.

This cloister of pillars may not make an immediate visual
impact but I found when sketching that the shapes of the individual
pillars and, more importantly, the shadows cast by them suggested
interesting forms. Sketching freely I gained an understanding of what
I was looking at and I observed the pattern that the shadows made on
the ground and those cast by the neighbouring pillars. One shadow in
particular had a shape that suggested forms that I saw immediately
could be developed into ceramic pieces. Rapidly making a sheet of
coloured pencil sketches clarified my thoughts and ideas for
complementary surfaces sprang to mind. My next step would be the
maquette in order to explore the forms in three dimensions. I am a
big fan of the maquette. It saves time and effort.

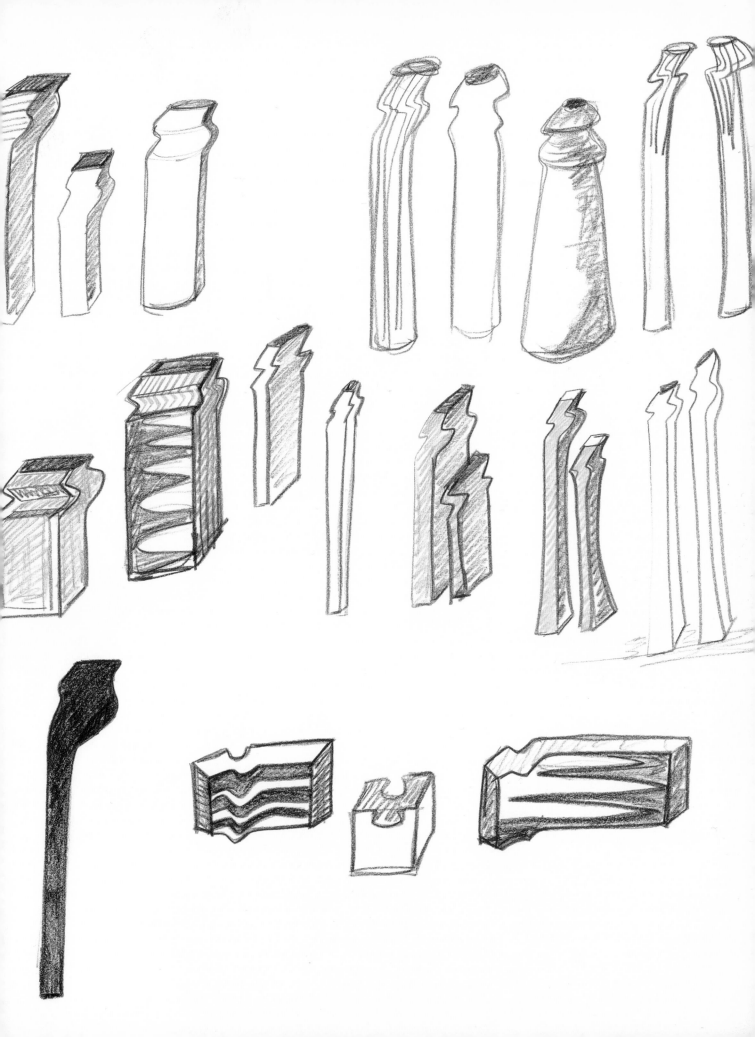

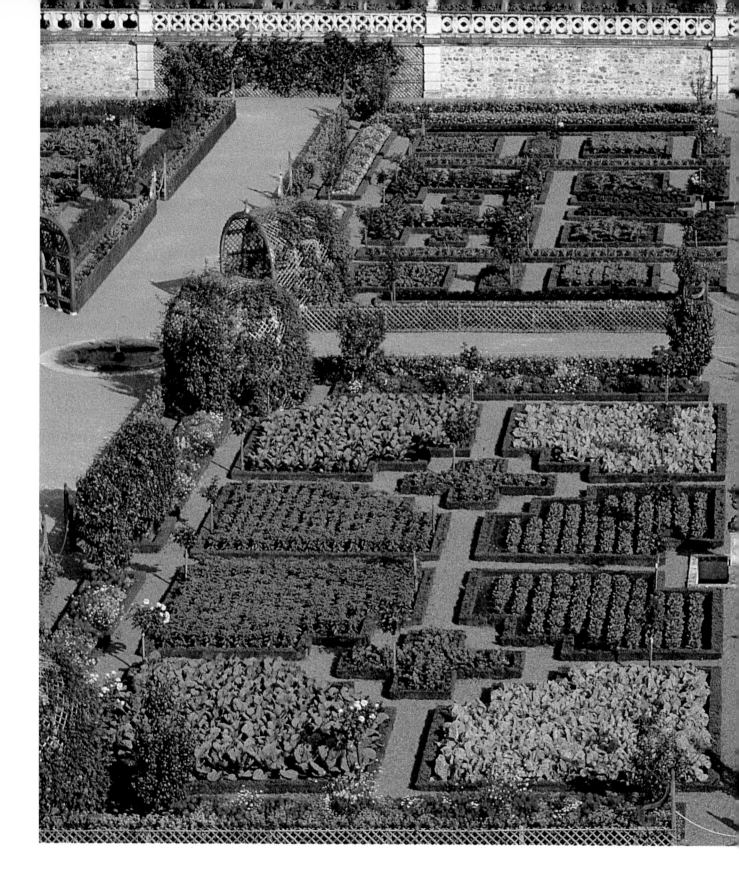

Villandry is an imposing chateau in the Loire Valley, surrounded by magnificent gardens. The vegetable garden is a geometric landscape that delights me at any time of year. Originally created in the Middle Ages, it was planned and tended by the monks and the standard roses that grow amongst the vegetable beds symbolise them. Restored

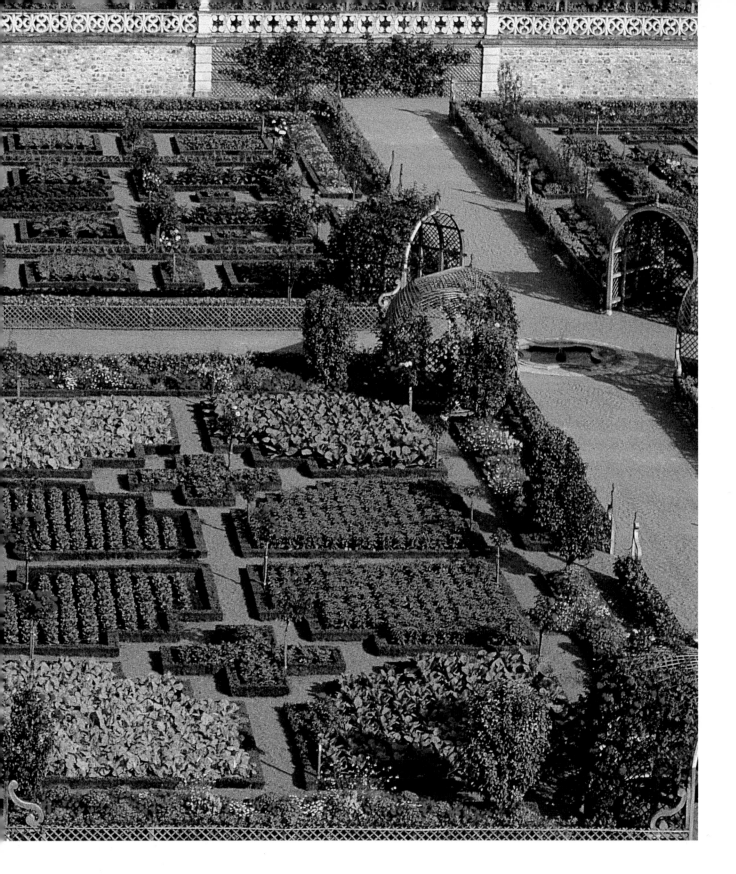

at the turn of the 20th century by the Spaniard Dr Joachim Carvallo, the chateau and gardens are still owned by the same family. Above the kitchen garden there is a very beautiful ornamental garden, each part of which represents an aspect of love. I like the geometric design of both gardens and find them a wonderful source of inspiration.

Kitchen garden, Chateau de Villandry, Loire Valley, France.

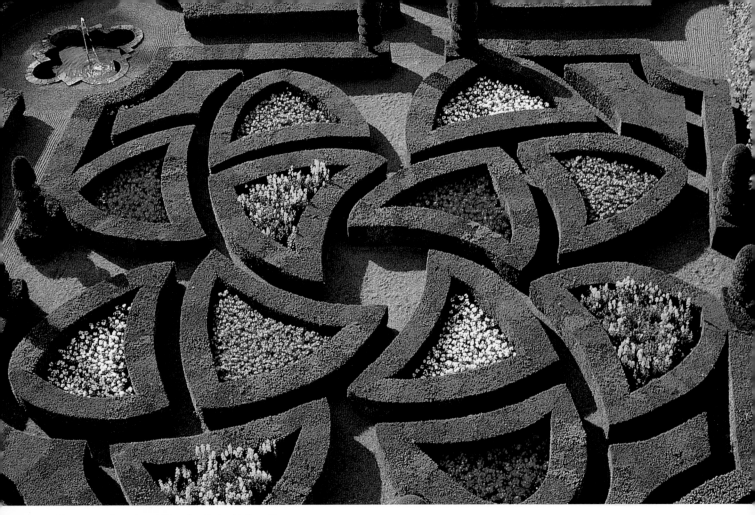

Ornamental garden, Villandry, Loire Valley, France.

I chose part of the ornamental garden from which to develop ideas for form and decoration. I find the tight design, which some might consider restrictive, interesting as within this framework I am free to 'play' with pattern and scale. Because the structure is basically geometric, it suggests abstract forms. However, working in a more organic fashion it would be possible to create softer more natural pieces.

I enjoyed the exercise of taking one shape and a limited palette (colours determined by the garden itself), and changing the scale and proportions had some surprising results. Doing the same exercise with another shape gave me additional information to consider that which I thought might transfer excitingly into clay.

Geoffrey Eastop and John Higgins are two ceramists for whom architecture and geometry have been a source of inspiration. In John Higgins' work the architectural and geometric references are clearly visible influencing form and surface and remaining relevant in his current work. In contrast Geoffrey Eastop's work is informed by an earlier interest in these subjects.

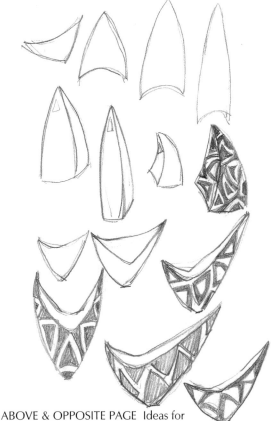

ABOVE & OPPOSITE PAGE Ideas for vessels and surface pattern developed from the ornamental garden.

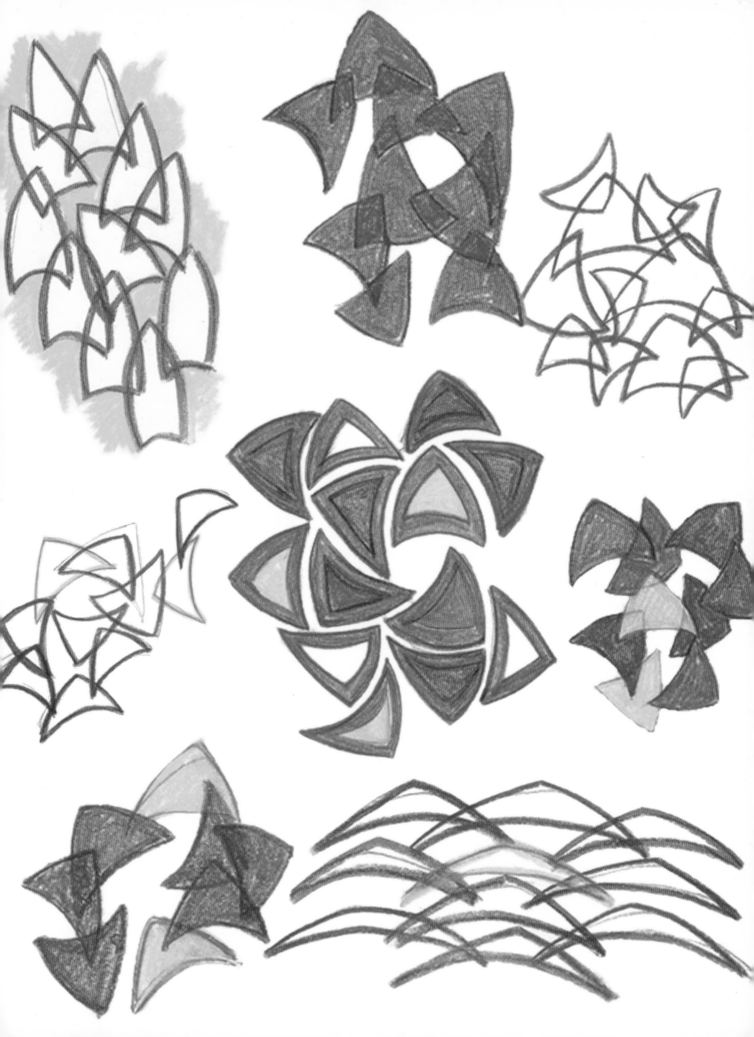

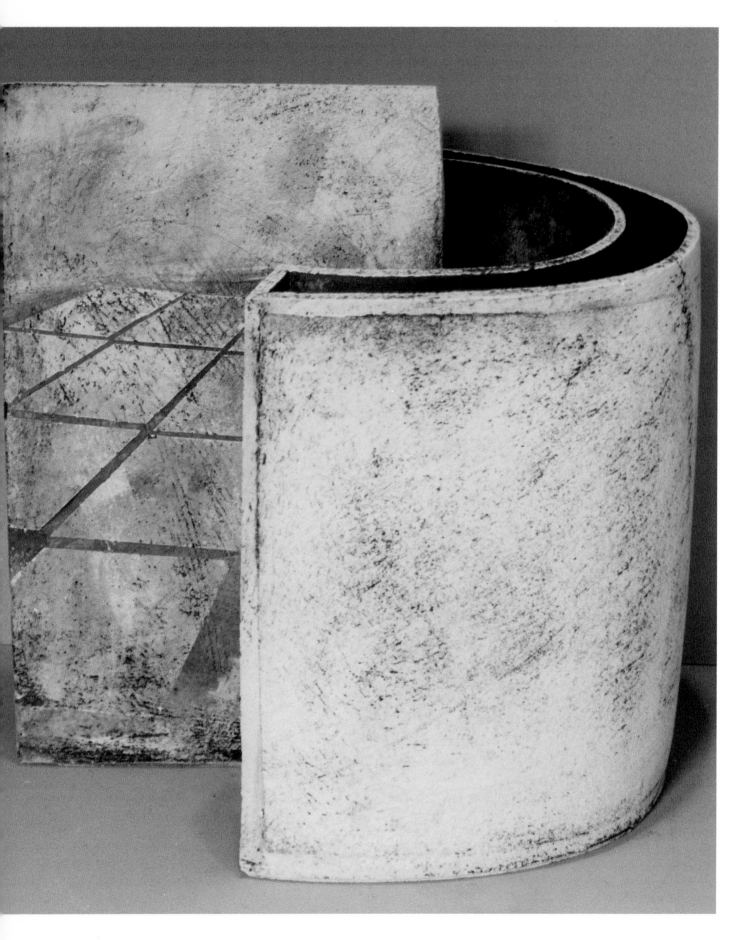

John Higgins

In the early 1970s John Higgins began to develop a range of work based on optical illusions – a theme which he continues to explore today but which has, over the years, encompassed many diverse influences and sources of inspiration. Form and surface treatment are considered as part of this illusion and it is important that they work together to create an overall illusionary effect.

Initially his ideas developed from the observation of still life groups such as 'Kettle, Jug, Saucepan, Frying Pan' (typical objects used in still life groups at this time) and the work of the painter William Scott. As a teacher of painting and drawing John was aware of other optical illusions: Roman mosaics, Cubism, even visits to the theatre where viewing the stage from the gods created distortions of objects and sets.

Pieces he has made which are freer in execution were influenced by the drawings and paintings of Ben Nicholson. The quality of Nicholson's linear drawings, use of composition, flatness of painted surfaces, application and choice of colour, all in their way affected John. After seeing one of Nicholson's still lifes of fruit, John began to draw bowls of lemons from all angles, attracted, not only by the distortions but by the colour of the lemons. A certain preoccupation with yellow resulted and pieces of his work often contain a splash of vivid yellow.

For a long time John felt a need to make objects that

BELOW LEFT Optical illusion studies, by John Higgins.
BELOW RIGHT Vessel, 1977, by John Higgins.
OPPOSITE PAGE Vessel, 2000, by John Higgins.

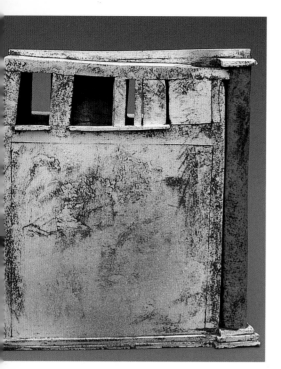

ABOVE Blue column, by John Higgins.
BELOW Fortification on the coast, Crete.
Source photograph by John Higgins.

were thin from back to front in relation to width. These pieces came close to becoming more two-dimensional than three. Whilst enjoying the visual tension created by these pots, John was aware of the need for stability and subsequent pieces became more three-dimensional.

For the last few years, the forms, shapes and surfaces found in architecture, both ancient and contemporary, have been his main source of inspiration. Visits to Crete and particularly the ancient city of Knossos have contributed to his work. The sandy surfaces of the buildings, the small shards of pottery that he found and the Minoan pottery of Heraklion Museum have all inspired John and enabled him to pursue the development of slab built forms and to create a range of surfaces that included texture and colour. 'Blue Column' was a response to the image of a slit in the wall of an ancient fortification: walls, thick on the inside, thin on the outside, framing and accentuating the colour of the sky that was just visible and seeing pictures of the Palace of Knossos. Equally, contemporary buildings such as the Guggenheim Museum in Bilbao by Frank O Gehry, with its distinctive shapes, have been influential.

Once ideas occur, pieces develop through the making process without reference to source material. John says, 'My main aim in the

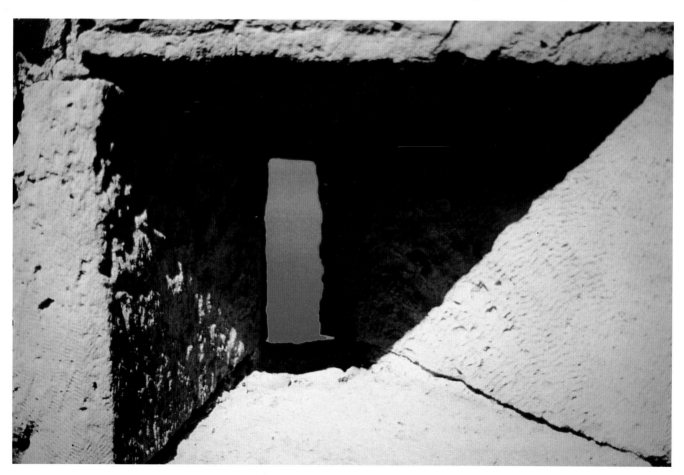

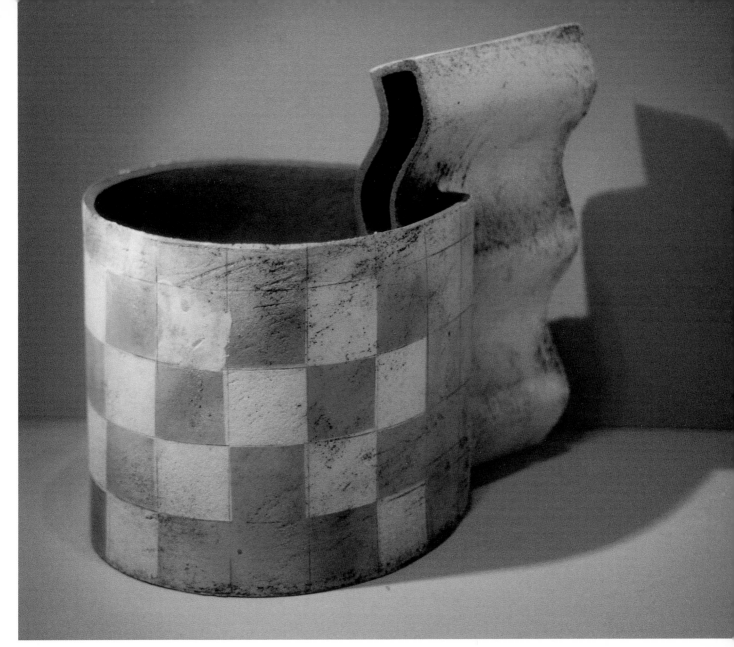

Vessel by John Higgins.

use of any source material is to lodge the imagery in my mind's eye and work with the ideas, shapes, forms and colour in an interpretative way and not be constrained by the original sources'.

However, when he is really struggling to find a way forward, John turns to the two-dimensional activities of drawing, painting or monoprinting. Monoprinting can be particularly rewarding as it provides a textural line and quality that is spontaneous and lacks absolute control.

Though his ideas may seem to be continuous to the outsider, John makes groups of work that relate to one another or explore a particular theme. Before he starts each group he feels he must have a new idea or trigger from which to develop. When I look at the work of John Higgins, I am excited by the variety of form and the relationship to surface. His work, with its clear associations with architecture, has a flow and rhythm that is at once challenging but tranquil. The surface has a richness and depth reminiscent of the Old Italian frescoes that for me conjures up images of warm Mediterranean days.

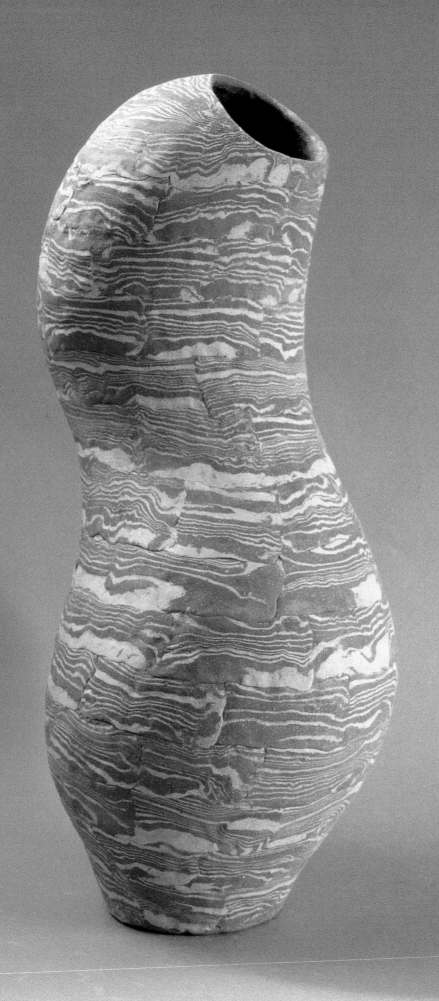

Geoffrey Eastop

Simple forms enhanced by interesting textural surfaces characterise Geoffrey Eastop's ceramics. Both forms and surfaces are developed intuitively, informed by his knowledge of painting and sculpture.

Many of his ideas and his approach to his work can be seen to be influenced by Geoffrey's early training as a painter. As a student of painting Geoffrey recognised in the work of Cezanne the remarkable way he created the effect of volume of objects, and how they related to and connected with the space around them. He began to understand the importance of the interaction of space and volume and the quality of 'surface'.

Geoffrey refers to the long quest he has pursued to bring together these concepts of the painter/sculptor with the craft skills of the potter. Looking at his early painting *Nude*, (No.9), 1952 . It is clearly apparent that his concerns were for space and volume and that he had a passion for

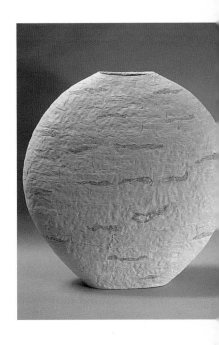

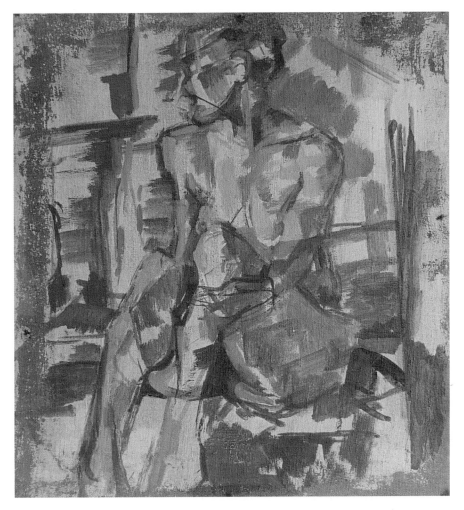

ABOVE *Large Medallion*, two-sided, handbuilt, 44cm high stoneware, by Geoffrey Eastop.
LEFT *Nude*, (No. 9), 1952, oil painting, 40 x 60cm, by Geoffrey Eastop.
OPPOSITE PAGE *Reverse Curve*, 49cm high, by Geoffrey Eastop.

RIGHT Sketched ideas, 'Porcelain Under
Tension', 1979, by Geoffrey Eastop.
OPPOSITE PAGE *Spire with Stopper*,
handbuilt agate stoneware, by
Geoffrey Eastop.

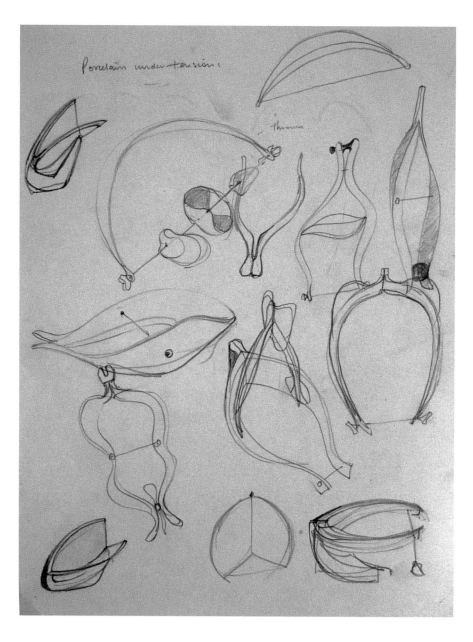

surface – all this before he had thought of becoming a potter.

Over the years he has explored various directions, sometimes through the handling of the clay, sometimes by more obviously linking aspects of painting and sculpture. Specific examples of painting and sculpture that he finds interesting tend to change naturally either because he discovers something he has not noticed before, for example the sculpture of Giacometti, or, as happened recently, from studying the layers of paint of the work of Jackson Pollock.

Geoffrey acknowledges that nature is a continuing but subconscious source of inspiration. Work seldom starts from a specific natural form and Geoffrey writes, 'the importance of nature in art, is that it must not be taken too literally but allowed to sink to the back of the mind so that it can emerge later in the course of time'. During the

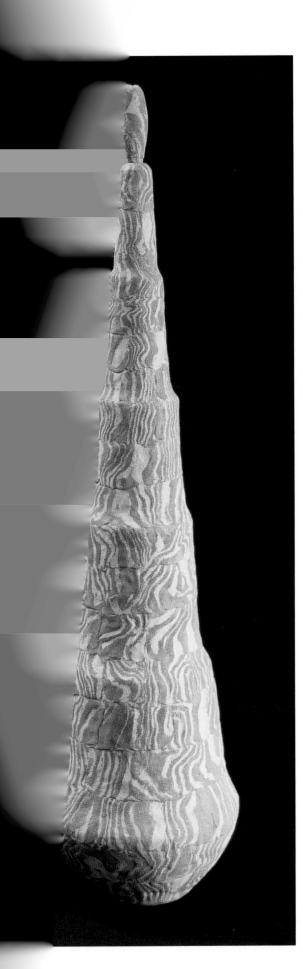

1970s, when looking at a form he had made, Geoffrey would be reminded of a natural object and might make small alterations in order to create an illusion of the object but never an imitation.

Natural forms, resembling seeds or fruit, evolve from the way he works, and as they usually have a geometric base they can be further modified by the geometric needs of the pot. Forms in nature are more of a discovery than a pre-considered idea.

Geoffrey's work over the past five years shows his continuing interest in textured surfaces. Abandoning glazes for vitreous slips built up in layers, Geoffrey has achieved textures that suggest rock surfaces, which have been a source of visual stimuli for recent work.

For Geoffrey the route from source to making is not a direct one. It is more a matter of evolution. His first and continued main underlying influence on the development of his ceramic work was his early study of Cezanne's work. It is this and his understanding of both the principles of painting and sculpture, combined with a love of material and sensitivity to all that is around him, that ensures his work has a quiet presence.

CHAPTER 3

Shadows, reflections and silhouettes

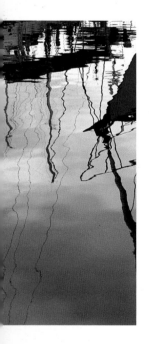

S HADOWS are projected by an interception of light, silhouettes create an outline of an object and reflections throw back an image, but all of them create a new way of looking at the natural and man-made world.

Looking into a lake, the ripples of the water distort the reflections of the trees creating wonderful patterns, the trees 'with rhythm' contrast starkly with the trees growing on the bank. The shadow of a person or object on the ground is distorted, sometimes foreshortened, sometimes elongated, depending on the position of the sun. Falling on a pavement or wall, the texture of these surfaces become part of the whole 'shadow picture'. The silhouette of an object against the sky or another building makes a powerful impact challenging the viewer to look more closely. As a source of inspiration, shadows, reflections and silhouettes all offer a new way of seeing the world and many artists including myself use them in their work.

Shadows are exciting in that they fall over surfaces becoming part of them. A collection of photographs of shadows reveals a myriad of patterns that are easily overlooked when concentrating on the known object. This can be clearly seen in the image of the railing and its shadow on a pavement. The distinctive design of the paving slabs is contrasted with the strong shadow of the railing, whilst the vivid yellow of the actual railing acts as the focal point. Looking at this, the shadow is predominant but altering the emphasis by accentuating the design of the paving slabs or, in turn, the vivid yellow of the railing, challenges

ABOVE Reflections of boats.
RIGHT Sheffield Park, Sussex, UK.

48

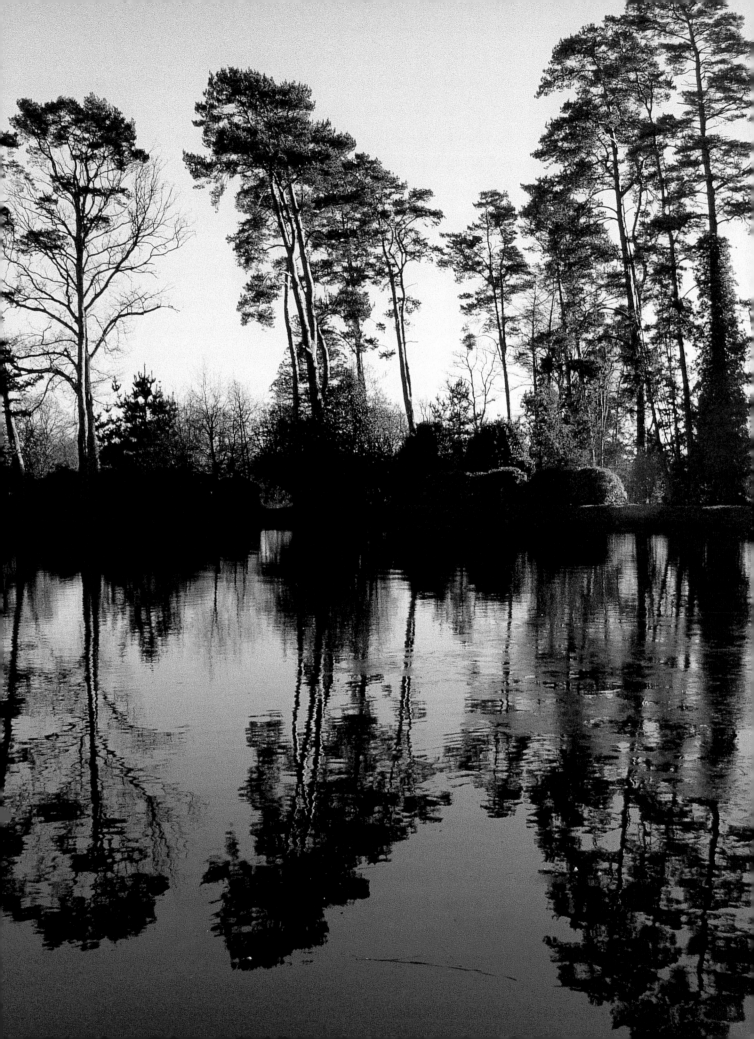

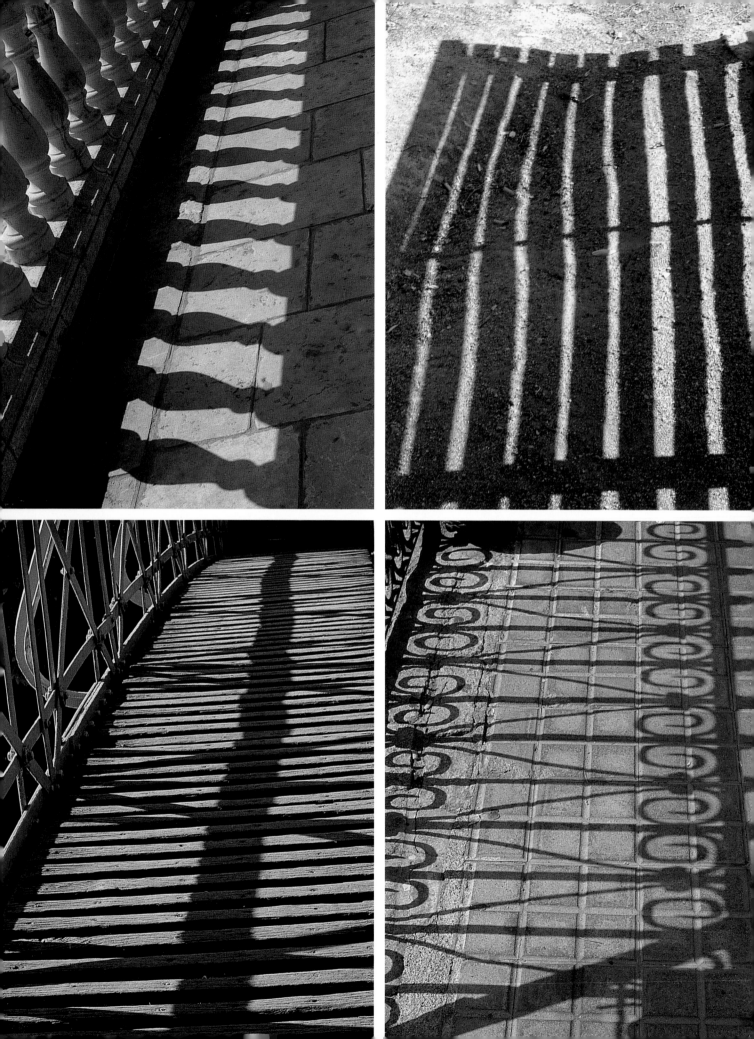

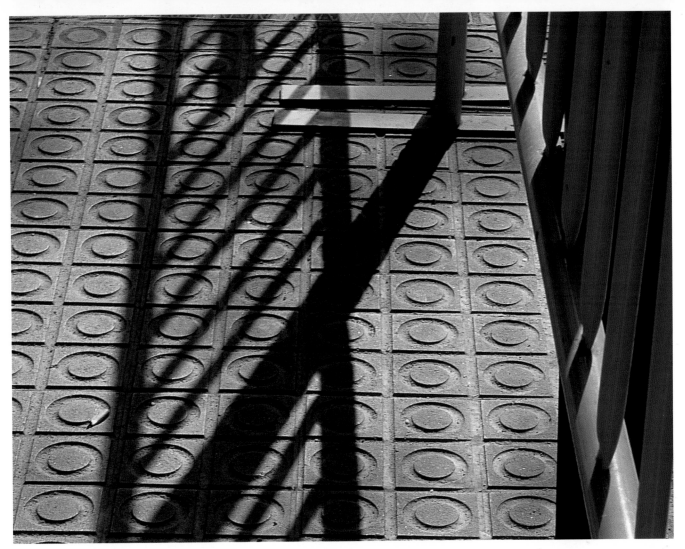

perceptions and one sees things abstractly. Continuing with this theme by playing with colour and pattern in a free, less formal way also immediately creates new possibilities. Instinctively I concentrated on the use of dots and circles influenced by the paving slabs, and sketched designs for plates and pots, my mind full of variations that might be successful in clay. I find that taking time to 'play' like this relaxes me and is often productive.

LEFT Sketched designs for pots & plates.
OPPOSITE PAGE Watercolour studies.

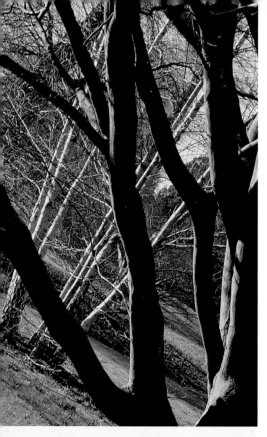

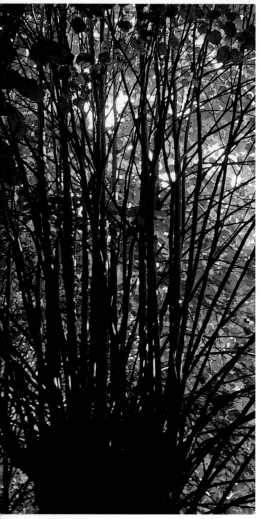

As a ceramist I am naturally interested in form but a sense of spatial awareness is always useful. Relating objects to each other and the space they occupy informs my own work by questioning my understanding of what I see.

A few years ago, visiting a Mondrian exhibition in London, I was intrigued to see a few of his studies of trees. They seemed to me to be a progression to the abstract – the first focussed on the tree but in the next couple it was apparent that he was increasingly interested in the negative space between the branches. The tree was no longer the subject but part of an exploration of form and surface. Excited by what I had seen, I decided to base a series of vessels on this theme.

Taking photographs of winter trees, I studied the shapes of the negative space and discovered new forms. Sketching in turn led to the development of designs that I felt would relate to the forms. Over time both forms and surface continue to progress through the making of test tiles and final pieces. As you can see, when developing my own work, I tend to work in my sketchbook and sometimes only a few rough drawings are enough to fire my imagination and creativity. However, occasionally, it can be useful to work in a more structured manner and from an almost routine exercise, ideas will flow.

LEFT AND ABOVE Trees.
OPPOSITE PAGE Silhouetted trees.

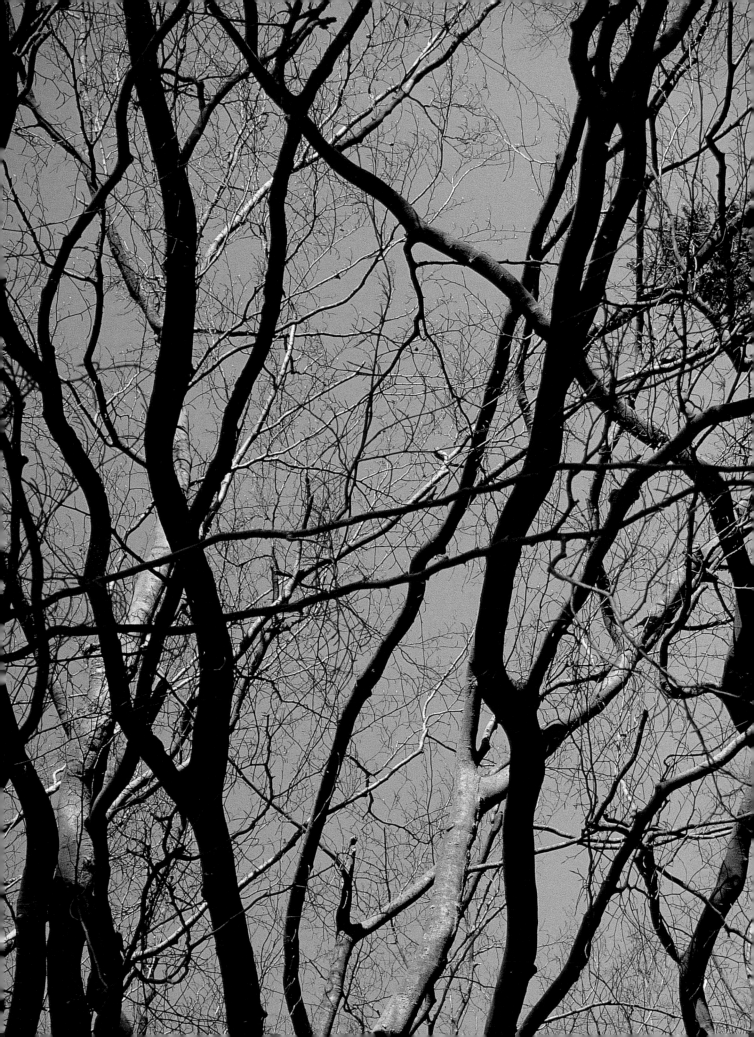

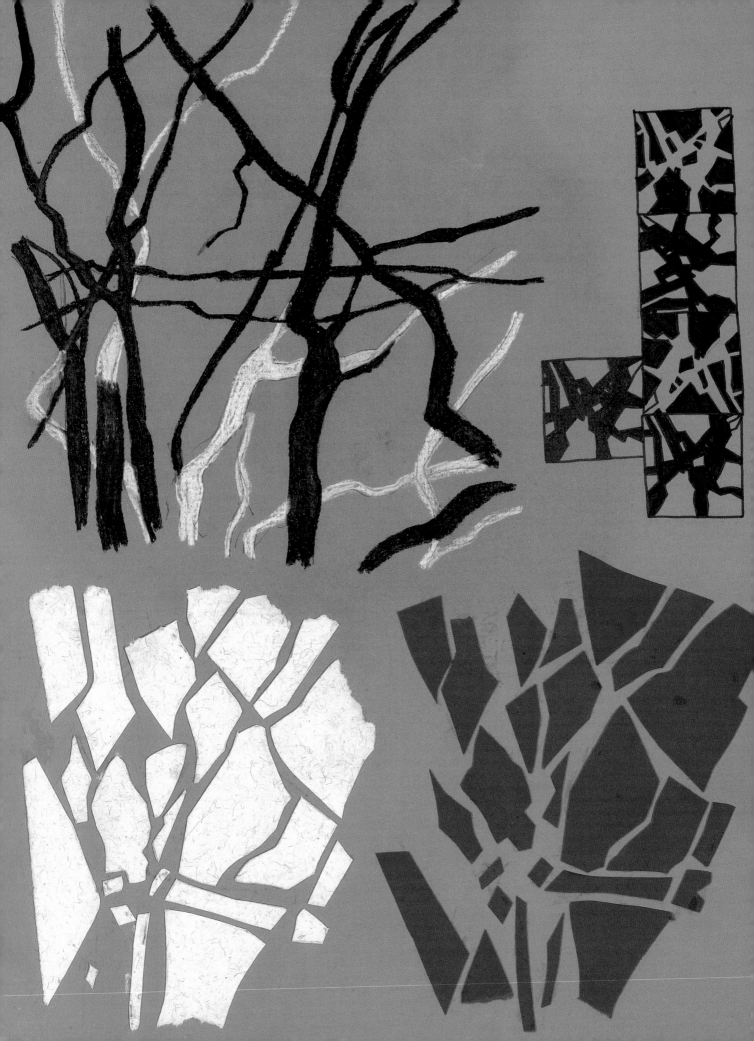

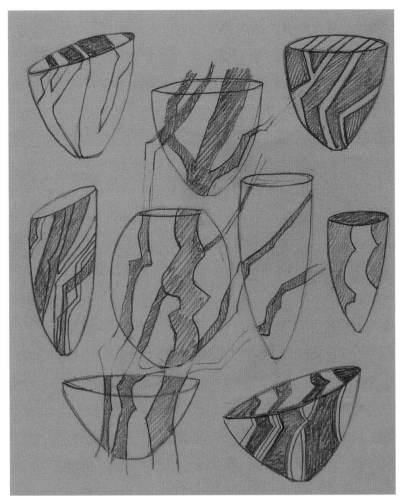

A tree with no leaves, silhouetted against a cloudless blue winter sky illustrates negative space. The branches entwine but the shapes between are also of interest suggesting ideas for form and pattern. Sketching simply in black and white, just to get the feel of the rhythm of the branches reveals possibilities. By cutting out the shapes of the negative space, first in black paper and then in white, one notices the change of emphasis. This 'play' may lead to new forms. Half closing the eyes reveals individual shapes. Drawing ceramic forms over a sketch of trees could be a starting point for surface, so could the repetition or stylisation of a few marks.

LEFT Development sketches for vessels.
BELOW Vessel Based on Silhouettes, 1999, by
 Carolyn Genders.
 Photograph by Mike Fearey.
OPPOSITE PAGE Exploring negative space.

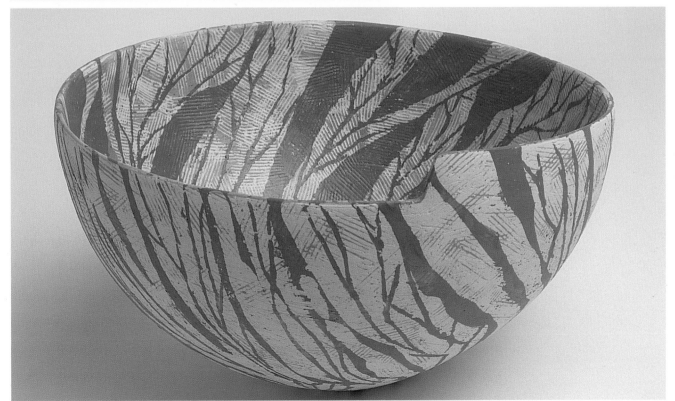

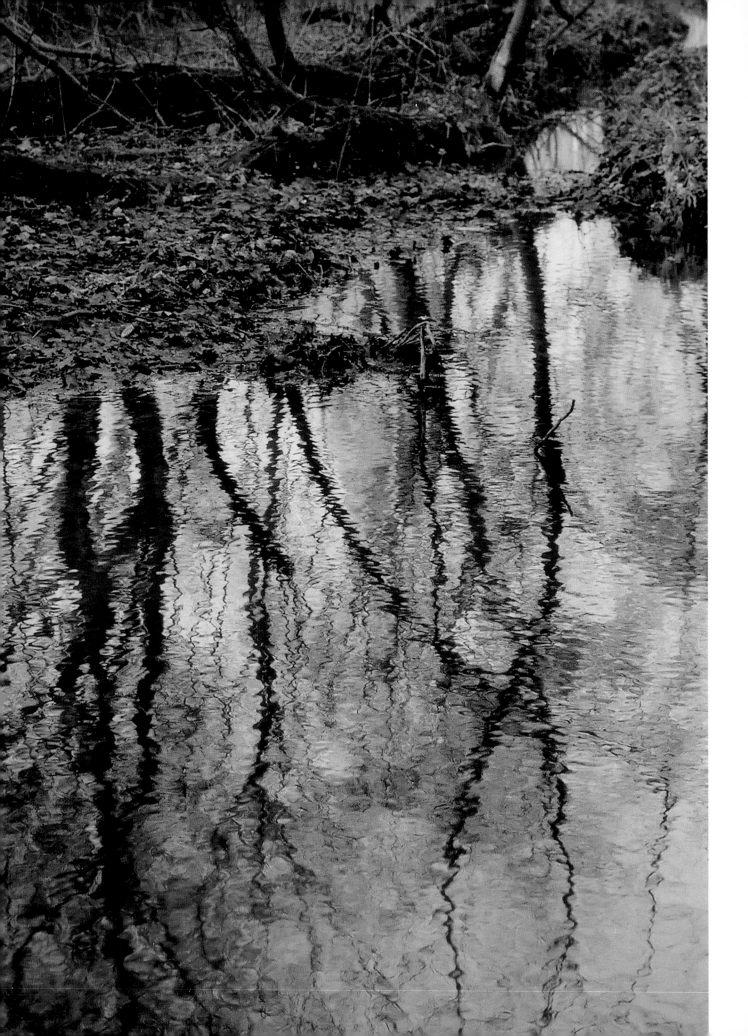

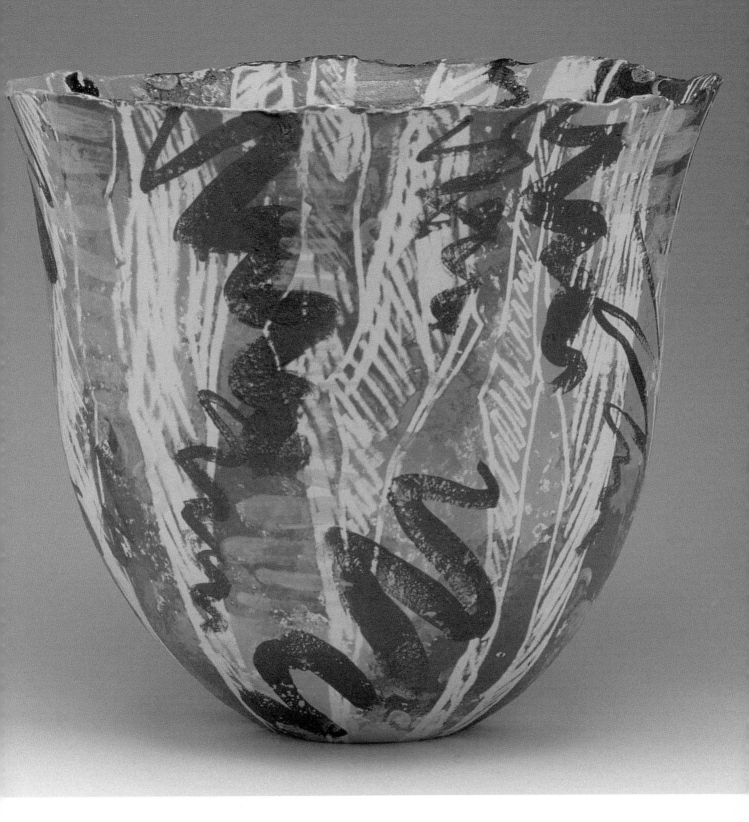

Reflections are full of mystery and promise, as though the mirror image has a life of its own. The relationship between the tangible object, and the intangible reflection creates moods and atmosphere. I am fascinated by the fragmentation of light produced by the ripples and the resulting patterns – a recurring theme in my work. These early vessels and preliminary sketches of mine show how I was working at that time.

ABOVE Vessel based on reflections, 1988, by Carolyn Genders.
OPPOSITE PAGE
Winter reflections.
Photograph by Steve Hawksley.

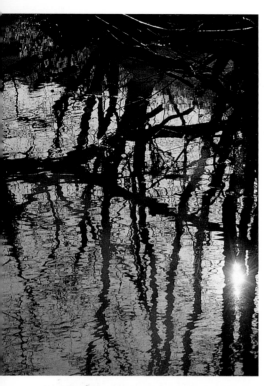

Although I take photographs for reference, I prefer to sketch from life and then to develop pieces from my creative memory, occasionally referring to photographs if necessary. It is during this sketch stage that I start to think about colour but once I have made one piece, subsequent pieces follow naturally, forms evolving through familiarity with the material, and colour prompted by test tiles and colour studies.

Many ceramists touch on this theme of silhouette, reflection or shadow, interpreting it in relation to their own particular concerns. As a source of inspiration it is rich and challenging.

LEFT Reflections.
BELOW Sketchbook ideas, 1988, by Carolyn Genders.
OPPOSITE PAGE Sketchbook ideas, 1988, and vessel based
 on reflections, 1987, by Carolyn Genders.

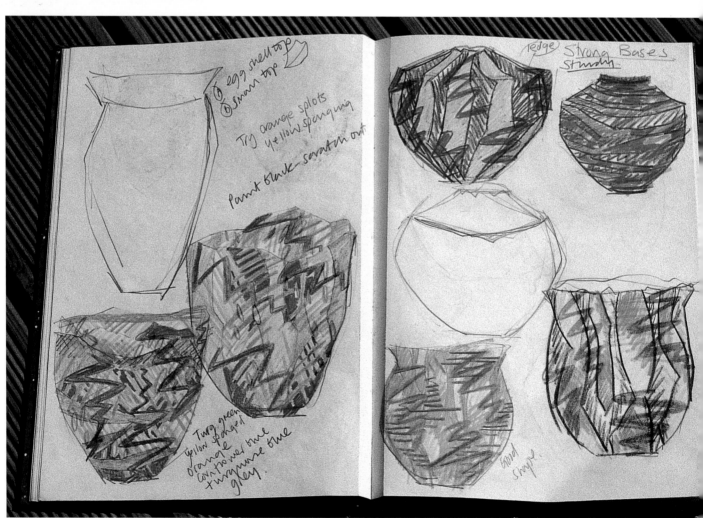

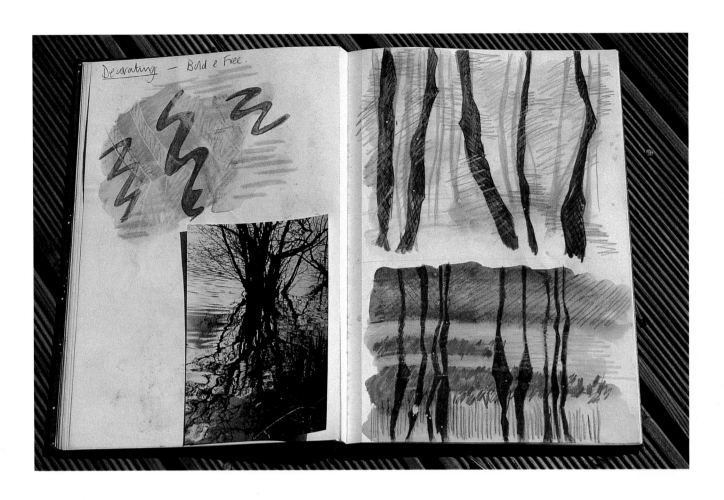

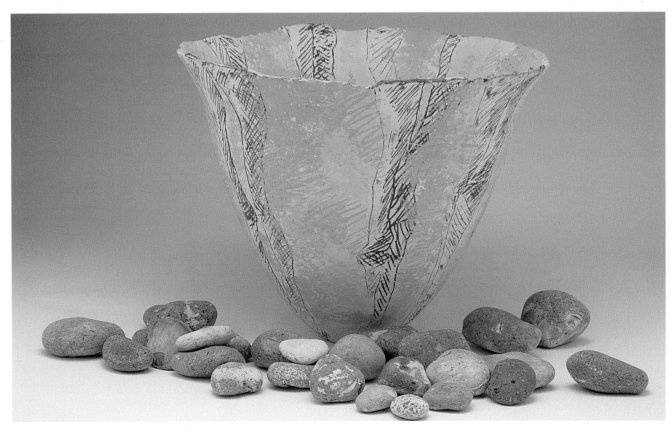

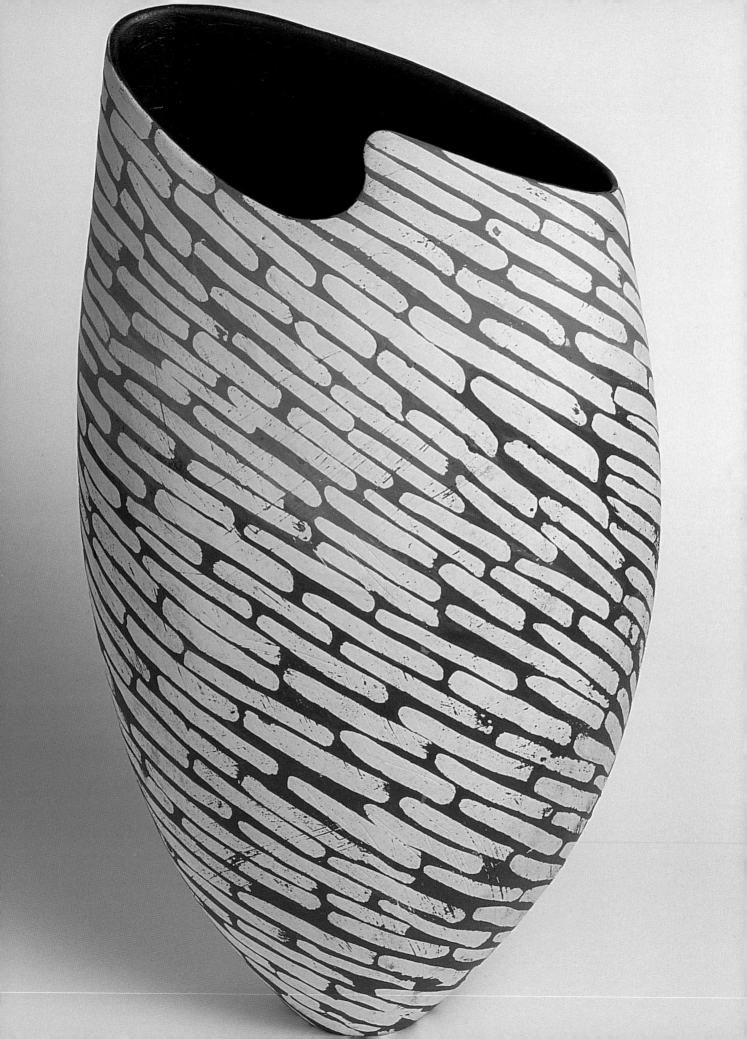

Carolyn Genders

As a child, I soon discovered the clay in the ditch at the bottom of the garden. I loved the feel of the clay and it was a joy to me to spend hours making pots. I grew up surrounded by exotic objects from the Far East, my birth place: large Chinese vases decorated with painted horses, carved ivory figures and elaborately decorated glass bottles. From my Austrian mother I inherited my delight in decoration – the Austrians live to decorate, carving and painting hearts, flowers and dots in simple patterns on every surface. Brought up in the country, I studied nature with my father. He taught me to identify the different birds and flowers and to be aware of the changing seasons. The natural world remains the strongest source of inspiration for my work and it is there that I find most of my ideas for form, pattern and surface.

When I went to art college to study ceramics it seemed natural to me to use these early interests and I sought to combine them in my work, making decorated vessels. At that time, I treated vessels as three-dimensional canvases, solely vehicles for decoration.

On leaving college and setting up a studio, I continued working on themes started there, but gradual and natural evolution has led to my work of today. This reflects my interest in the relationship between form and surface and surface decoration.

Although I primarily express myself by making ceramics, I feel the peripheral activities of painting, etching and even knitting are essential to me as an artist. Working in other disciplines generates ideas for ceramics by allowing me to explore another side of my creativity and, perhaps most importantly, gives me great pleasure.

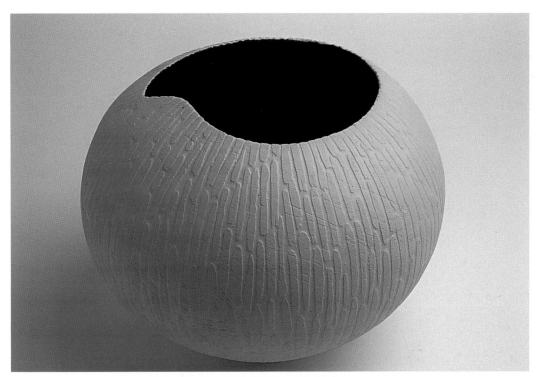

LEFT Vessel, 1999 by Carolyn Genders.
OPPOSITE PAGE Reflections vessel, 2001, by Carolyn Genders.

Photograph by Mike Fearey.

Etching, 2000 by Carolyn Genders.

I usually carry a sketchbook, which over the years has become a sort of visual diary, in which I scribble ideas for pots, noting anything of interest.

Painting is my antidote to ceramics. I love the immediacy of squeezing paint from a tube, mixing colours, applying them to the canvas and seeing an instant effect. It makes a welcome change from the labours and technical considerations of achieving colour in ceramic that is a particular challenge and satisfaction of its own.

I am proud to be part of a ceramic tradition and feel an empathy with the ceramics of ancient civilisations. When I first discovered the collection of vessels from ancient cultures in the British Museum, their presence and quiet simplicity immediately attracted me. The Minoan pots in Heraklion Museum in Crete also made a lasting impression on me. I recognised the consummate skill of the potter, his complete knowledge of technique and the materials available to him, achieved by years of making.

This was a quality that I sought in my own work and I realised that it can be elusive, achievable only through a real understanding of the craft. The potter of ancient Crete made with function in mind but, whilst this was the prime consideration, he nevertheless embellished the vessels with exuberant decoration reflecting his world. The pieces that survive today have a surface patina and quality that comes from their long life and is one to which I am drawn.

Visiting art galleries gives me the chance to enjoy and study the work of certain painters such as Paul Klee, Patrick Heron and Georges Rouault whose brushwork and use of colour create a surface texture that I find very exciting. I have learnt about decoration from Gustave Klimt's intricately patterned treatment of the clothing of his sitters that contrasts with the sensitive painting of the portrait.

Vessel forms come from my studies of the natural world and from architecture. Early work was inspired by the skeletal human figure, bones and rocks but more recent work has evolved from other sources; the silhouettes of trees against the winter sky, beach pebbles, the textures of old walls, medieval frescoes and reflections in the water and studying the work of sculptors such as Hepworth, Moore and Brancusi.

Rather than working directly from sketchbook observations when I am in my studio I rely on my creative

memory, occasionally referring to my sketchbook when seeking something specific. I do not naturally intellectualise my work, preferring to make, responding spontaneously and instinctively to materials and ideas. I am aware that my judgements are informed by my sketchbook studies of source materials and the experience of making I have gained over the years.

Looking back on my work it is easier for me to see influences and I realise that certain themes continue to recur. I am content that this is so, accepting that I am not a maker who demands radical change but one who prefers quiet evolution.

ABOVE Etching, sugarlift, 2000, by Carolyn Genders.
LEFT Silhouette Vessel, 2000, by Carolyn Genders.
Photograph by Mike Fearey.

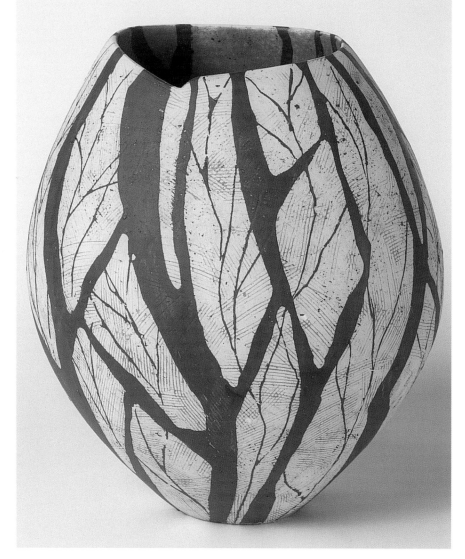

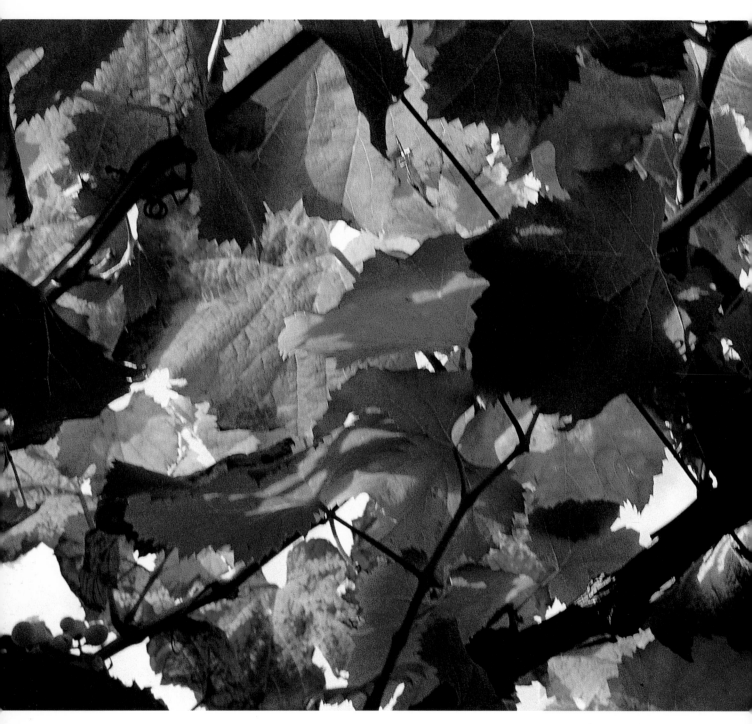

ABOVE Grape leaves in the sunshine.
OPPOSITE PAGE Gunnera flower.
Photograph by Steve Hawksley.

CHAPTER 4

Plants

Plants are a rich source of inspiration and have been used in many ways in art throughout the ages – entwined in borders of Medieval manuscripts, embroidered onto rugs and carved into the wooden surrounds of doors. They lend themselves to decoration – the colour, texture and patterning of leaves and flowers and the shapes that stems and branches form suggesting a multitude of designs.

Plants appear symmetrical but they are not. Responding to lack of space or light they turn their stems or leaves, seeking the best position. This asymmetry can be used in creative work, and often it becomes all the stronger for it, adding sensitivity and life. Contrasts within a plant are common rough/smooth, dark/light, shiny/matt – these too can contribute to one's work by inspiring unusual textures and surfaces.

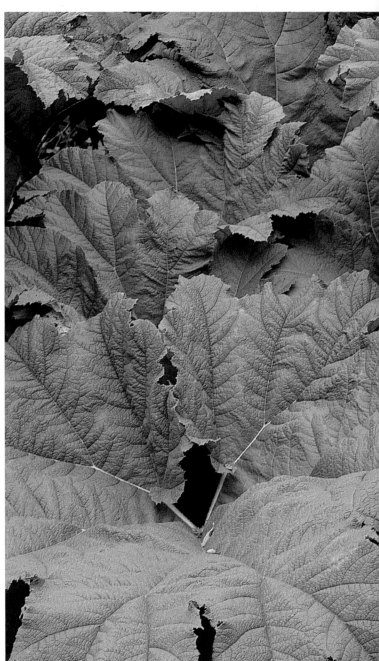

ABOVE Heliconia. Photograph by Ann Frith.
ABOVE RIGHT Gunnera leaves.
OPPOSITE PAGE Detail of a Sunflower.

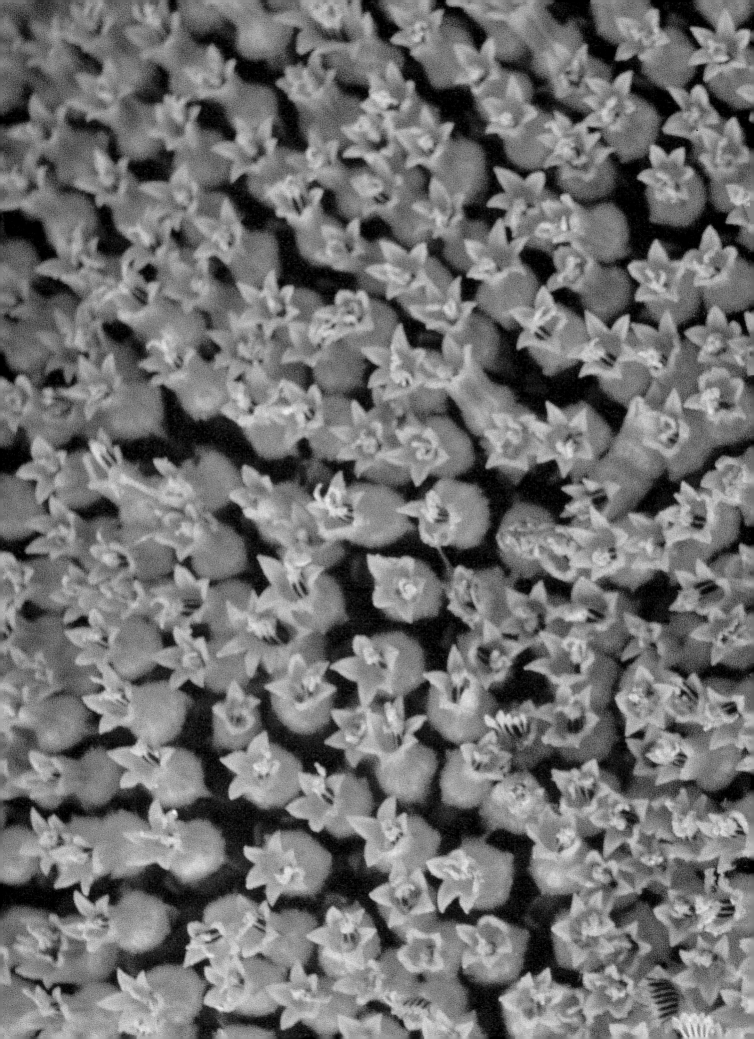

Flowers often thought of as just 'pretty', are at a casual glance a splash of colour and an impression of shape. Closer observation reveals many shades – bold patterning and vivid colour attracting insects, subtler hues providing camouflage, both interrelating to form. Plants and flowers have, as with all of nature, evolved for survival and it is this instinct that makes them individual and interesting. Seeds and pods have a sculptural quality that readily suggest ideas for form which many ceramists use as a starting point for complete themes of work.

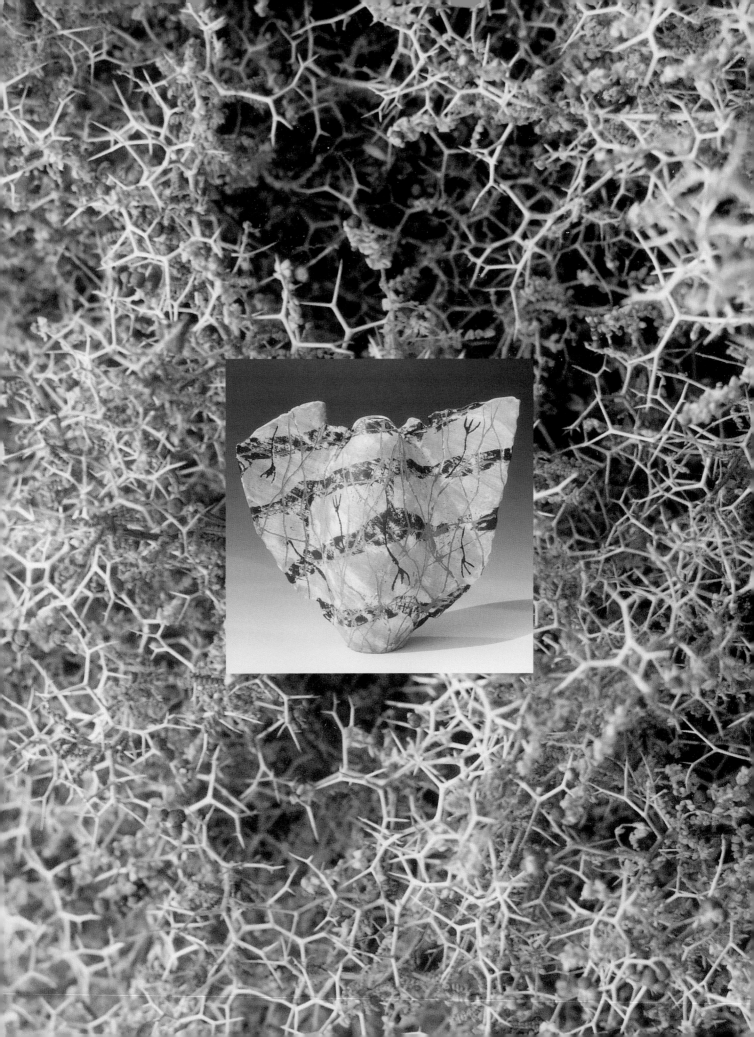

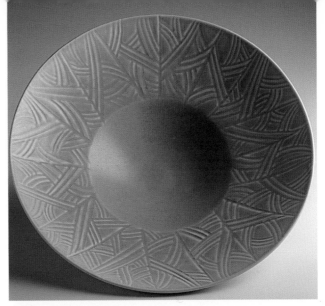

Plants are a continual source of inspiration for me and my work is often informed by studies of plants and plant structures whose pattern and colour I interpret, translating into surface marks and textures. The shapes and forms of seedpods and stamens have influenced vessel forms, and observational drawings of plants sharpens my eye for detail and my understanding of three-dimensional form. The prickly plant opposite inspired the surface of my 'Vessel with Extensions'. While not wishing a direct translation, I sought to create a similar visual quality that conveyed the angularity of the thorns turning densely in on themselves, to protect the softer foliage.

Other ceramists also find plants an inspiring source for decoration as well as form. Laurence McGowan paints stylised two-dimensional patterns onto pots with deceptively simple brushstrokes while much of Peter Lane's work is concerned with atmospheric interpretations of landscape, and his carved and pierced vessels have evolved in response to nature. However, although inspired by the exotic flora that he has seen in Australia and New Zealand, a piece such as 'Porcelain carved bowl' comes more from a subconscious fusion of sources than directly from his photographs and drawings. In contrast, Felicity Aylieff found that through making observational drawings of fruit, pods and seeds, she gained a greater understanding of structure when seeking to develop her sculptural forms.

TOP LEFT Spiral growth, Queensland. Stimulus for Peter Lane's Porcelain carved bowls.
Photograph by Peter Lane.
TOP RIGHT *Porcelain carved bowl*, 25cm diameter, by Peter Lane.
ABOVE *Circular rotation*, 70 x 70x 74cm, press moulded, by Felicity Aylieff.
OPPOSITE PAGE Thorny plant, stimulus for *Vessel with extensions* (inset), 1995, by Carolyn Genders.

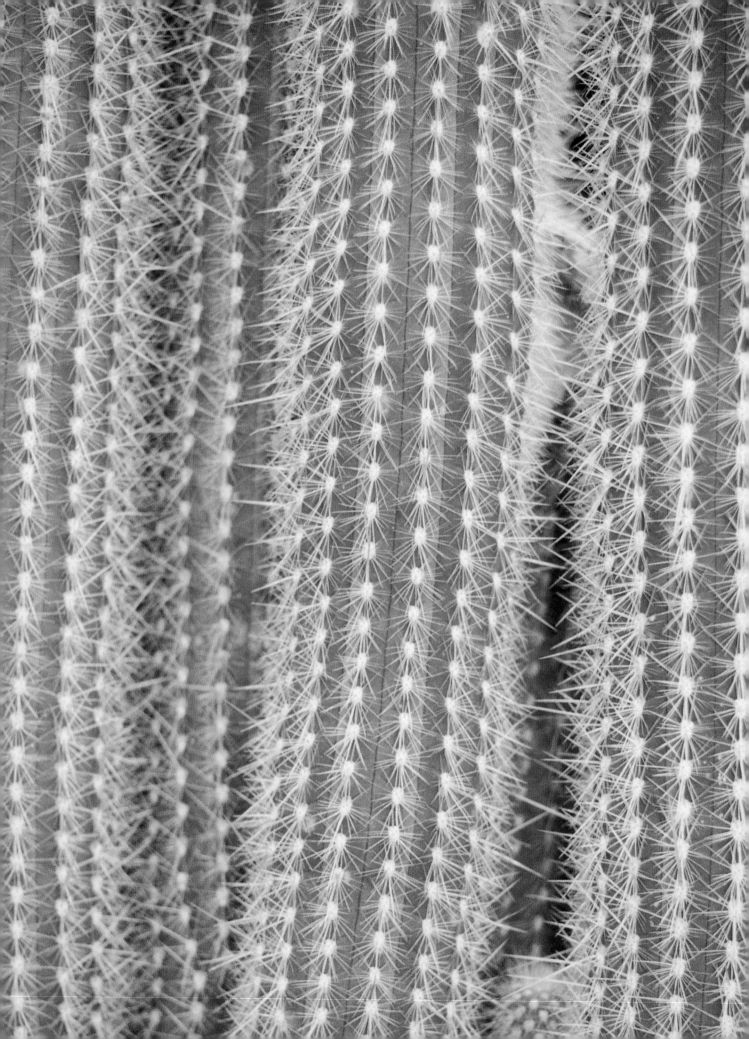

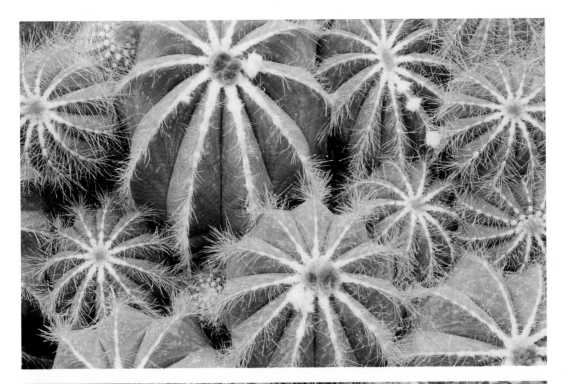

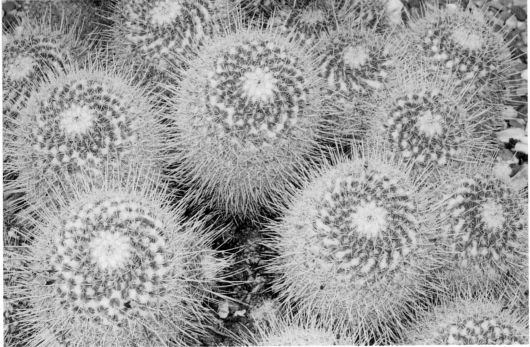

Visiting the Cactus Garden in Ashington, West Sussex I immediately felt transported to the desert on entering the humid atmosphere of the glass houses. Surrounding me were cacti of all types and sizes; tall, narrow extremely prickly ones, groups of small fluffy spheres and emerald green juicy succulents with bulbous forms and fleshy texture. Occasionally a cactus had a huge scarlet or magenta flower that contrasted with the softer grey green of the main body. No ceramist could fail to be inspired by the wonderful variety of form and intricacies of design.

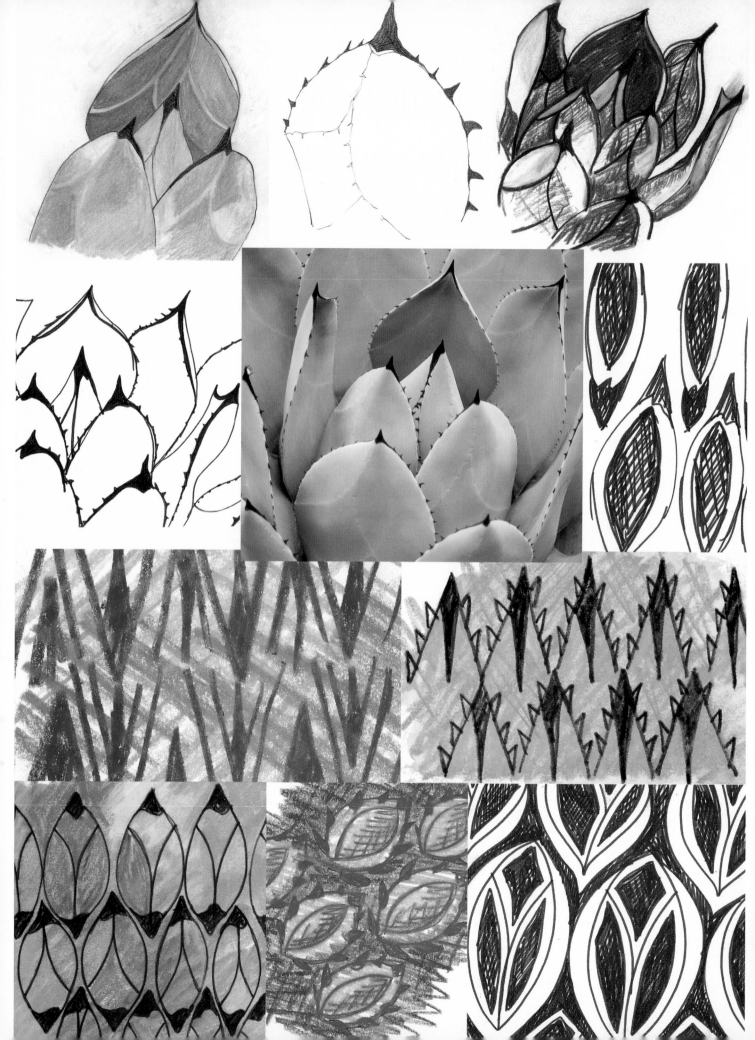

The cactus that inspired the sketches shown was monumental, reaching to waist height, each leaf a sculptural form in itself. First I made a few simple drawings in pen and ink to gain a better understanding of the individual shape of the leaves and their relationship to each other, which I felt created a wave like rhythm. Then turning my attention to the subtle variations of tone, I imagined pots with graduating colour and I began to consider how colour could emphasise form. Isolating an individual leaf, I looked at the attachment of thorn to leaf and noticed that each thorn was a different shape and size. Each leaf had a series of markings that resembled stitching criss-crossing the surface, rather like patchwork.

Back in the studio I worked from my sketches, putting the photographs of the source aside. I prefer to work from memory and not wanting to replicate a cactus in clay, I loosely sketched ideas rapidly. This drawing is about the generation of ideas for form, not about producing 'the' pot or the 'perfect' design. I think it is important to relax and enjoy the physical act of drawing and not to get hung up on 'finished' pieces and certainly not to make finite decisions at this stage. I approach the development of surface and pattern in a similar manner.

At a later date I might review my sketches and maybe choose to make a few small, undecorated maquettes to give me a clearer idea of the form in three dimensions. Sometimes I know immediately the direction I want to continue to explore but sometimes maquettes remain on the shelf for months until I resolve my ideas.

RIGHT Quick sketch ideas for form and
 decoration.
OPPOSITE PAGE Cactus source, preliminary
 sketches and studio development of ideas.

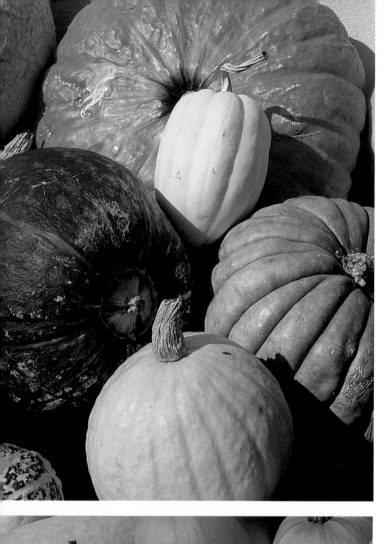
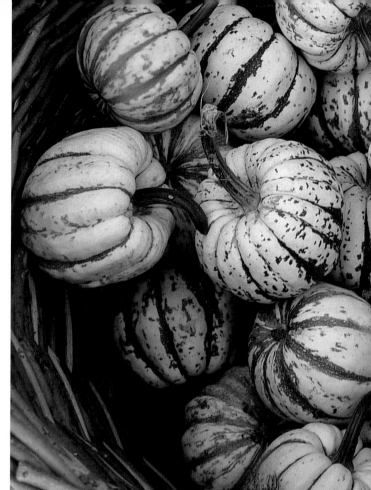
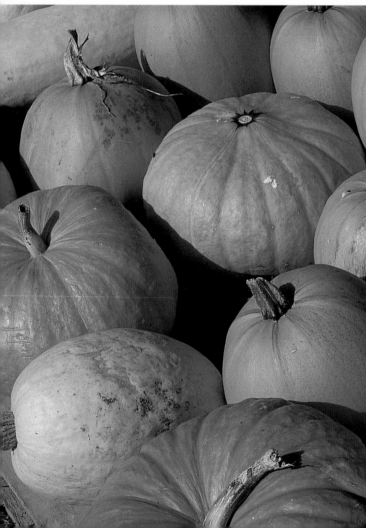
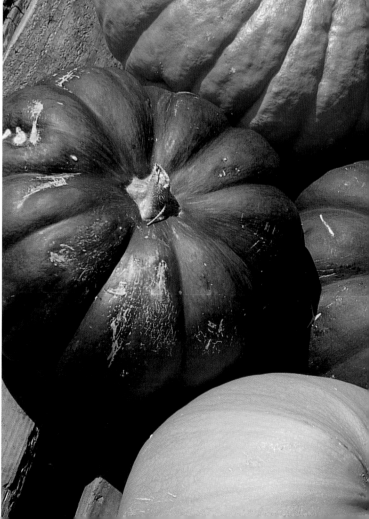

Gourds galore

OPPOSITE AND BELOW Gourds at
Wapsbourne Farm, Sheffield
Park, Sussex, UK.

On a crisp, sunny October day, I followed a sign: 'Gourds Galore'. At the end of a track was a farm that once a year, in autumn, displays its crop of gourds or squashes, grown from seed brought from Canada. The North American word that 'squash' is derived from is Askutasquash, which simply translates as fruit of the vine or vine apple.

A huge array of the brightly coloured squashes with enticing names such as Pink Banana Jumbo, Butternut, Baby Boo and Delicata were arranged everywhere, inside and outside the house, along paths, up steps, in baskets, tables groaning with the voluptuously shaped fruits. How could such a wonderful sight not excite anyone, especially a potter?

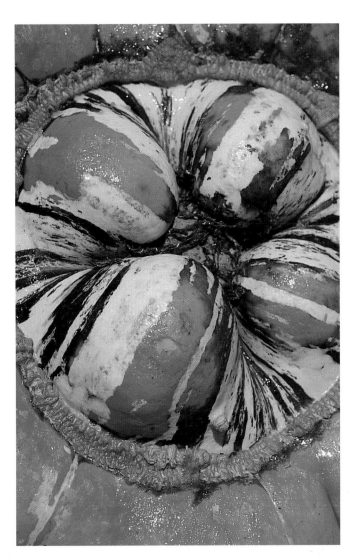

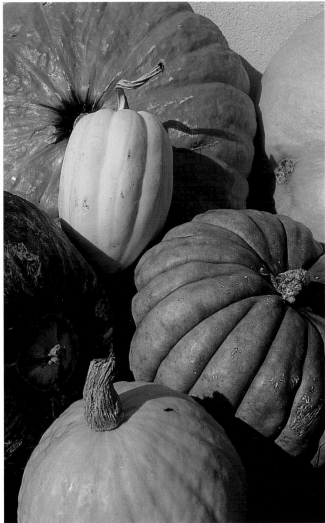

TOP Mixed study.
MIDDLE AND ABOVE Adding colour to
 linear sketches.
OPPOSITE PAGE Observational studies
 of a gourd.

The curvaceous shapes, colours and textures of squashes call out to be made in clay and many ceramists have found inspiration, making satisfying pots and sculptures based on them. It has, perhaps, become almost hackneyed to translate gourds literally into ceramic. Even so, there is a great deal of visual stimulus and pleasure to be had from studying them in depth.

Reaching for my sketchbook, I did some simple pencil observational studies of individual gourds, concentrating on capturing the essence of the form. Noting detail – how the stalk joined the squash and its attachment to the vine, the diseased knobbly growths that distorted the surface creating a texture. I drew only to 'get to know' the forms, to understand them fully and soon moved on to a looser charcoal drawing of a collection of gourds in a basket.

A large piece of charcoal gives freedom, allowing the making of expansive marks that become almost abstract. Drawing like this, using the whole arm, making sweeping gestures, I felt a rhythm that echoed the curved contours of the gourds and I gained an understanding of the relationship of one gourd to another and how they were placed in the basket. This was not about realism or the careful recording of a basket of fruit but an emotional response to the subject. Using watercolour and big fat brushes I painted a large colourful study of the same squashes which suggested ideas for pattern and colour. I was attracted by the weave of the basket, the graduating shadow across the table and the negative space (always so revealing) between the gourds.

'Playing' is such an important part of developing my ideas and often I do things that remain forever in my sketchbook but which are part of the 'journey'. Gluing old sweet papers roughly onto gourd shaped pieces made me once again consider form and the irrelevant dots and squiggles of the shiny paper reminded me of the many possibilities for pattern. Pastel drawings reassembled with small details of other sketches became abstracted images, rich in exciting marks and colour. Photocopying drawings several times to a different scale gave me a quick and simple way to experiment with colour and by building up layers I created textures and colours of depth and luminosity. By now I found that I had moved away from the gourd form completely and what I was doing bore no resemblance to the original source. This is as it should be for an artist – one thing leads to another. This theme could be continued by cutting open the gourds, looking at the contrast between soft inner pith and hard shell and exploring the possibilities presented.

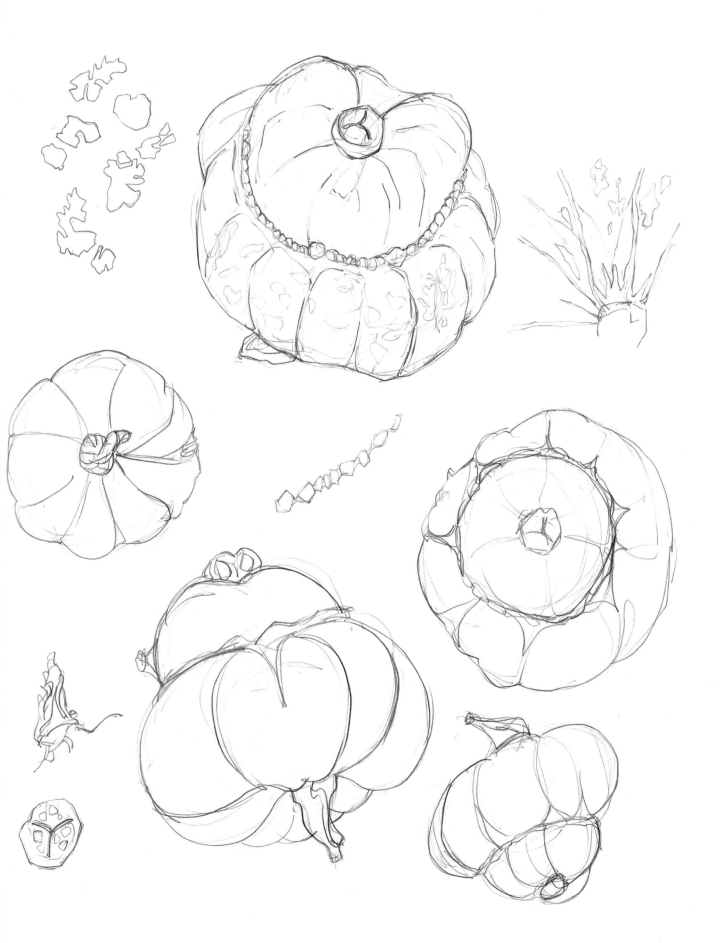

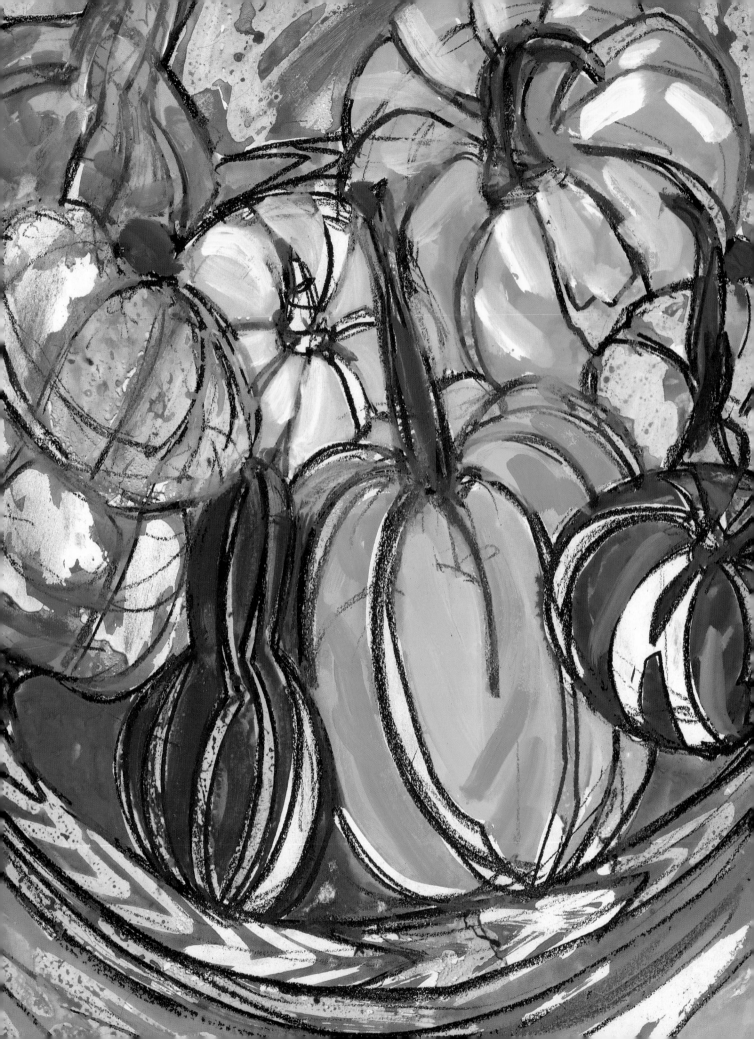

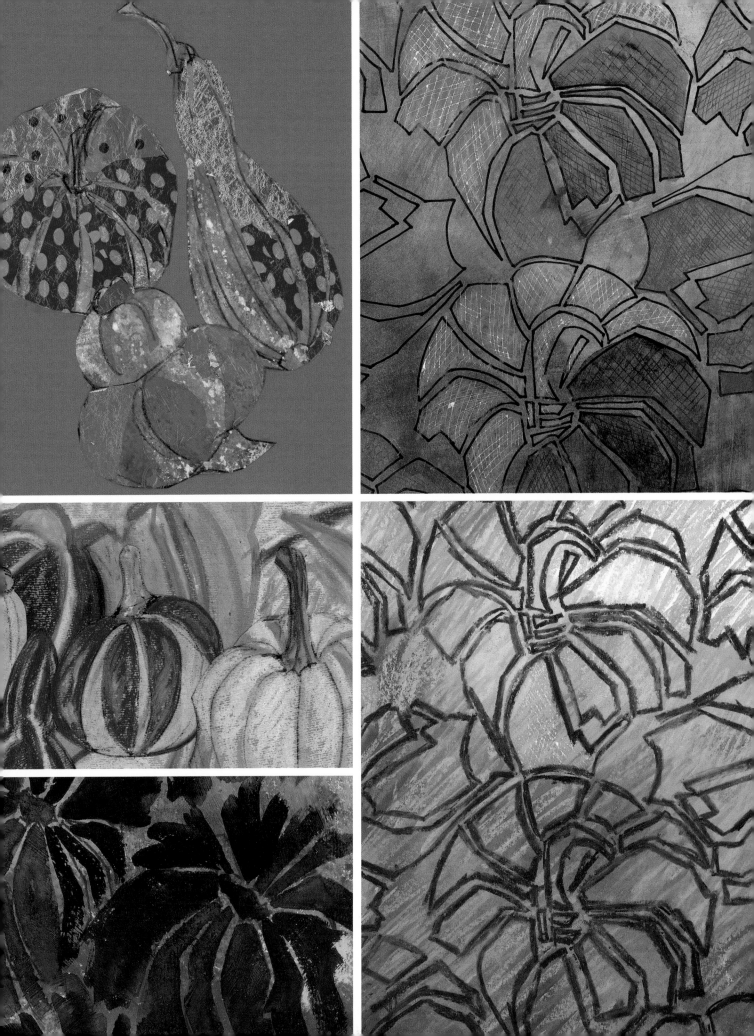

I have decided not to demonstrate ideas and designs for sculptural and vessel forms here because there are a myriad of ideas possible for the development of two- and three-dimensional work and no finite end to investigations such as these. I hope only to encourage the reader and to show that this is a subject that is a rich source from which to develop personal and individual ceramics.

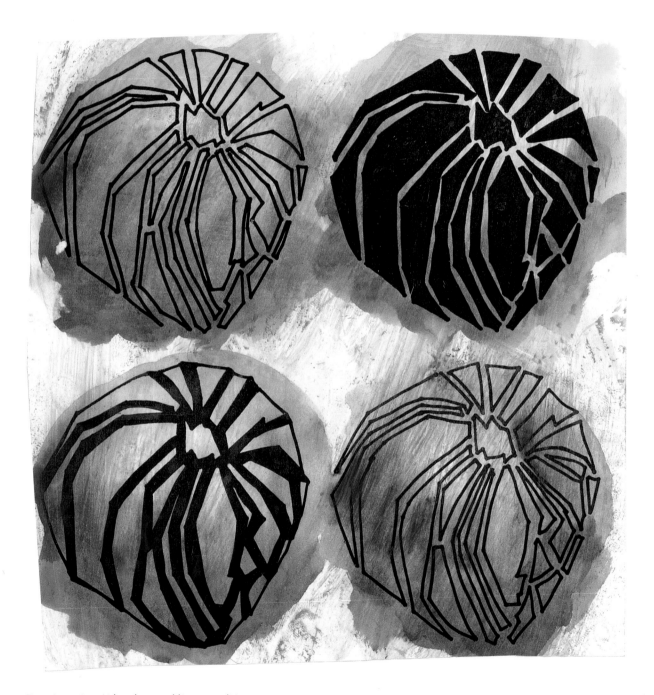

Experimenting with colour and linear qualities.

Laurence McGowan

Laurence McGowan is well known for the distinctive decoration and brushwork of his pots. Unlike many ceramists, although his work is always functional, form does not necessarily follow function. Sometimes Laurence develops the form to accommodate a particular design and he regards his pots as three-dimensional patterns on which he puts two-dimensional patterns. Laurence is aware the design

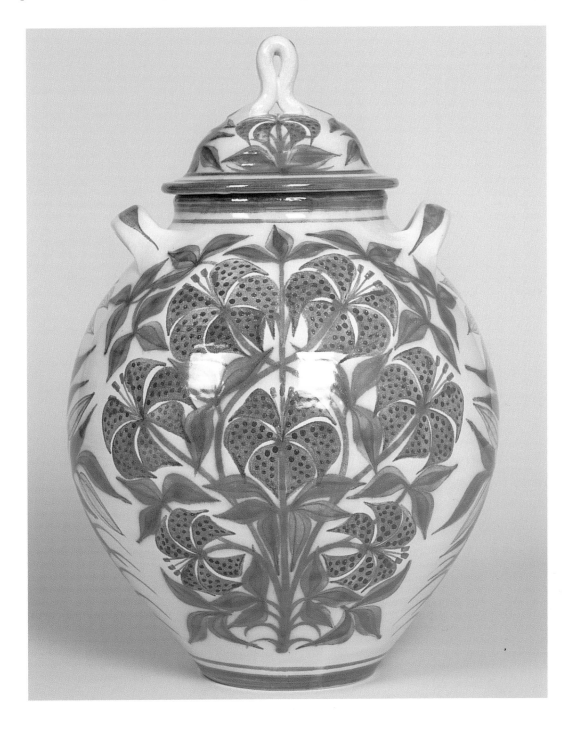

Lidded jar, purple flowers, 14in. high, by Laurence McGowan.
Photograph by Magnus Dennis.

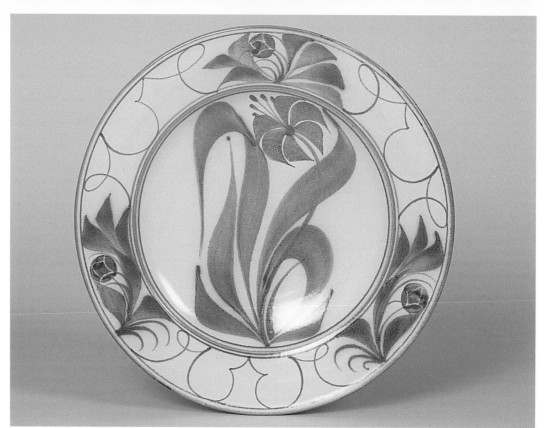

RIGHT Rimmed dish,
 red flower motif,
 29cm diameter, by
 Laurence
 McGowan.
 Photograph, Magnus
 Dennis.
BELOW Indian ink
 drawings by
 Laurence
 McGowan.

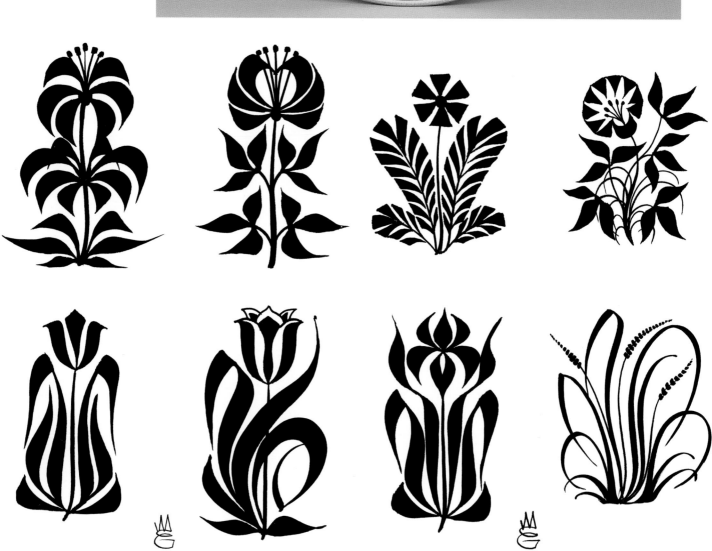

constraints of his chosen technique of decoration and says that certain forms just do not work technically.

Most of his decorative motifs are reflective of natural forms and Laurence says that summer tea breaks find him prowling the garden, looking at plants, trying to grasp their essentials and then attempting to stylise them into two-dimensional patterns which he can render in simple brushstrokes. These motifs are not a copy of what Laurence has seen, more a 'remembrance'. Sometimes recognisable but more often a symbol of the flower – familiar but infinitely more personal.

Laurence feels it is most important to cultivate a decorator's mind; to remain open to ideas, keeping alert for design possibilities and to regard everything as potentially useful. Decorated pots have arisen from birds in the garden, radio programmes, Turkish carpets, even cereal boxes. Often, working to a specific commission sparks off ideas for subsequent pots.

If ideas are slow in coming, Laurence haunts old bookstalls looking for books of quotations or poetry. Enjoying the added dimension that inscriptions can give to pottery, he is pleased when he comes across an appropriate couplet to letter or illustrate.

Certain themes recur, gradually growing and varying as new aspects occur to him. Working spontaneously Laurence doodles on paper to clarify ideas that he has seen or that lurk in the back of his mind. If a design is too thoroughly developed on paper he finds that when it comes to decorating the pot, the interest is no longer there. For Laurence decoration should be both exploration and adventure.

Aware that his chosen technique of decoration is an Arabian one, Laurence readily admits he is also interested in history, particularly Islamic patterns and pattern making and the philosophies of William Morris and Pugin. Through this interest he has become conscious that, throughout history, artists come to many of the same conclusions. For instance, for over 2000 years, artists have been stylising the flowers that grow around them, using them as designs for pottery, amongst other things.

Laurence is part of this tradition but far from being a copy, his work is a modern and personal interpretation in design of his daily environment and observations of the world in general.

Dish, blackberries, 13in. diameter by Laurence McGowan.
Photograph by Magnus Dennis.

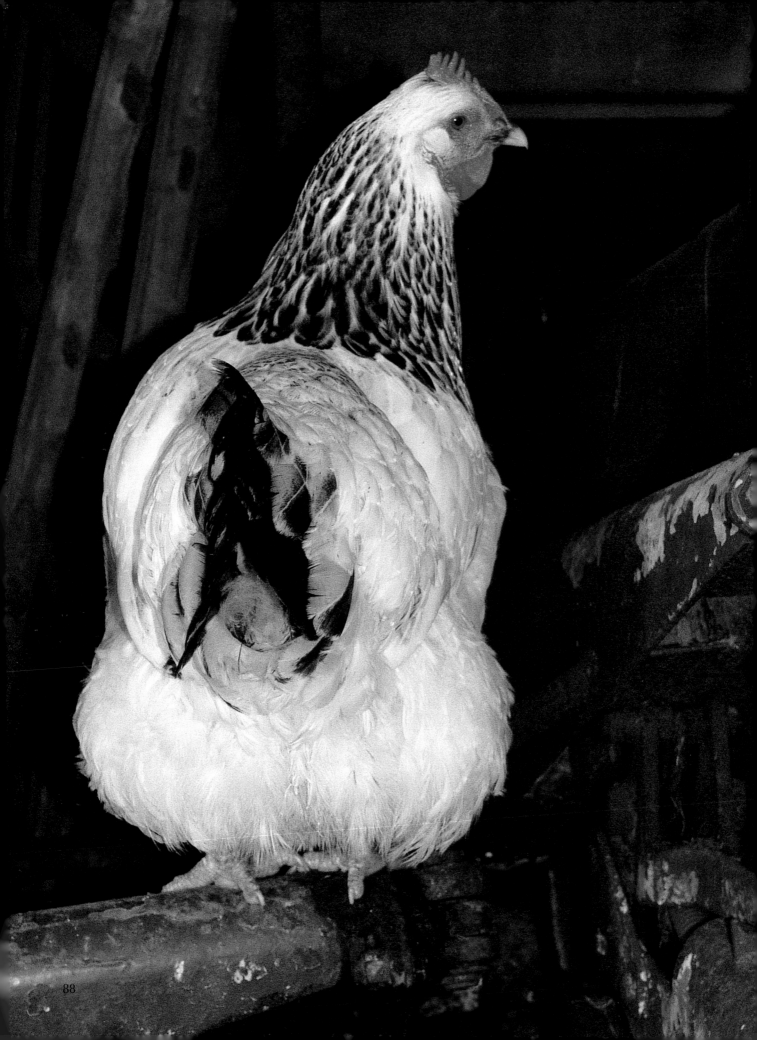

CHAPTER 5

Living beings

ANIMALS have always played a part in the life of humans – as a source of food, to help man work the land and as a companion and friend, so it is not surprising that they crop up time and again in art. Many contemporary artists continue to use the theme of animal life in their work, sometimes representationally, sometimes symbolically.

The human figure also appears in art to illustrate and record historical events or allegorically to inform and teach society, or sometimes just to celebrate the human form, the rhythmic and expressive movements that reveal all man's emotions.

Artists who work figuratively or choose an animal theme know the importance of understanding the form and structure of their subject. Without this knowledge it is impossible to capture the true spirit of the bird or animal.

For the contemporary artist, photography is a useful tool for recording the subject, the photographs can be used to jog the artist's memory when in the studio, but without the

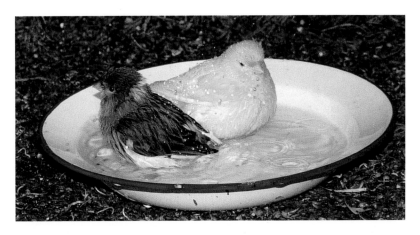

LEFT Bathing canaries.
OPPOSITE PAGE Chicken.

ABOVE Detail sketch of butterfly wing.
RIGHT Observational studies of butterflies.
OPPOSITE PAGE Developing ideas for surface pattern.

experience of drawing from life, it is impossible to really appreciate and understand the rhythm and movements of the different animals. The sway of an elephant's walk comes from the delicate balance between the enormous body and the trunk, whilst the ungainly crawl of the caterpillar ensures that it can balance securely on a leaf. Through drawing and painting from life the artist learns to understand what lies beneath the skin, how the muscles work and the skeletal structure – this knowledge leads to work that has power and integrity. Picasso understood this perfectly and his sculpture of a goat is a good example, although made from scrap metal it is characteristically a goat.

As a source of inspiration for colour and pattern, the butterfly is hard to beat. Butterflies used to be common in town gardens and in the countryside.

Every summer the buddleia bushes were alive with Peacocks, Red Admirals and Tortoiseshells. Nowadays they are much rarer and when I see one I always marvel at their delicately patterned and vibrantly coloured wings.

Having taken the time to make pencil studies to observe the intricate detail of the patterning on the wings and made colour wash studies to record the often surprisingly complementary and contrasting colour combinations, I was inspired to develop some of these sketches into a surface pattern for bowls and plates.

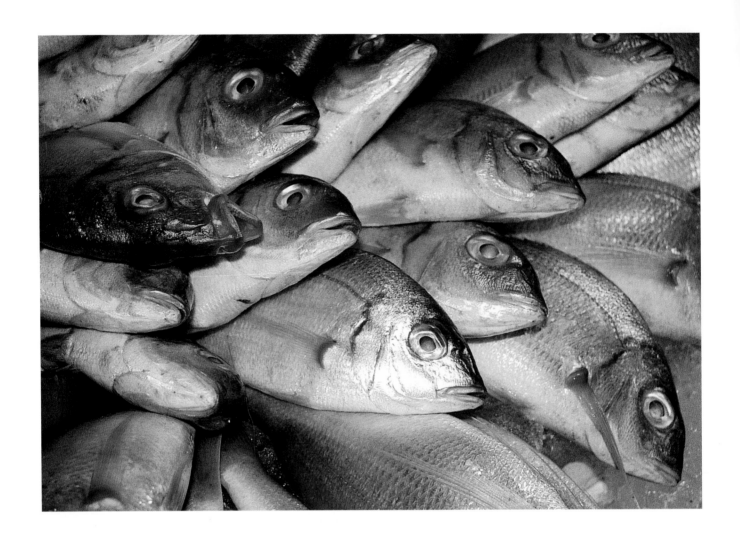

We have a fish tank in our kitchen and I love to watch the fish swim. Greedy for food they cluster by the glass, the scales glinting in the light, the fins and tails curving lightly around them. To capture their graceful movements in paint I use a flowing arm movement that reflects their motion. Looking at the pattern of tropical fish reminds me that nature has evolved for the protection of the species and that, whilst the scales suggest ornate designs that I might want to use in future work, ornamentation in nature is born of necessity. Inspired by my watercolour sketches I play with pattern and colour. Some of the markings would make interesting ceramic shapes and the combinations of colour may be useful in the future. Painting on textured paper is similar to working on a clay surface.

Fish images are a popular motif, often used in painting or carved on furniture or woven into textiles and it is easy to become used to the stylised 'fish' and to slip into the habit of using it rather than returning to the source and reacquainting the eye. Drawing or painting directly from the source material ensures that work does not become hackneyed or derivative and maintains a spontaneous quality.

TOP Fish at the market.
ABOVE Fish collage from sweet wrappers.
OPPOSITE PAGE Watercolour studies of
 tropical fish markings and designs
 developed from them.

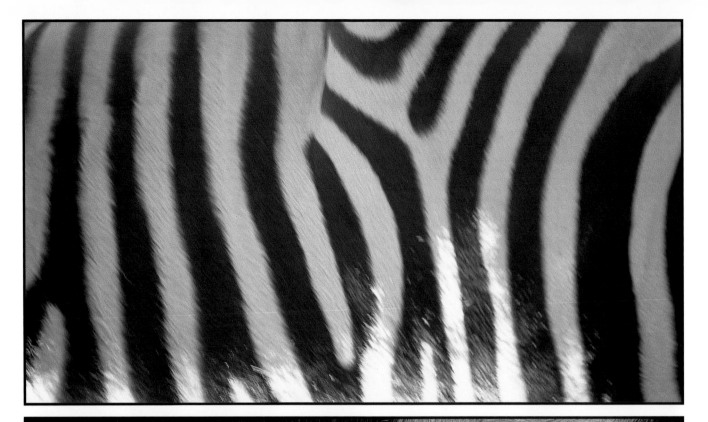

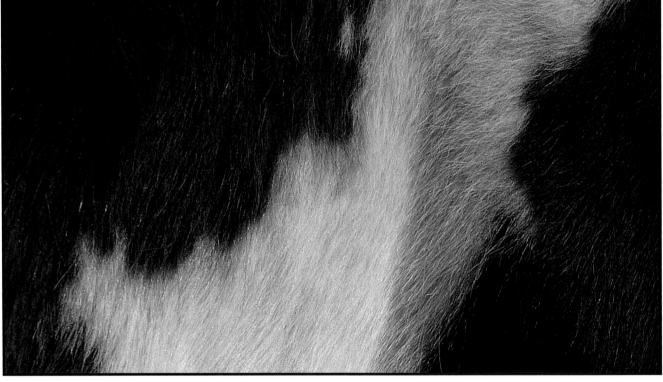

TOP Zebra.
 Photograph by Ann Frith.
ABOVE Cow.
 Photograph by Steve
 Hawksley.
RIGHT Cocker spaniel.
 Photograph by Steve
 Hawksley.

Ceramists for whom the principal source of inspiration is animal life, use it in a variety of ways; some make the animal in clay or use the markings as a starting point for design. The ceramic form lends itself well to animal life decoration; a fish can swim around a bowl, or crabs can crawl across the concave surface of a platter. The ceramist may use the rhythm of the form to echo the vitality of the animal.

Animal markings, for instance the camouflage marks of the zebra, designed for the African bush, or the feathered markings of a duck, are a good source for design

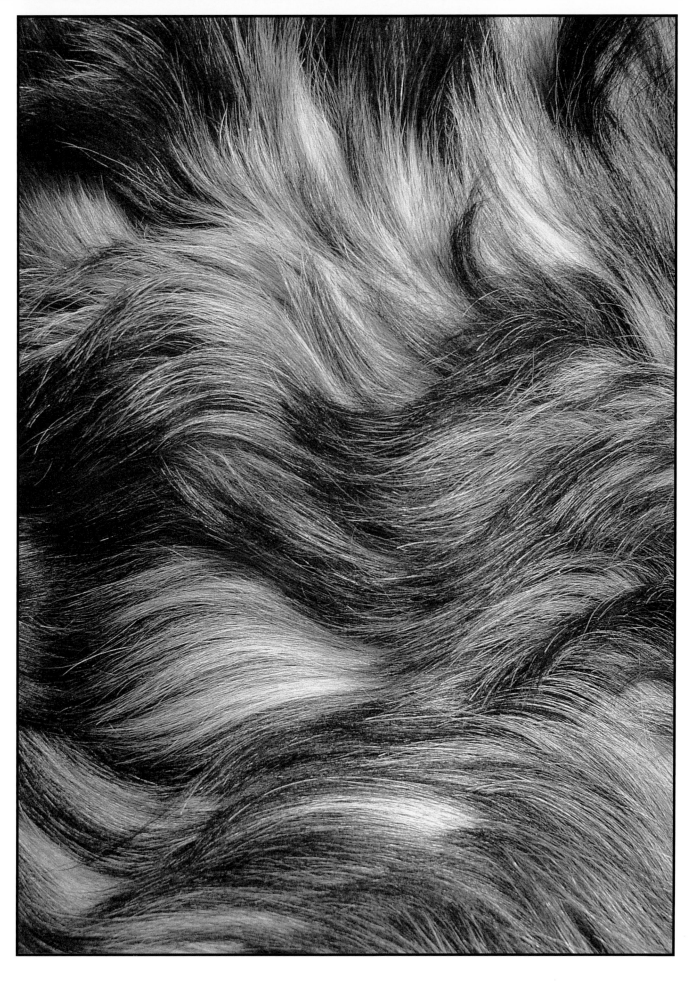

95

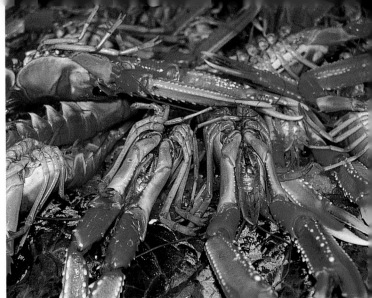

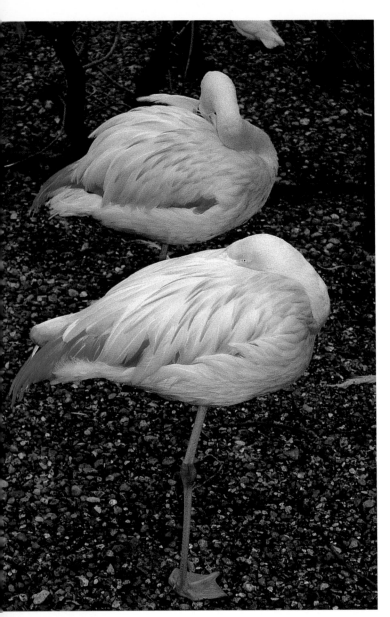

and colour. Looking at a group of animals further extends the design choice, the group becoming pattern and abstract form when viewed through half-closed eyes. Looking closely at a shell reveals intricate patterns that may work well as a border for the rim of bowls and mugs or equally suggest forms for monumental coil pots. Piles of shellfish in the market, make an exuberant pattern – the curves of individual prawns indistinguishable from each other suggesting a surface texture and inviting colours.

There is so much colour and pattern in the animal world that could be a source of inspiration and a starting point for rich themes of work, we just have to take the time to see it.

TOP LEFT Guinea Fowl.
TOP RIGHT Langostines in the market.
LEFT Flamingoes.

Eric Mellon

Eric Mellon has been making pots for over fifty years as part of an artistic life that includes drawing, painting and etching. Trained from 1939–1950 he was educated in a tradition of European culture. The history of architecture, anatomy, life drawing, drawing from the antique, study of composition and perspective were the components of his classical education, with drawing as the central demand.

After 1948 changes were made in education and instead of concentrating on traditional skills, innovative work that disregarded the old values was encouraged and conceptual ideas were emphasised. Eric did not feel happy as part of the modern movement, and, believing absolutely in classical education, he continued to immerse himself in the study of composition and the other principles until he used them instinctively. This knowledge and understanding underlies all Eric's work.

Once introduced to ceramics the new challenge for Eric was to understand the methods and materials and to learn to control them sufficiently to enable him to communicate his ideas and observations of the human condition.

Although interested in the technical side of ceramics, and having devoted much time to researching and developing ash glazes, Eric has concentrated on making ceramics that accommodate his figurative, narrative decoration. In his book *The Ceramist as Artist* he says that 'it is essential to make drawings on ceramics and not to make merely a useful artefact'.

Cherry Ash Felines, tile, 8 x 4in. 1997, (note use of golden section adding impact), by Eric Mellon.

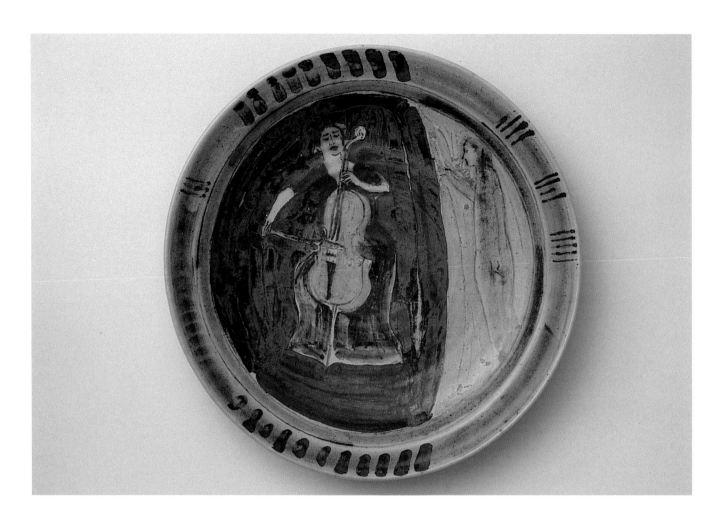

Natalie Clein bowl,
1975, by Eric
Mellon. Mellon
breaks the rules of
classical composition
by creating an
intentional division.

One sees that the subtle curves of his bowls and the generous bellies of his vase shapes are forms on which he explores particular themes. These themes for decoration come from his awareness of the world in which he lives. Early works touched on the natural world, the flowers, animals and landscape surrounding him. Moulded dishes were decorated with a slip-trailed bird or a brush drawn head or owl.

Commissions he received and meetings with other potters prompted new themes and series of work. Sometimes he collaborated with other potters, such as Rosemary Wren, who introduced Eric to stoneware and coiling.

Teaching life drawing, Eric began to use the nude as ceramic decoration and it is primarily for his depiction of the human figure that he is known. Initially he would work from his studies of the nude transferring them onto the clay but nowadays he has the confidence to draw directly from life onto tiles and bowls.

In the1970s Eric began making a series of pots on the theme of Greek mythology. This theme is continued in his current work and it seems to me that Eric often uses the tales of Greek mythology to express events from his own life in ceramics.

Eric sees the role of the artist as one of social comment and pots are made on subjects as diverse as the atomic bomb and caged animals. In 1994 he

saw Young Musician of the Year and was so impressed by the winner, Natalie Clein, that he made work on her in both ceramic and aquatint.

In 1968 the theme of the 'Circus' was started. This explored the idea that modern man has faith in himself whereas medieval man had faith in God. The bowl, 'Girl on a Horse', conveys the confidence the girl acrobat has in her ability to balance and the enjoyment and exhilaration that comes with such confidence. Also evident in the composition of the decoration is Eric's classical training. Aware of the Chinese tradition that a bowl has a border and central area for decoration, Eric consciously breaks with tradition by positioning the horse with its legs interrupting the border and running off the edge of the bowl. The girl's body creates a vertical whilst the direction of her head and arm draw the viewer to the usually ignored bottom-left corner. The horse's back and tail create the horizontal. Interest in the top-left corner is provided by the horse's head ornament whilst the bottom-right of the bowl is empty, needing no emphasis, the viewer's eye being naturally drawn there. All this subconsciously challenges the eye by creating interest and clearly demonstrates use of the 'Golden Section', as used by classical artists such as Rembrandt. This is no coincidence as, upon further study of Eric's work, it is evident that these principles are firmly adhered to whether working in two or three dimensions.

The 'Theme of Tenderness', started in 1979 and continuing today, contrasts with thoughts of death by looking at the relationship between man and woman and the birth of children. Once again, the use of classical composition and colour adds emphasis to the subject.

Although figurative decoration has on occasion been out of fashion in this century, the work of Eric Mellon cannot be ignored. He is not bothered by 'fashion'. His use of classical principles and understanding of human form, combined with his awareness of all that is around him, gives his work a depth that draws me back time and again. As Eric says in *The Ceramist as Artist*, 'Ceramic enables us to make a record of our civilisation and our cultural awareness upon which future generations will judge our times'.

I have no doubt that all ceramists and artists can learn much from studying the work of Eric Mellon and that it will be valued long after many others are forgotten.

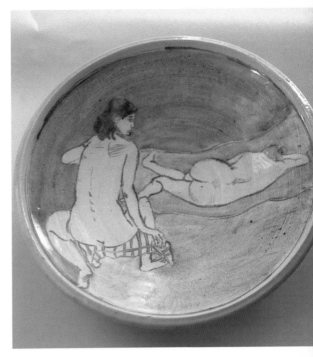

Theme of tenderness bowl by Eric Mellon.

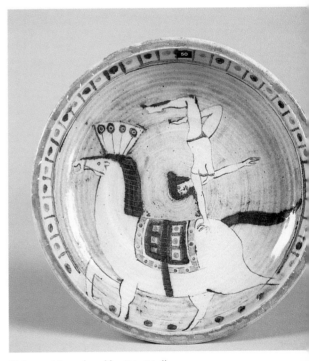

Girl on a Horse bowl by Eric Mellon.

Jill Fanshawe-Kato

Jill Fanshawe-Kato has travelled extensively and it is from her travels that she gains inspiration for her work.

Returning frequently to Japan where she studied ceramics for five years, she stops *en route* to visit the Seychelles, Maldive Islands and other exotic places. Snorkelling on the coral reefs and seeing the amazing, brilliantly coloured fishes and extraordinary coral formations have all led to work that reflects the colours and forms she saw there. A visit to Brazil had a similar effect. For a period of time, she worked with a palette of colours that evoked the rainforest; green, Indian red, ochre and black and white. The shapes of the exotic fruits and gourds and the Indian baskets all inspired forms for a series of work.

Equally, when she is at home in London, she spends much of her free time on the allotment and whilst growing vegetables and flowers, she has the time to watch the birds and observe nature. She is a passionate supporter of nature conservation and as a result creatures appear in both the abstract and the figurative on many of her bowls and dishes.

Wherever she goes, Jill draws, finding this keeps her ideas fresh. Her sketchbooks are full of birds, plants and animals that are the starting point of her work in clay. If she has room, she prefers to travel with large and medium sized sketchbooks and a large box of oil pastels. Colour is vitally important and her drawings are always in colour. At home she has dozens of small sketchbooks related directly to clay, full of ideas that she can refer to in a 'blank spell'. For Jill, drawing has many functions. She

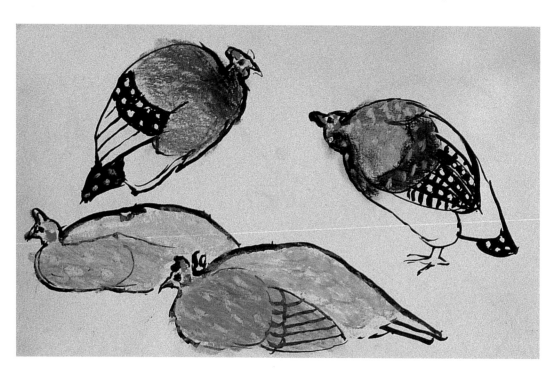

Sketch book of
Jill Fanshawe-Kato.

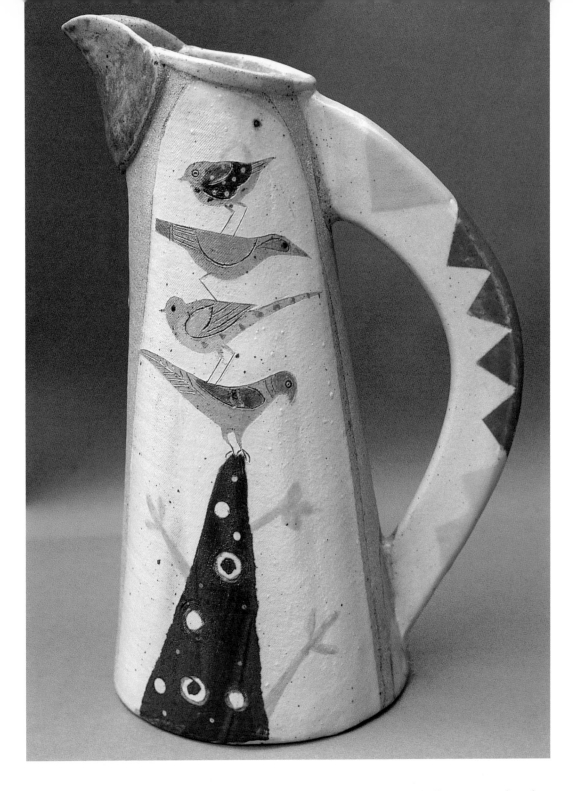

Jug: piles of birds developed to decorate tall, thin forms; influence: Indian wall hangings and embroideries, by Jill Fanshawe-Kato.

believes that it boosts confidence and gives her a much needed distance to the clay. The drawings need not relate to her clay work, it is the 'doing' that is important and from travelling and experiencing a new environment totally new ideas appear often seeming irrelevant at the time. Released from clay drudgery, a period away from the studio, swimming, walking etc., can unlock creative doors. For Jill, drawing is about enjoyment, sometimes leading to clay, sometimes not.

After a recent visit to Kew Gardens, where Jill made several sketches of guinea fowl, she returned to her studio and spontaneously made a guinea fowl.

RIGHT Guinea fowl, raku, by Jill
 Fanshawe-Kato.
BELOW Guinea fowl inspired pot, by Jill
 Fanshawe-Kato.

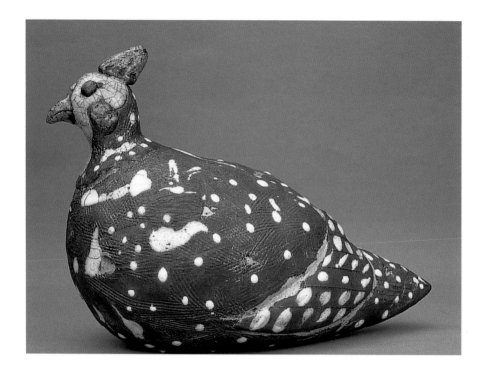

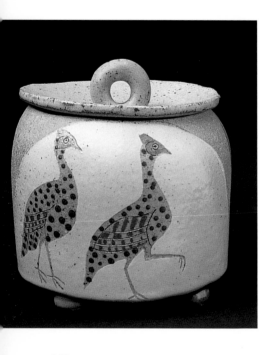

Jill thinks that this was a freeing experience and allowed her to enjoy not only the form and markings but also the humourous characteristics of the bird further. From this piece and her sketches she has developed her ideas and guinea fowl appear on many recent pieces. That is not to say that she has just copied the image onto the form randomly – form and image relate. Some pieces are abstract, for instance, simply echoing the black and white dots of the Guinea fowls markings.

Jill thinks about form a great deal and although her early work was dictated by form (colour and decoration following) recently the three have become interrelated. For instance, the coconuts and seeds she collects from beach-combing are sometimes turned into pots, the interior colour echoing the blue sea whilst fishes swim on the outside. She says that these pots are 'an experience converted into clay' and stresses that it is from her own experience that she draws inspiration.

Because she was figuratively trained (she studied painting at Chelsea) her work used to be predominantly figurative but recent work is markedly more abstract, both in form and use of motif. Abstraction is a new challenge, offering tantalising opportunities and exciting developments for both form and mark making. Trailing brushstrokes echo the form of a handle but not in an obvious way.

Jill tells me that challenges are important as she wishes her pottery to keep developing. She has loosened up and now has a sense of freedom, she did not experience in her earlier work. She finds large sculptural pieces stretching but she also creates her own challenges by constantly rethinking the forms and imagery she uses.

John Mullin

John Mullin says that he has always been excited by the world around him and as a child expressed this excitement by drawing. He has continued to draw, finding analytical drawing a particularly rewarding activity.

When he began to make pots his intention was to marry his love of painting and drawing with his love of ceramics and his work clearly combines his skills as a draughtsman and a potter.

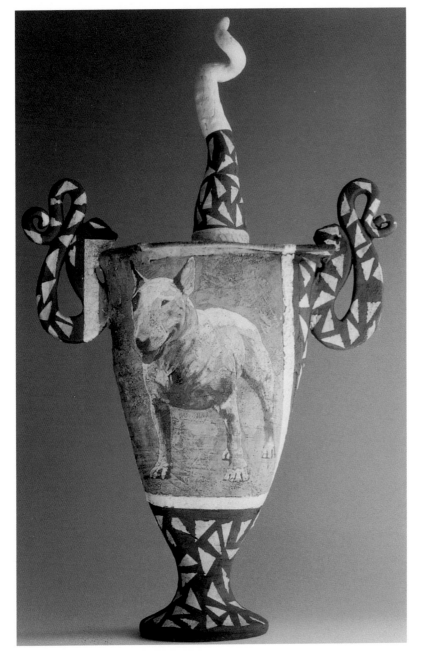

LEFT Vessel by John Mullin.
ABOVE Rough sketch – ideas by John Mullin.

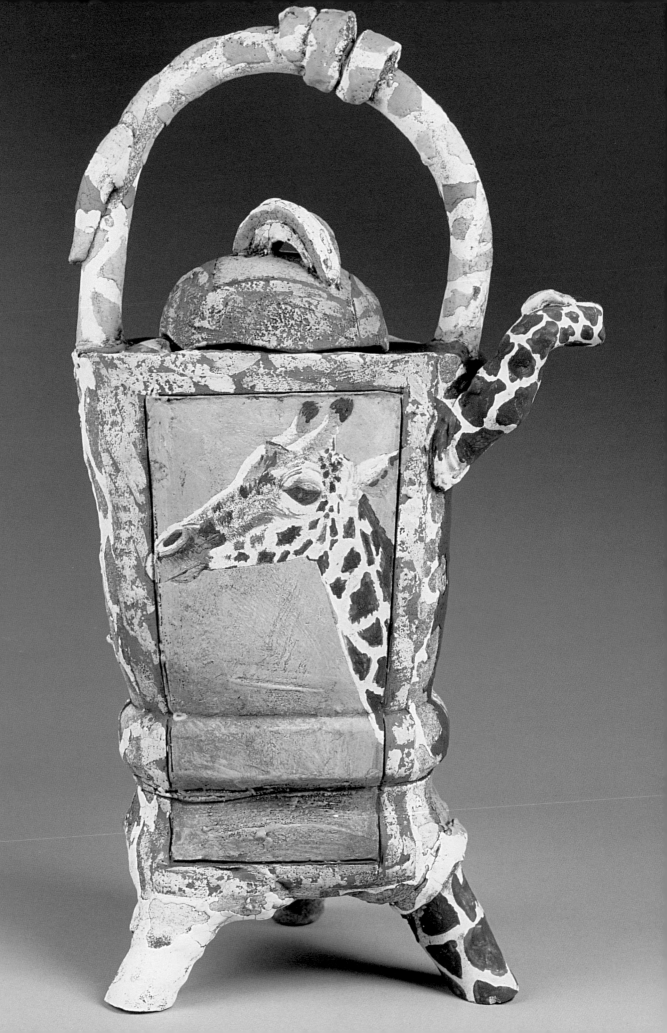

Animals are the visual inspiration for all of John's work and whilst admiring their dignity, he also delights in their beauty and the infinite variety of form, colour and pattern. Animals may be the central theme – the surfaces of his pots are decorated with carefully observed drawings of an animal or a bird – but for John this is not where it ends. He wants to embellish his vessels further with patterns and colours, exploring the relationship of form and surface.

Marks derived from animal camouflage and objects such as weathered paint on an old door inspire surfaces. John collects photographs and paintings of images he finds interesting and will look through them when seeking new inspiration. His admiration for the painters of the early Italian Renaissance, especially the work of Piero Della Francesca and the fresco painters of this time led to his decision to use coloured slips. Seeking to create a similar surface on clay, coloured slips provide a surface not unlike gesso and give John the freedom to work much as a painter uses paint.

Traditionally trained, John's ceramic knowledge and skill allows him to break rules and work spontaneously. Forms are made intuitively, starting, for instance, with a classically inspired thrown base, and then combining coiling and slabbing as is most appropriate.

Ideas for form are loosely sketched but the pots are sketches in themselves, leading from one to another. Two-dimensional sketches are of limited use and there comes a point when it is necessary for John to work in three dimensions in order to realise his ideas fully.

On a less practical but equally relevant note, when considering 'inspiration' John suggests that when artists consider their influences they often overlook the spiritual dimension to their creativity. For him it comes from practising the Buddhism of Nichiren Daishonin. He writes, 'Whilst I gain no visual stimulus from this daily practise, I do believe that I have come to understand how inspiration comes from within my own life. I believe that I have something positive to say as an artist for the betterment of society. On a practical level I have found the strength and unflagging determination to continue to survive simply as an artist for many years and that is an inspiration in itself!'.

OPPOSITE PAGE Giraffe teapot by John Mullin.

Josse Davis

Josse Davis' ceramics reflect his life in Arundel, West Sussex. Arundel is a small town built into the side of a hill, surrounded by rolling countryside within a few miles of the sea. Josse has lived there all his life and it is from these environs and nature that he finds all the inspiration for his work.

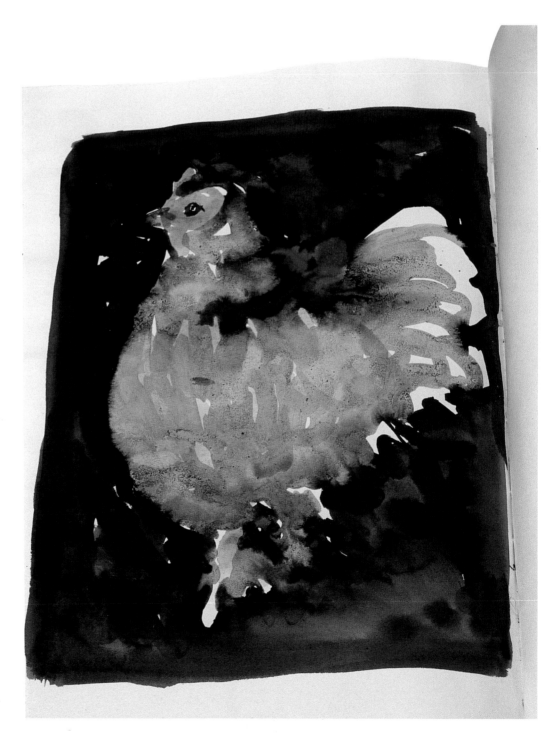

RIGHT Watercolour sketchbook, by Josse Davis. OPPOSITE PAGE Raku pot, by Josse Davis.

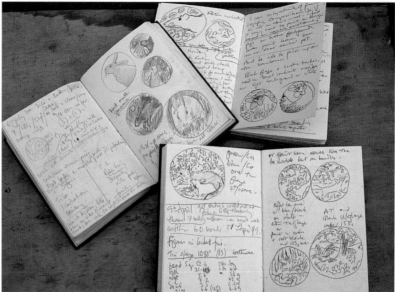

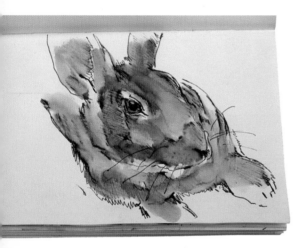

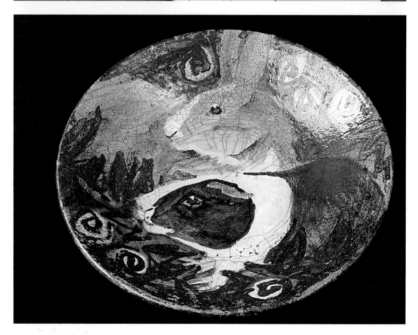

TOP Sketchbook, life studies, by Josse Davis.
TOP RIGHT Notebooks, by Josse Davis.
ABOVE Watercolour sketch, by Josse Davis.
ABOVE RIGHT Rabbit & guinea pig bowl, raku, by
 Josse Davis.
OPPOSITE PAGE Multi-animal pig, stoneware bowl,
 by Josse Davis.

He walks the dog in the countryside or on the beach, carrying his sketchbook everywhere. From his studio in the garden he sketches the chickens, the dog or even the odd rat. Walks are particularly inspiring to him. Bird watching, chasing butterflies, picking snowdrops, all are potential subjects. As Josse says, 'The only limitations are the powers of my imagination'. He is also influenced by the seasons. In the winter he paints in oils but as spring arrives he starts to make ceramics, each summer working on a 'multi-animal' design. In autumn he turns to Raku, feeling the need to work with bright colours and lustres.

His simple bowl and vase forms are the blank canvases on which he expresses his delight in the world. Josse rarely uses

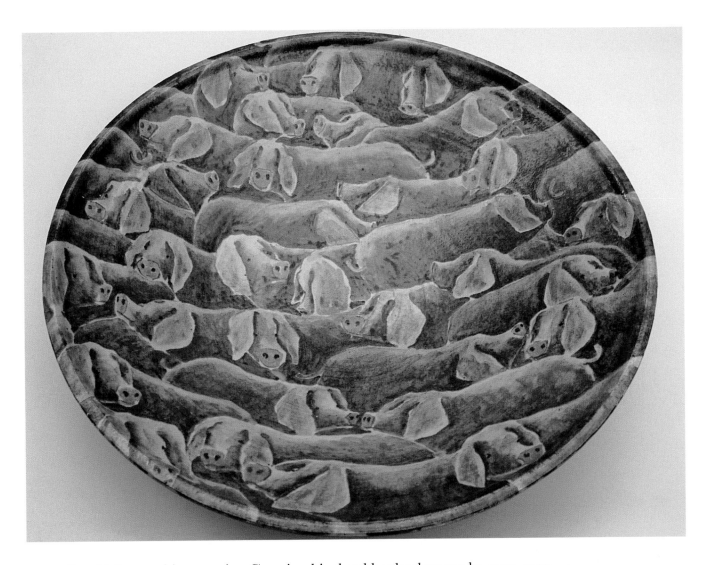

a pencil guideline on his ceramics. Carrying his sketchbook wherever he goes, even to the pub where he often works out designs, Josse studies his subject until he can see it with his eyes shut. He then feels ready to approach the pot.

He has developed two distinct styles of decoration – the more spontaneous Raku and the thoughtful and considered linear stoneware pieces. Inspiration for the looser Raku comes from chickens, butterflies and flowers – all things lively and colourful, whilst animals with linear potential or definite pattern, such as zebras or rats, form the basis for his multi-animal stoneware bowls.

Josse's work is filled with humour and a real knowledge and love of his subject. He readily admits, that, although serious about his work, wit is important to him. His blue and white decoration allows him freedom to 'doodle' but looking at a jug in this style one is constantly delighted and surprised to discover a bird here or a butterfly there, hidden amongst the pattern.

Paul Klee wrote, 'Art does not reproduce the visible; it renders visible' (from *The Life and Works of Klee* by Linda Doeser.) This is true of Josse's work. Using subjects familiar to us all, Josse captures the essential character and reveals the subject in a fresh way.

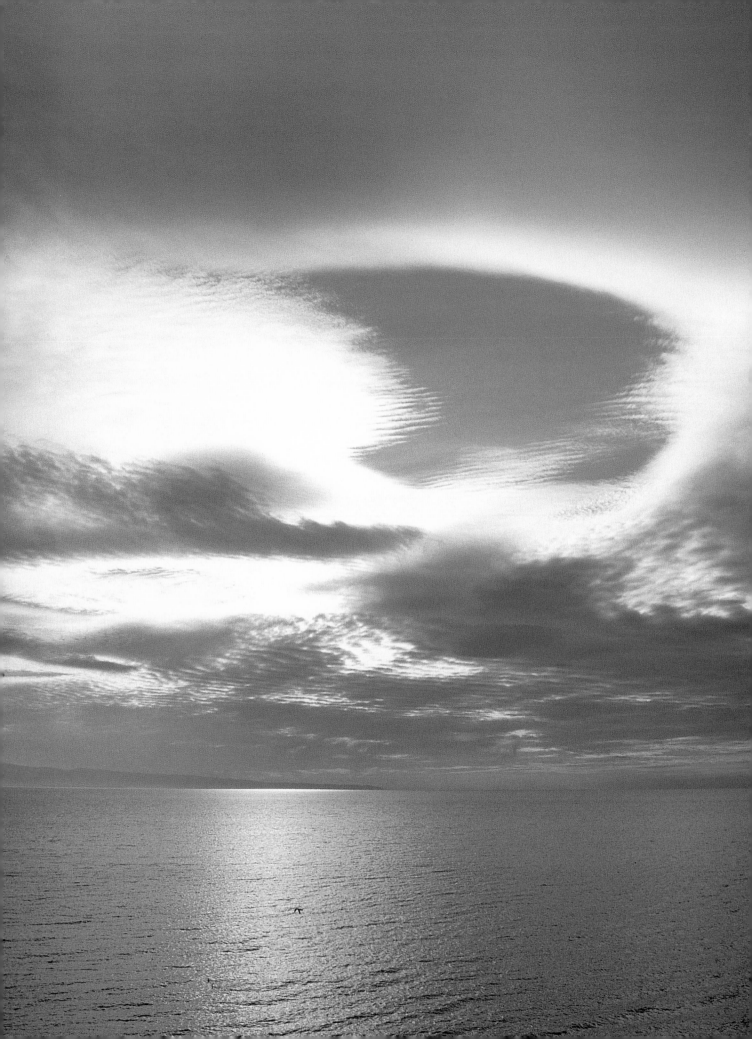

Landscape

Artists sometimes say that their work is affected by their environment and since living in the country I begin to fully understand what this means. For the first time in my life I am 'living' with a view. Looking out over the forest and beyond to The Downs I have watched the view for a year. Each season brings a new landscape, spring is leafy greens, summer a haze of soft yellows, autumn brings a riot of warm oranges and browns as the leaves turn, and with winter so much is revealed that has been hidden for the rest of the year. Unseen fields appear and I notice the tracts of conifers that in summer and autumn are overshadowed by the deciduous trees.

Then there are the sunrises. The house faces directly east and I wake to skies of vivid pinks and reds, or cool icy blues. I did not imagine the huge variety of sunrises, each foretelling the day ahead.

Occasionally I have seen a landscape that lingers in my memory. When I think about it I remember not only the colours and structure of the scene but the more intangible mood that I felt when I looked at it. Years later I notice that, unconsciously, it has influenced certain pieces or themes of work. I think that this is so for many ceramists whose work refers to landscape.

More aware of my own environment, I now realise how much landscape defines a country and its people. Historically, people developed agricultural practices that were compatible with the land. Whether looking at rice terraces in Bali or a harvested field in Sussex, I am aware that these agricultural practices reinforce that character of the land creating the patterns and rhythms that attract the artist.

OPPOSITE PAGE Sunset.
Photograph by Howard Cole.

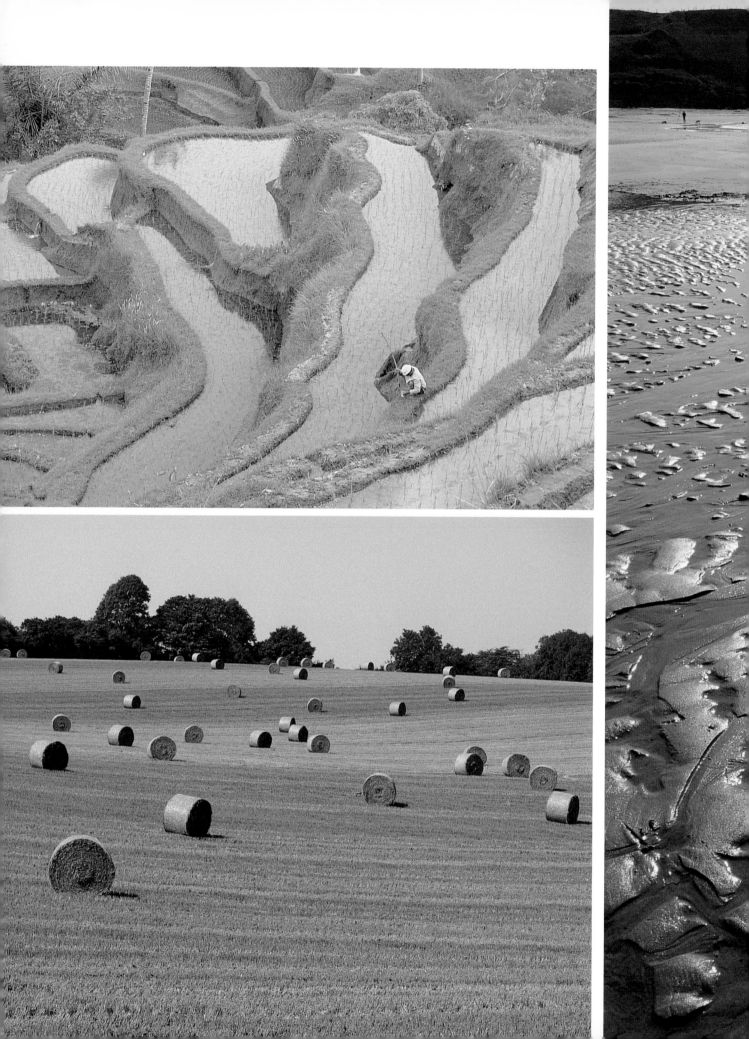

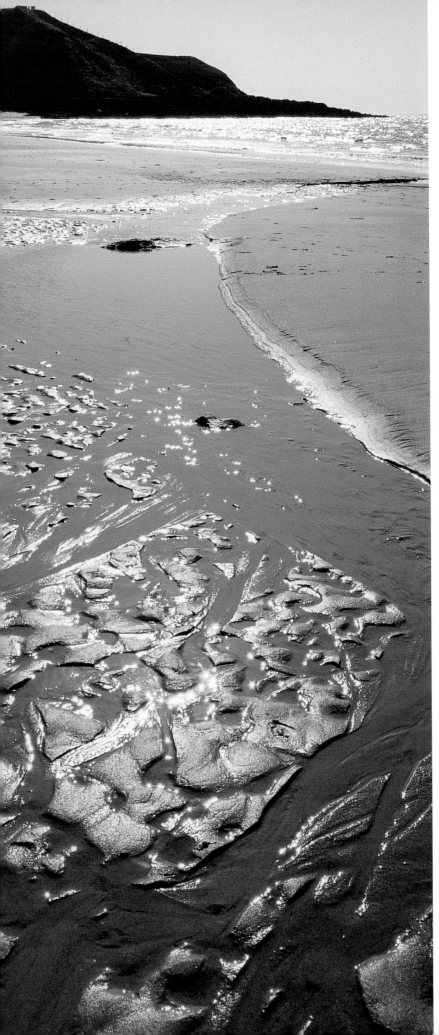

The photographer Howard Cole lives and works in Wales. He needs look no further than his surroundings for inspiration and his beautiful and evocative photographs show a complete understanding of this landscape. For this, they are richer and convey a strong sense of place. I can easily imagine myself part of the landscape. Landscape, for me, evokes atmosphere and mood more than inspiring concrete ideas for form or decoration.

LEFT Sand. Photograph by Howard Cole.
OPPOSITE PAGE, TOP Rice terraces, Bali, Indonesia. Photograph by Simon Arnold.
OPPOSITE PAGE, LEFT Harvest, Sussex, UK.

113

Making small atmospheric sketches in oil, pastel or watercolour creates a visual diary that captures the essence of the landscape and records unusual colour combinations that may be useful for later work. I feel a sense of wonder when I see a spectacular sunset.

The more I look, the more I see subtle variations of tone and hue – the merging of one colour into another, and yet each colour has an individual intensity and depth.

I am awed by the amazing combinations of colour all created by the light of the sun. Sometimes I play a game with myself trying to work out how I would mix an individual colour in oil paints, but I use a Alizarin red crimson and a touch of burnt sienna.

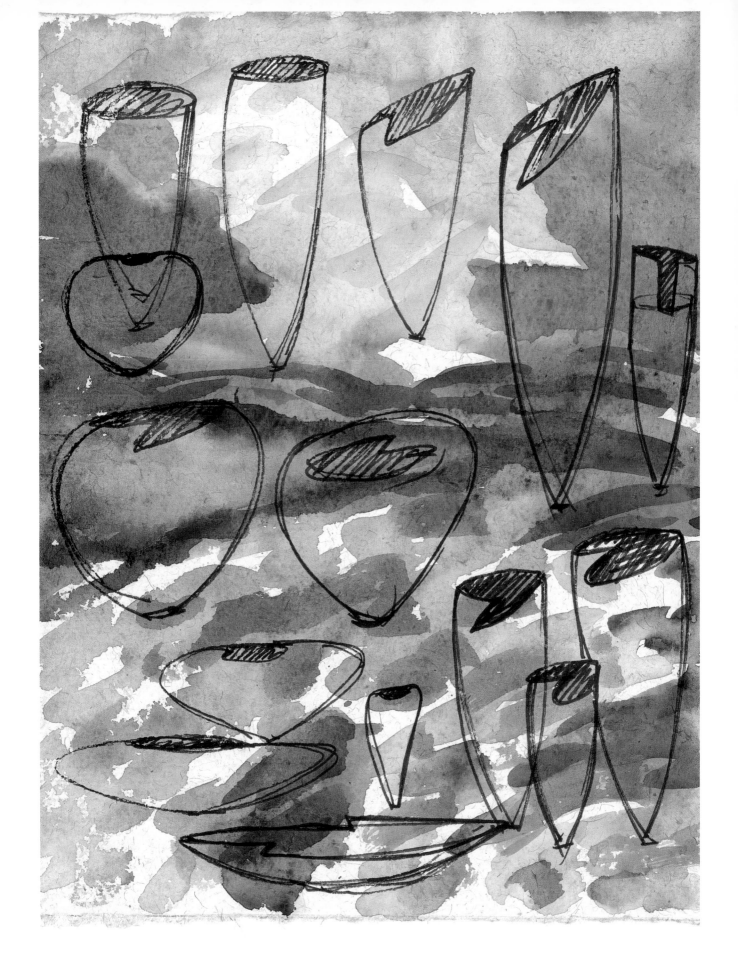

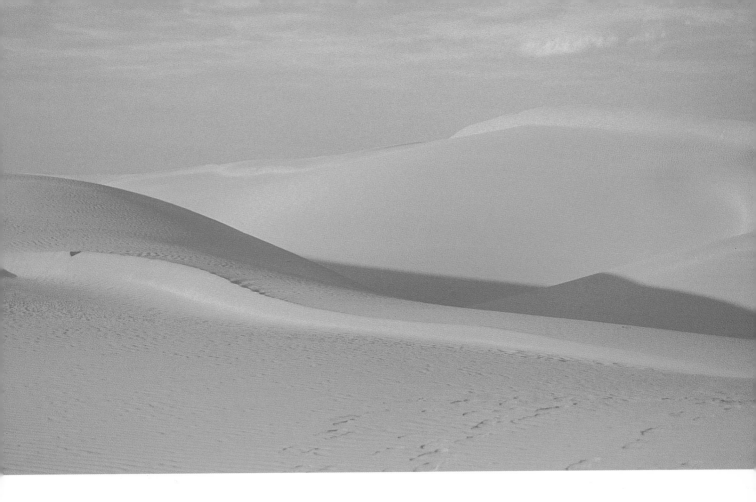

Creating colour-wash pages inspired by land or sky, for use as a sketchbook page on which to draw rough ideas for vessel forms, adds a new dimension. Immediately the forms have life. Three-dimensional ideas spring to mind and new approaches to the application of colour.

Using a pencil or soft crayon, simply to explore the rhythm of the landscape such as the undulating sand dunes of the desert, or the patterns created by the wind blowing across the sand suggests form and structures that have a flowing quality that would work well in clay.

Three ceramists for whom landscape is a principle source of inspiration are James Tower, Peter Lane and Kyra Cane. James Tower found inspiration for form and decoration in the Kent landscape of his childhood. Peter Lane expresses his emotional response to landscape in his delicate porcelain vessels and Kyra Cane's drawings of landscape inform her making decisions when she is in her studio.

TOP Sand dunes. Photograph by Ann Frith.
ABOVE Pencil sketches exploring tonal and linear values.
OPPOSITE PAGE Sketches of vessels on a colour-washed page prompt ideas for surface.

117

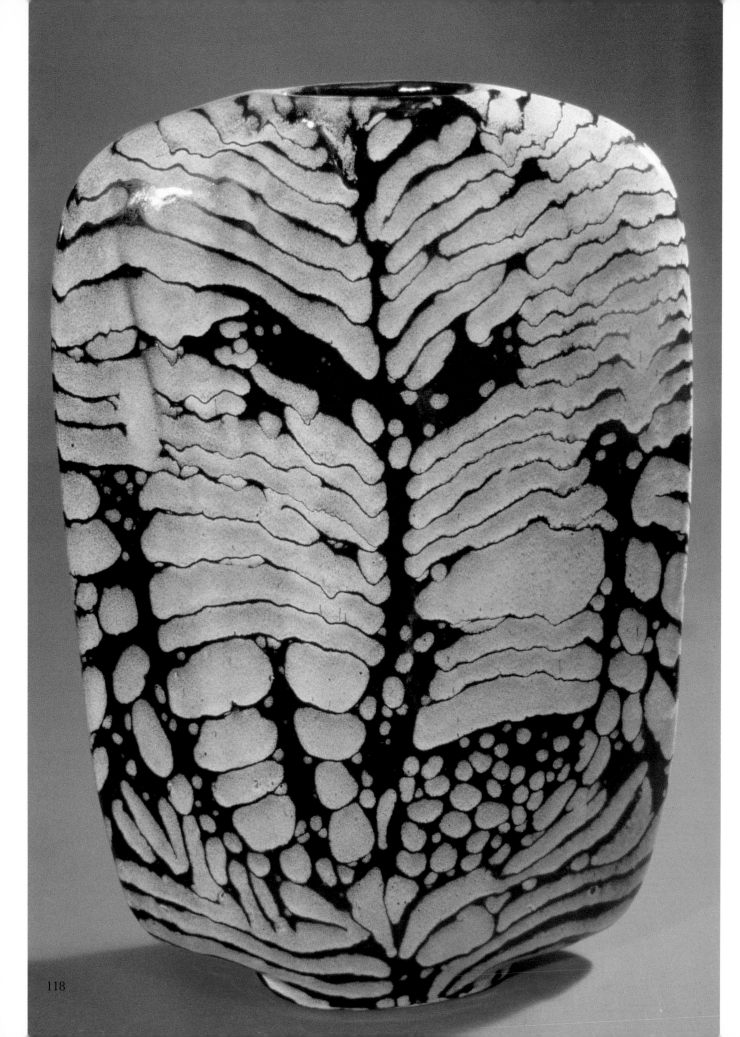

James Tower

James Tower referred to himself as 'an artist who happens to be working in clay'. He first became interested in ceramics whilst studying painting at The Slade in 1949, struggling to assimilate the principles of abstraction. Familiar with the slipware and tin glaze painting of the English pottery he was struck by the freedom and verve of the decoration: 'The wayward, humanist elegance, the marvellous sense of the material, the liquidity of the slip, and the rich transparency of the tin glaze painting. I became aware that we had inherited a splendid tradition in ceramics in this country, characterised by an intuitive elan and spontaneity. A vitality that lifted many of these pieces from mere function to major works of art. Where the tremendous empathy of the artist for his material had fused with instinctive feeling for design within a given shape, and works of great immediacy and lyrical beauty had resulted'.

During this time, James painted large compositions of figures in landscape and worked a great deal from the life model. This figure work, in particular from the torso, was important as it became, both as a source of decoration and of form, a recurring theme in his ceramics.

His early ceramics, which owed a great deal in feeling to the English tradition but also contained strong elements stemming from the Kent coastal landscape of his childhood and his travels before the war to Australia and the South Seas, were mainly dishes and vessels in slipware and tin glaze painting.

In the 1960s and early 1970s James moved away from decorated forms and made large-scale terracotta forms, with plain or ribbed surfaces, but by the end of the 1970s he felt the desire to return to the richness of decorated forms. He made press moulded vessels which allowed him an enormous range of shapes whilst retaining simplicity of form. This simplicity was vital to James as it provided him with a surface to decorate 'so that the surface may be animated, energised and made to work harmoniously with the whole'. Shape and decoration were closely considered, and it is apparent in his work that the source of both can be found in the landscape of his childood: 'The quality of "shape" interests me enormously. This is perhaps due to my childhood on the Isle of Sheppey in Kent. This is a landscape of long, silent marshes where the sky seems to dominate the grey green distance. There are few trees or hills. The forms that engage the eye are the small ones of the beach and the tidal waters. Shells, particularly the bi-valves, oyster, mussel and razor shell. The flattened fish of the estuary, plaice, flounder and ray. The rhythmic gradation of the beach, from sand to gravel, to worn flints, arranged in the carefully sorted bands by the tide. These forms draw me by their shape – distinctive, flattened, rhythmic. On the marsh the reeds and grasses are displayed in exact rhythms, echoing the weather and responsive to the constant wind; endlessly rearranged in organic groupings that are miraculously and infinitely varied in their rhythm. It is this world

OPPOSITE PAGE Chest form, 1970s, by James Tower.

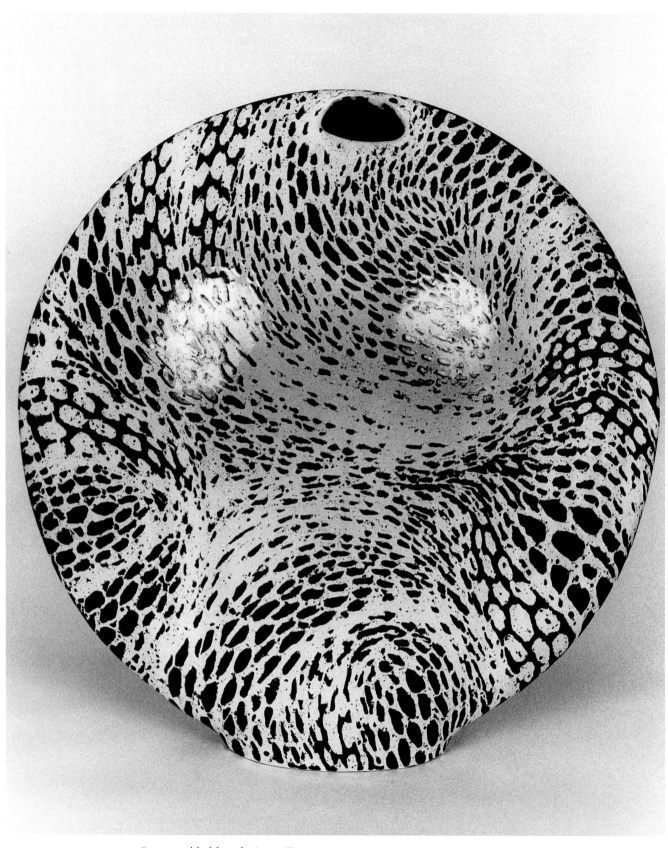

Press moulded form by James Tower.

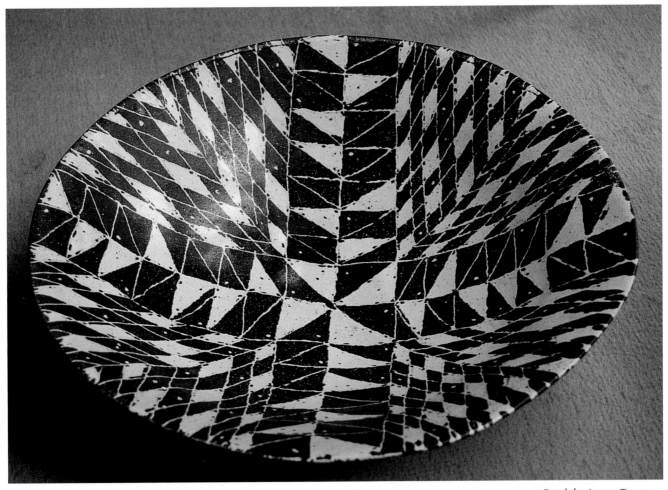

Bowl, by James Tower.

of shapes, rhythm and weather that provides the stimulus for my motifs and method of working'.

Although decoration was an integral part of all his ceramics, James felt that the first consideration for an artist is form: 'If we look at any great period of ceramics history we can see that form, whether fused with painting, or undecorated, is always unique and strong. Ceramic form is the enclosure of space and the enclosure needs to be taut and energetic'.

To achieve this tautness and energy in decoration in his own work he used the sgraffito technique, working directly onto the pot, swiftly and intuitively, 'rather like action painting'.

No one who has seen the work of James Tower could remain unmoved. Its presence draws the viewer back again and again but James Tower himself summed up eloquently, 'In general, the quality which I aim for could be best defined as a sense of completion and serenity. To make forms which convey a sense of wholeness, releasing inner tensions, serene and harmonious, a world where abounding energy is held in calm restraint, the objects which I strive to make are attempts at hymns to the beauty of the world'.

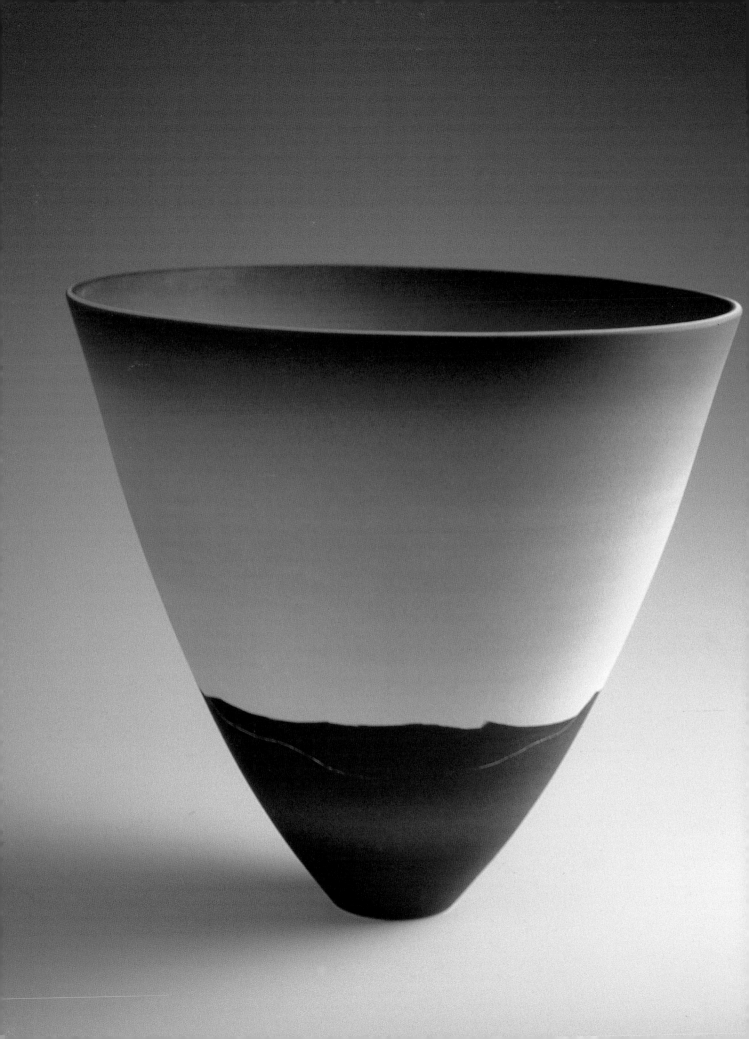

Peter Lane

Well known for his finely proportioned vessels, Peter Lane says his forms evolve, firstly as a direct response to the material, especially porcelain which suits his perfectionist nature and secondly through his preference for simplicity and crisp, clear profiles.

These simply shaped vessel forms provide him with three-dimensional canvases on which to express his emotional responses to the landscape, sea, skies and plant life that continue to be his inspiration.

Peter has lived all his life in the countryside and the patterns and structures of plants and trees and the movement of water are reflected in his carved/pierced vessels, while his airbrushed work captures the atmospheric quality of mountain skies.

First introduced to the landscape of the Lake District by his wife in the mid-1950s when they were students at Bath Academy of Art, they subsequently went to

OPPOSITE PAGE
Mountain sky – winter series, porcelain, 17cm high, by Peter Lane.
BELOW Source photo: Cascade Mountains, Oregon, US.
Photograph by Peter Lane.

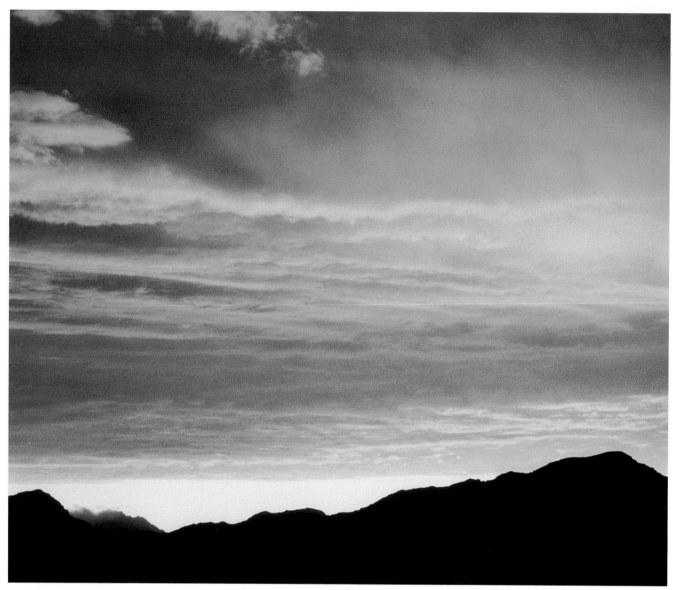

live in Cumbria for four years. Peter says, 'We were able to indulge ourselves fell-walking, drawing, painting, photographing, enjoying the constantly changing effects of colours, light and shade in landscape and skies'.

This love of mountains and landscape has not diminished and Peter continues to photograph the mountain skies above the Rocky Mountains in North America as well as the mountain scenery of Europe and New Zealand.

Unlike many ceramists, Peter does not work directly from his source material. The natural world is a constant source of wonder, inspiration and delight to him and it is these feelings that he tries to convey in his work rather than actually reproducing the plants and scenery he has observed. Enjoying the tactile sensations of creating surfaces by carving, piercing and incising Peter achieves a harmony and balance in his work that gives it a quiet but strong presence.

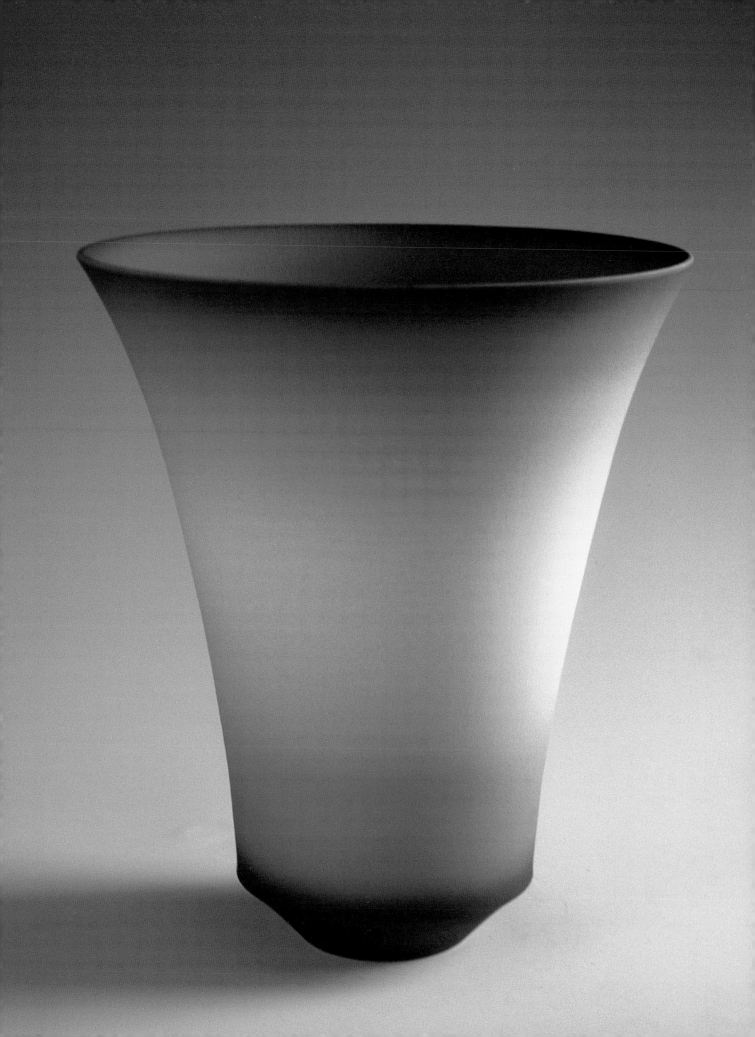

Kyra Cane

Kyra Cane's primary reference and inspiration for her work comes from the landscape. The solidity of land mass, the way it is divided, carved up and cultivated, and the edge of land hold a particular fascination for Kyra; the place where land meets open sea, or a huge expanse of sky and undulating coves and bays create forms that have rhythm but never repeat.

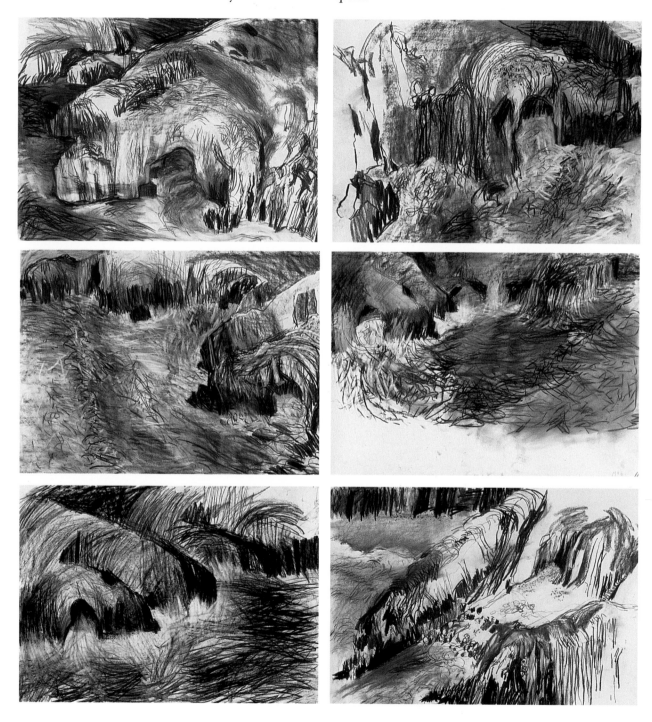

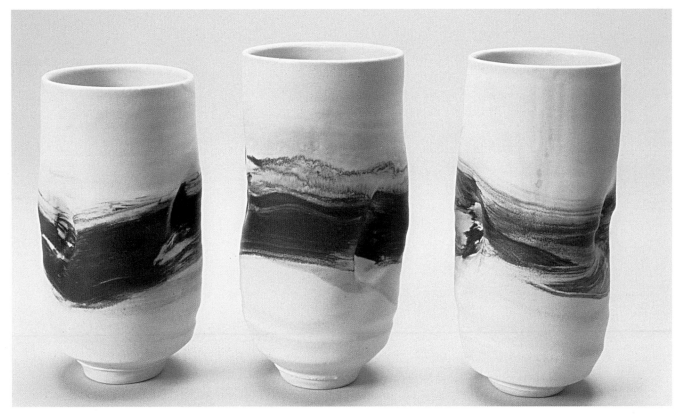

Porcelain, 2000, by Kyra Cane.

Land never stays the same, changing colour and texture with the time of day, the weather and the seasons. Large open spaces make Kyra's body tingle and her mind comes alive. She loves desolated and deserted places, enjoying the absence of people and the contrast to everyday hustle and bustle.

Before she had children, Kyra travelled extensively, drawing wherever she happened to be…The Grand Canyon at dawn, Tuscany at dusk, rice paddies in Bali, the sea in Turkey and Gaudi columns in Barcelona. She says, 'I've drawn in fabulous places and I'm sure I will do so again but the wild seas of Pembrokeshire, the storms across the Island of Skye and the misty mountains of the lakes equal any of these, they are my love and never cease to fascinate, to provide me with the opportunity to tussle with land, sea and sky. I can be found in rain and mist, battling with the elements, thriving far more on these less than perfect conditions, give me a changing environment and a sketchbook rather than a vivid flat blue sea any day…That is the weather for going up mountains to the high places!'.

Drawing is Kyra's way of exploring the world, concentrating her mind, feeding it and allowing her to focus and absorb all that is around her. The image is almost the by-product. These drawings do not result in a literal translation of ideas into ceramics but are part of the lexicon of experiences that influence the judgements she makes when working with clay. Working in her studio, she likes to take risks. Never working from drawings as she finds this 'freezes her mind', making her too self-conscious, she works intuitively, responding to the nature of the material. Form is governed by what she wants to say.

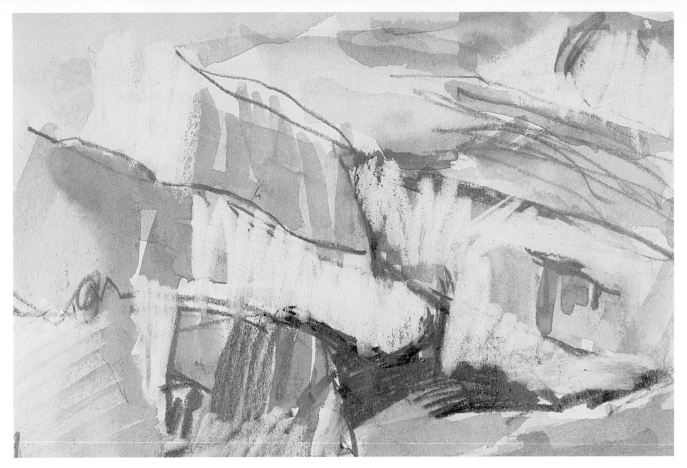

Painting, Pembrokeshire,
1988, by Kyra Cane.

Constantly concerned with contrast, variety and the evasion of a fixed and final interpretation, Kyra writes, 'The creation of vessels which are gradually revealed to the mind of the person who lives with the piece, that are three-dimensional and without one focal point, pots that remain slightly elusive'.

Just as space is her inspiration so scale is vital to her. The balance of a bowl, the relationship of foot to rim, the softness of the body in contrast to the tautness of the rim – all these are important considerations for Kyra.

The impulse to mark and distort even and symmetrical forms are constant threads through her eighteen years of working. Often bodies of jugs are made to carry handles, and these are gestures equivalent to a brushmark or a line on paper. Mark-making refers indirectly to her experience of landscape. It is related, rather as words to punctuation – dots that are trees or lines that are edges.

Colour is related to feeling and qualities. She builds up layers, rubbing out and re-doing, firing as many times as the pieces require. The creamy base glaze originates from her early work, using celadon glazes: making marks on the pale unfired glaze, she was disappointed when they came out of the kiln. The background was too dark and so she developed the glaze she uses today.

In Kyra's work I find a quality that I often notice when looking at oriental ceramics. The spare brushwork creates expressive marks bringing to memory forgotten landscape and places. It is the combination of remembered landscape and response to material that gives Kyra Cane's work a quiet excitement and harmony that wills the viewer to turn the pot and look again.

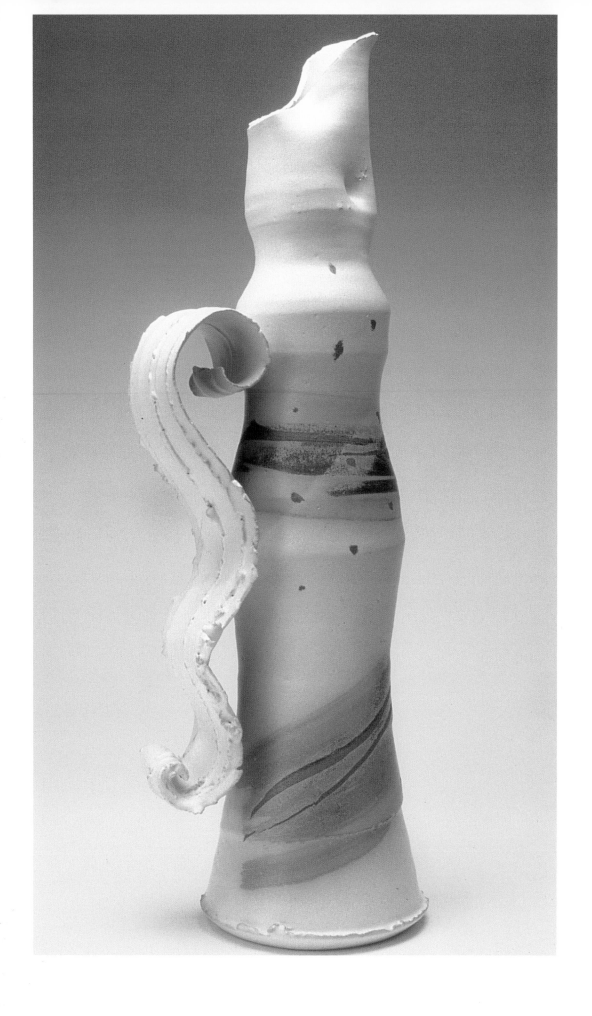

Jug, 58cm high,
by Kyra Cane.

CHAPTER 7

Man-made

M AN-MADE objects and structures surround us in the
world. Some of them are beautiful and enhance the
organic world; electricity pylons marching across a
landscape, the Clifton suspension bridge majestically spanning
the River Severn or the, by now, infamous Dome dominating
the river at Greenwich, UK. Some structures echo nature,
others provide a stark contrast, both can be equally compelling.

OPPOSITE PAGE Lighthouse
prisms, Kent, UK.
Photograph by Cohn M. Baxter.
BELOW Victorian glass marbles.

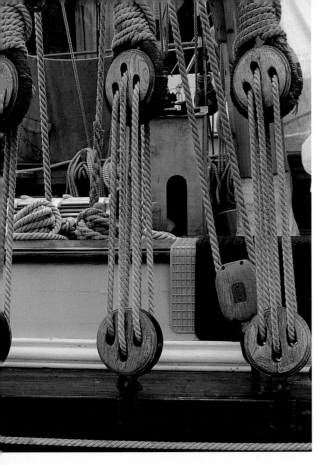

Then there are the powerful pieces of machinery, designed to do a certain job; motor engines, factory machines, aeroplanes, oil wells, the list goes on and on. There are also the smaller man-made objects, as diverse as screws, nuts and bolts, clamps and household objects, like the kettle and the toaster.

Whatever the size, these structures and objects are governed by the same criteria – form follows function. Designed by designers and engineers for specific purposes, there is little room for artistic pretensions and indulgent ornamentation and in this simplicity of purpose there is beauty.

Finally, there is the work of sculptors and craftsmen. Sculptors have something to 'say'. They may wish to convey a philosophical idea or to create objects of beauty or simply to share the pleasure they find in a material. Craftsmen, however, are concerned with using the material to make objects that are useful and make life easier.

Man-made objects are so much part of modern life, taken for granted and often regarded merely as useful tools whereas they are frequently aesthetically pleasing and a tremendous source of inspiration for ceramists.

Once one starts to look at man-made objects as a source of inspiration, one sees potential everywhere: heaps of clamps for scaffolding, spiky iron fencing silhouetted against the sky, wrought iron benches throwing their shadows onto the ground or even lighthouse prisms.

ABOVE Steam train wheel.
LEFT Details of vintage cars.
OPPOSITE PAGE Steam engines at The Bluebell Railway, Sussex, UK.

The Bluebell Railway in Sussex is one of the old steam lines and is gradually being renovated by enthusiastic and dedicated volunteers. At the station the visitor has the chance to get close to these imposing machines, whose paintwork and engines gleam in the sunshine. The mechanical components made of heavy steel ooze a feeling of solidity and power. In the car park there were shiny old cars and motorbikes in immaculate condition. All of these have shapes that hold promise of exciting forms and designs for the ceramist to develop.

ABOVE Fishing nets.
ABOVE RIGHT Chicken wire.
OPPOSITE PAGE Plastic netting.

Sketching netting draped over wooden planks, I noticed that the squares of netting crossing the planking form patterns that could evolve easily in to intricate linear designs as could piles of fishing nets or the netting of a fruit cage.

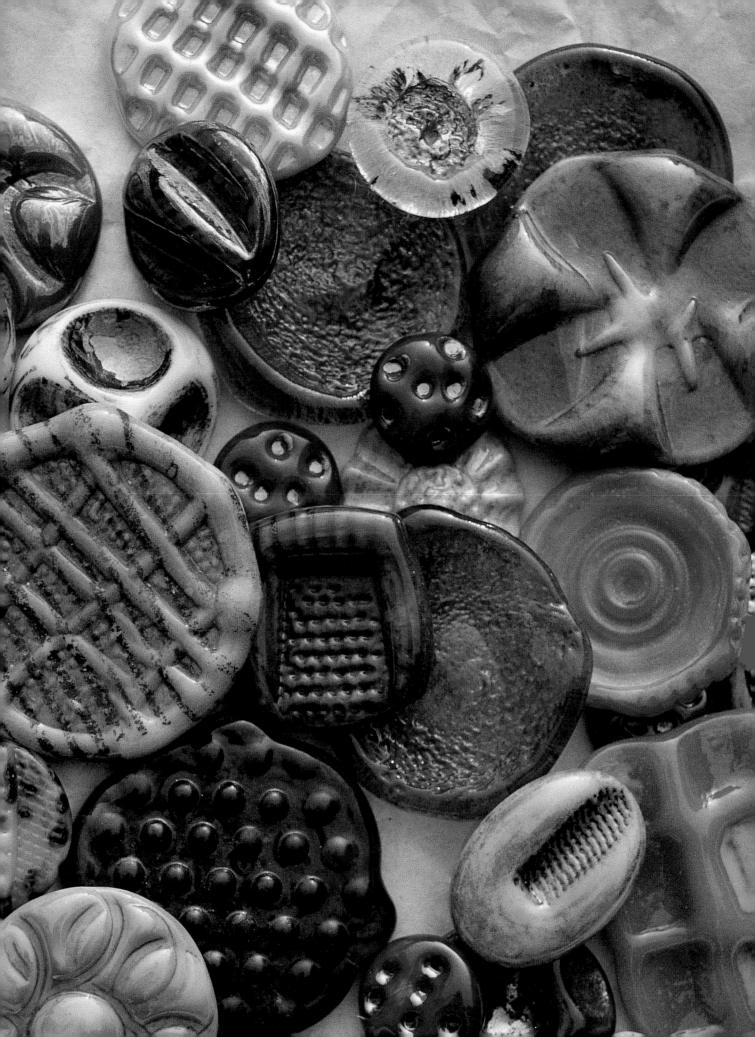

TOP Watercolour study.
ABOVE Pencil sketch.
OPPOSITE PAGE Glass buttons by Lionel Nichols.

The first time I saw these wonderful glass buttons I was attracted by their rich textural surfaces and glowing colours and immediately saw ceramic possibilities for me to explore. Handmade by Lionel Nichols, who supplied buttons to the couture houses in the 1950s and 1960s, the buttons were made from sheet glass, mostly Vitrolite. The design was pressed in by hand so no two buttons are exactly the same. Some buttons were painted with enamel paints and are particularly flamboyant. Much like many ceramists, Lionel Nichols collected things that he thought might make interesting indentations or textures, such as military insignia and ornate buttons.

I have a small collection of these buttons that I chose for their iridescent colour and sculptural qualities. Any of these buttons would translate into exciting ceramic surfaces, ridged, pitted or stamped, and the edges of several buttons suggest rims for sculptural vessels and pots.

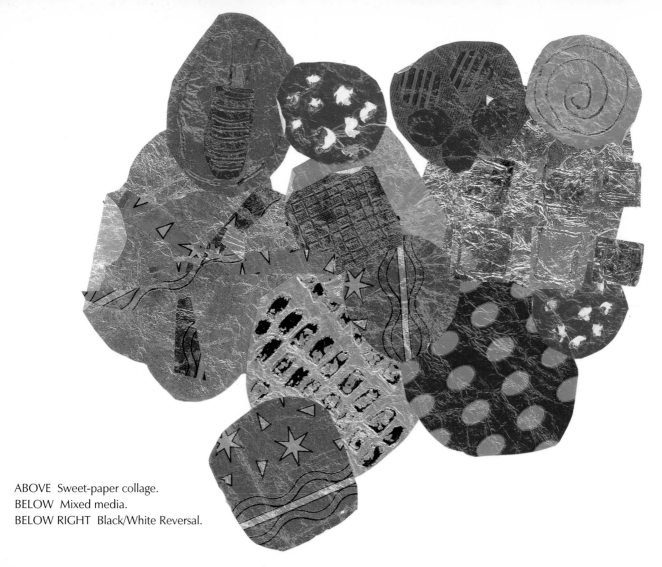

ABOVE Sweet-paper collage.
BELOW Mixed media.
BELOW RIGHT Black/White Reversal.

Abstraction, wax crayon.

Drawing and painting the buttons in a variety of media; conte, wax crayon, silver foil collage and paint, deepened my understanding of the objects and gave me a feel for the individual button shapes. Although interesting individually, grouped together I noticed some intriguing shapes created by the negative space. Finishing a line drawing of a group I put aside the buttons and started to explore ideas for pattern and decorative surfaces. I found that isolating a small part of a sketch and enlarging it, using complementary colours, created bold abstract shapes. Cutting a coloured sketch into squares, accentuated portions of pattern, and the change of scale simplified and further enhanced areas of colour and shape. For me, this theme suggests endless permutations for imaginative form and unusual surface decorations.

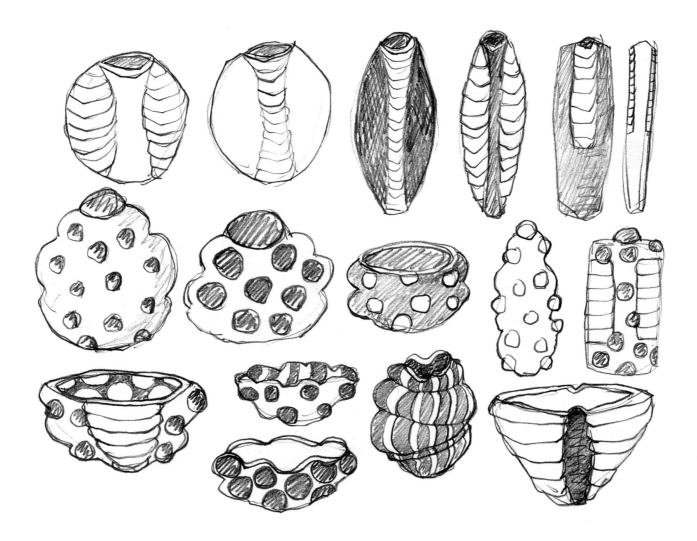

Some ceramists have found that the sculpture and craft of ancient cultures have had a profound influence of their own work. For John Maltby it was seeing the Etruscan objects, excavated in Florence, for me it was finding shards of Nabatean pottery in Petra. Felicity Aylieff studied the work of the Indian and Islamic Collections at the Victoria and Albert Museum and Geoffrey Eastop says that, at times in his career, certain pieces of sculpture have influenced his work. Derek Davis' continued awareness of modern sculpture undoubtedly made an impact on his own sculptural ceramics. Sources of inspiration may manifest themselves immediately in a ceramist's work but for many, may remain always in the back of the mind, an unconscious influence.

ABOVE Sketches for form and sculpture
 development from buttons.
OPPOSITE PAGE Changes of scale
 accentuates pattern and form.

John Maltby

For many years John Maltby has been known for his beautiful decorated stoneware pots. An expression of the artist himself, the pots were decorated with designs drawn from the world around him; the sea, flowers, Gothic architecture, whatever inspired him at that moment. However, a few years ago, due to ill health, John could no longer work in the way he had done, for so many years. So, he started to make the small sculptures that he continues to make today.

As a student (he studied sculpture at art school) he travelled in Europe in order to experience the 'Classical Tradition' at first hand. It was in Florence that he saw the small Etruscan objects, being excavated in large numbers, which became so meaningful to him, though it was to be forty years before he used their inspiration again in his own work.

It was these experiences and a subsequent love of the work of many European painters – Klee, Picasso, Bessiere, Dubuffet – and English artists such as Nicholson and the primitive Alfred Wallis, that gave what John feels is a rich, vigorous and varied background to act as a bedrock for his own mature work. He writes, 'the dignity of the effort, I would ascribe to these influences: the style now, unconsciously, my own: the subject of the work is the experience of my particular life'.

Early immersion in the workshop system of craft training, allowed John to acquire skills and technical expertise so that now the act of making has become unconscious. Free from restrictions, he can concentrate on developing his ideas. Just as his pots were concerned with things close to him, the driving force of his current work is his environment, the people around him. He 'lives' his work, it is his second nature.

But no potter can be creative all the time. The 'significant' time being that spent on ceramics, everyone needs an alternative to guard against becoming repetitive and boring. For some, it is teaching, as it was for John for a time, but now it is his swinging boats. They are his relaxation – another part of his unified creative life.

TOP *Small princess*, 10in. high, by John Maltby.
ABOVE Sketchbook, by John Maltby.
OPPOSITE PAGE *Two Windblown Figures*, 14in. high, by John Maltby.

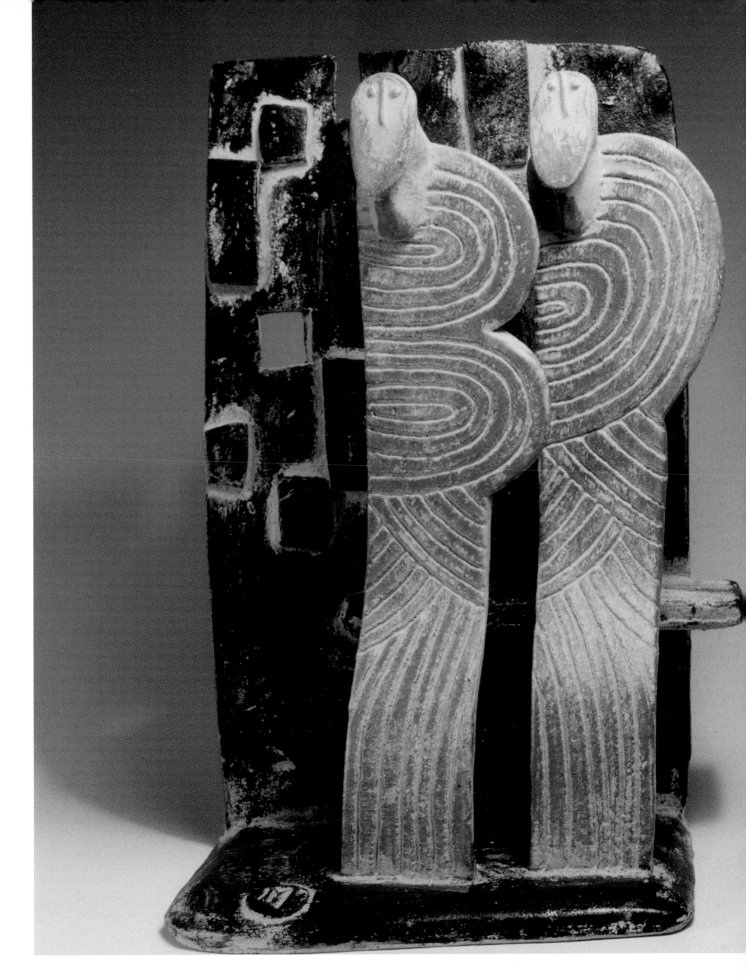

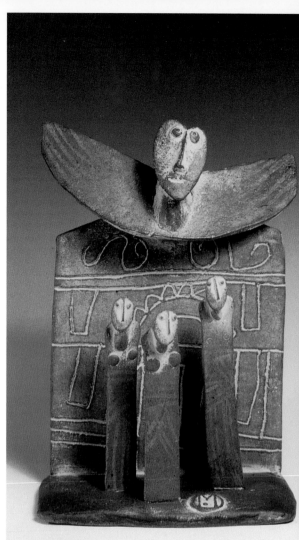

ABOVE *Sightseeing (Mozart's house)*, 16in. high, by
John Maltby.
LEFT Sketchbook, by John Maltby.

When he first made pots, he used to make thumbnail
sketches, much as Henry Moore did, perhaps one hundred in
an evening. From these he would choose one or two to make in
clay. Now his work is not about developing 'little' ideas but
pursuing 'good' ideas and it is essential to him that the work
moves on. John cannot return to his past ways of making and
feels that with his sculpture there is more potential than there
was with pots. As he wrote in *Heart to Art* (CR 166, 1997),
'Hopefully, the new objects carry with them the life blood and
experience of those years'. Undoubtedly they do.

Felicity Aylieff

Felicity Aylieff's early vessels were made of heavily stained clays that explored the proportions of archetypal form – positively defined shapes, clean direct lines and strong curves. The surfaces were inlaid with decorative images using agate structures that she says became her 'hallmark'. Later pieces were more refined, with carefully considered detail. Surfaces were unglazed and colour and texture minimal.

Wrapped, 70 x 70 x 72cm, press moulded, 2000, by Felicity Aylieff.

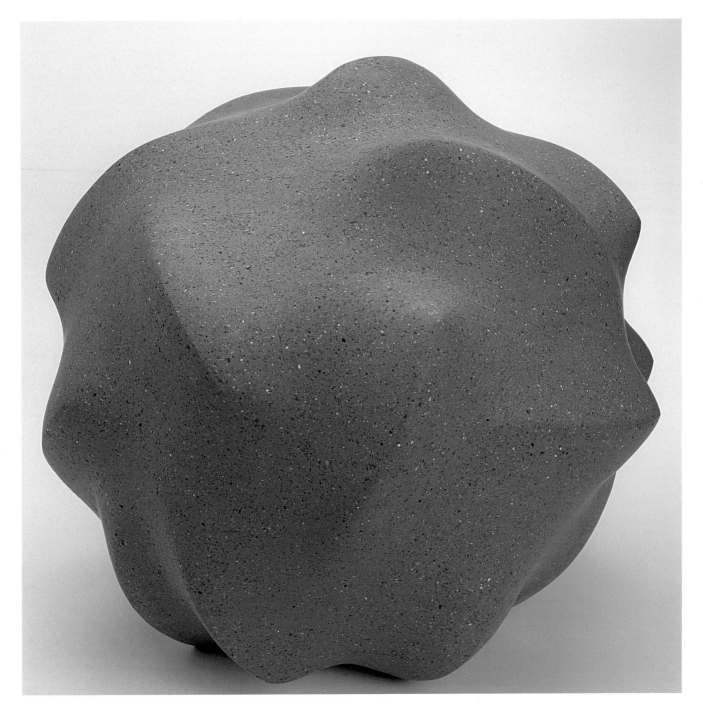

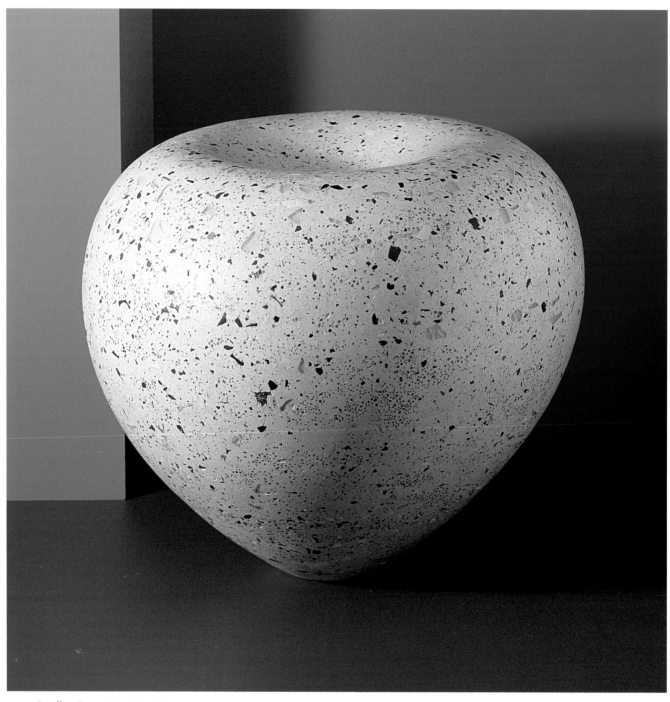

Swollen Form, 74 x 74 x 65cm,
handbuilt, by Felicity Aylieff.

A few years ago, she realised that she had achieved a technical perfection. She says, 'the work had reached a point of resolution'. After much soul searching what emerged was work that challenges our understanding of what clay can do and has more in common with sculpture than ceramics.

Intrigued by the relationship between sculptural and decorative form, she decided that she wanted to create work of a greater scale than the 'domestic'. Considering the making of pieces for large open spaces, interior and exterior, she began to see forms that would

identify more with their environment, relating less to historic ceramic references. This in itself led to the development of new clay bodies.

To clarify her ideas, she went to the Victoria and Albert Museum and looked at the Indian and Islamic Collections; to the Egyptian rooms and the classical casts at the British Museum; and to Kew Gardens; and the Herbarium in the Natural History Museum. She also looked through her books and photographs of architecture and artifacts.

She was particularly attracted to things that were rich in natural form, some of which she had previously only appreciated on a purely decorative level and used as two-dimensional reference material. Now they prompted thoughts about underlying form, structure, and surface articulation. By drawing natural forms; fruit, seeds and pods, she gained a greater understanding of structure and this, combined with her fascination for Indian sculpture informed and influenced early pieces of this new work.

In contrast to her previous work, these sculptural pieces are self-generating. One piece leads to another, a progression that makes use of certain aesthetic qualities that she finds exciting. Felicity sketches her ideas but instead of looking outwards for visual stimulation, she finds inspiration from within the work. She says, 'The making of maquettes helped me to see and understand the forms I was trying to create in a way that I could not adequately achieve through drawing alone'.

Felicity acknowledges that her forms are no longer vehicles for decoration. She sees them as sculpture and says, 'Of great importance to me is the emotional spirit of the work; it is my desire for both the form and surface to be satisfying through a visual as well as a physical sensuality'.

Through her research and development of clay bodies and materials that are sympathetic to her work, and also the monumental scale of her work, Felicity Aylieff's sculptural pieces have a presence that transcend the common understanding of 'ceramics' and this can only widen our own perceptions in a healthy way.

Derek Davis

Derek Davis originally studied painting and this has tended to influence his approach to ceramics. Self-taught, when he first began to make ceramics, after leaving Central School of Arts & Crafts, with little knowledge of technique and no skills, he broke rules and discovered ways of making by making. He approached ceramics from a different perspective to many of his contemporaries of the time and this meant that his work had a freedom and inventiveness that was unusual in the 1950s.

Life drawing has been, and continues to be, a central point of Derek's artistic life but sources of inspiration for ceramics are wide and varied. Looking at modern sculpture such as the work of Brancusi and John Warren-Davis, the creator of 'Wood Henge' in Sussex, have suggested forms to be tried in clay.

Unlike many ceramists, Derek has always felt that it is dangerous to use natural objects as a source of inspiration and so prefers to work from abstractions of things he has seen. His sketchbooks contain ideas but no detailed drawings and he is influenced by anything and everything – even a photo can become an abstraction. Over the years his sources of inspiration have changed and as he learnt to deal with sophisticated forms and became aware of the use of colour to emphasise form, Derek developed the conviction that decoration must relate to form.

Between the early 1950s and today Derek seems to have changed direction a number of times. Early ceramics were concerned with decorative glazes whilst later work deals with more abstract concepts such as race relations, aids and the vicissitudes and humour of domestic life. His dish *Chocoholic in Front of the Mirror* is an artistic comment on modern society, whilst other pieces deal with a quieter memory of the Sussex Orchards to be found near where he lives. Most of his pieces, whilst being decorative, are a narrative on life in the 20th century.

For the past few years Derek has turned to painting and it is interesting to note that his recent two-dimensional work echoes the themes of his last ceramics pieces.

TOP Press moulded porcelain, abstract decoration. 10 x 8 x 2in. by Derek Davis.
ABOVE *Chocoholic in Front of the Mirror*, 12 x 12 x 12in., 1991, by Derek Davis.
OPPOSITE PAGE Thrown and hammock moulded, 20in., by Derek Davis.

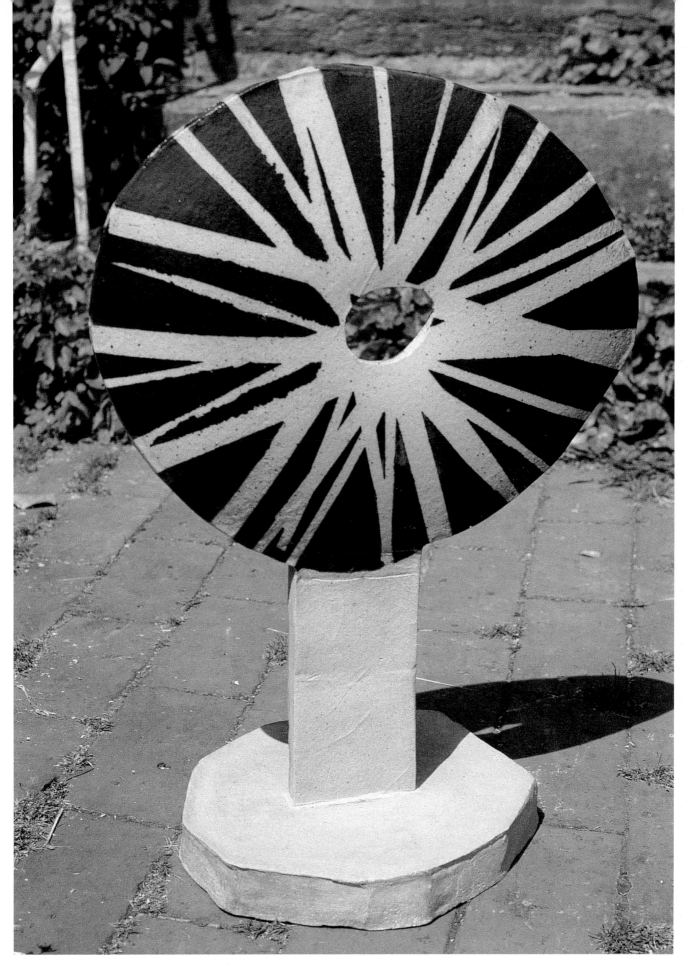

Texture and surface

Texture and surface quality are intrinsic to working with clay. The feel of the clay in the hand, immediately makes one think about texture: heavily grogged crank, velvety cool porcelain, lightly gritty St. Thomas', smooth malleable terracotta. Each has its own character and the potter's choice will affect what he makes, so it is essential to select one that will enhance the quality he seeks to convey, complementing the shape or intentionally challenging accepted perceptions. For example, by creating a surface that looks smooth but feels rough to the touch.

Many ceramists make intuitively, reacting to the clay and allowing the clay to suggest textures. Others look to the natural and the man-made to discover surface qualities that excite them and inform their work. Frozen puddles glistening in the December sunshine, the ice cracking as it melts – I see the promise of fragile layered texture, perhaps made of translucent bone china, and curvaceous sculptural forms of strong T-material. Sea polished pebbles or wave worn shells on the beach, craggy rocks, the worn hull of a boat, gossamer fine knitted wool, even the texture of eggshells, all these surfaces are inspiration for ceramics.

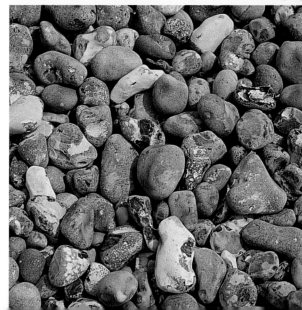

TOP AND MIDDLE Frozen puddles.
RIGHT Pebbles on a sandy beach.
OPPOSITE PAGE Eggs in a basket.

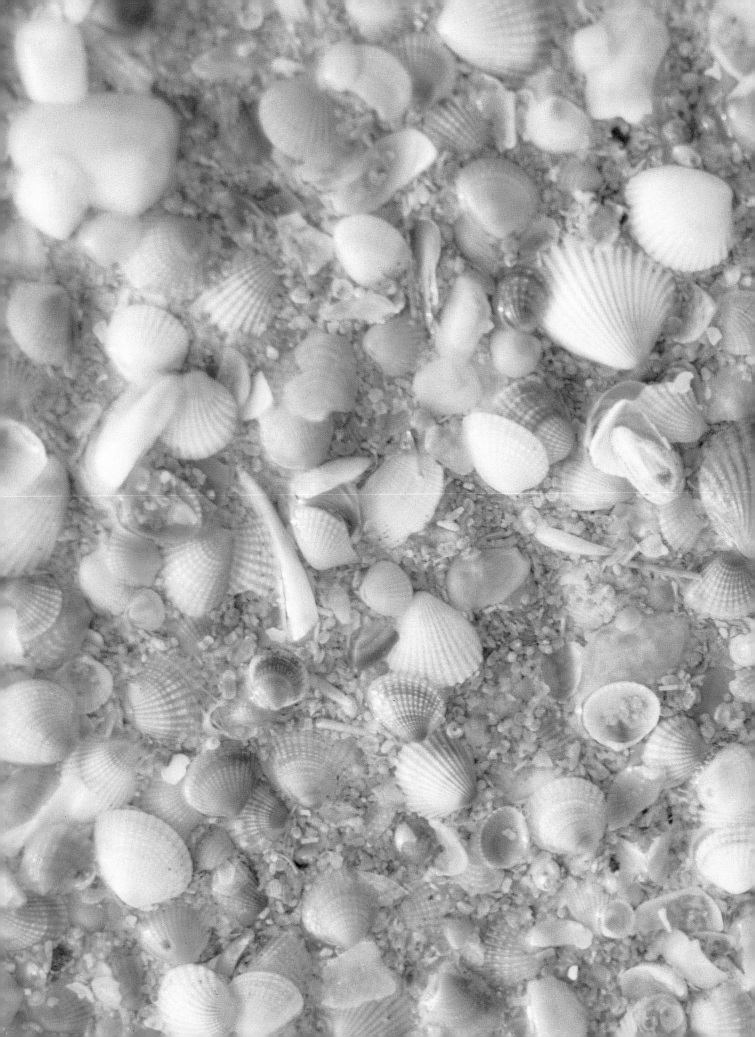

An old farm building built of corrugated iron, gently rusting in the sunlight, or a section of a flint wall, so typical of East Sussex – sometimes whole themes of work develop, inspired by something as simple as a patch of rust.

ABOVE Shadows falling on an old corrugated shed.
RIGHT Detail of a sussex flint wall.
OPPOSITE PAGE Shells on beach, Colva, Goa, India.
Photograph by Simon Arnold.

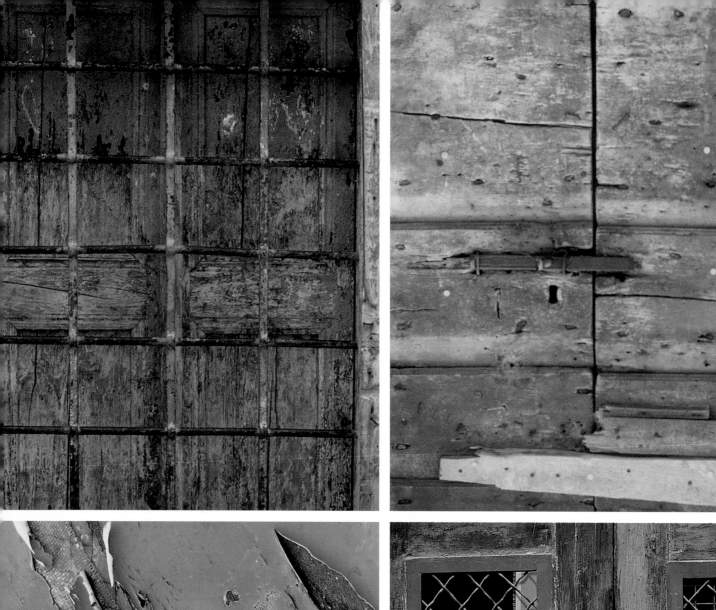

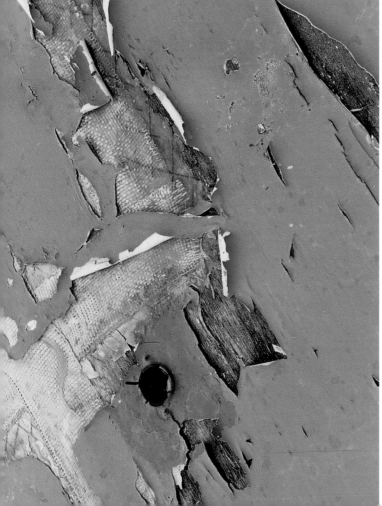

ABOVE Vessel, 2001, stained white earthenware,
vitreous slips, 16cm high, by Carolyn Genders.
Photograph by Mike Fearey.
RIGHT Sgraffito vessels, 2001, by Carolyn Genders.
OPPOSITE PAGE Details of old doors in France and
Spain. Photograph by Steve Hawksley.

Ancient doors and walls, with surfaces battered by constant use and peeling paint work revealing other layers, have a patina that I find particularly attractive and which I interpret by distressing the surface of some of my pots, scratching and rubbing to create depths of tone and colour. John Higgins shares my preoccupation with these textures and the surface of his sculptural pieces are reminiscent of the ancient walls of Knossos and so many fortifications of Greece and the Mediterranean – a modern interpretation, used in conjunction with geometric pattern.

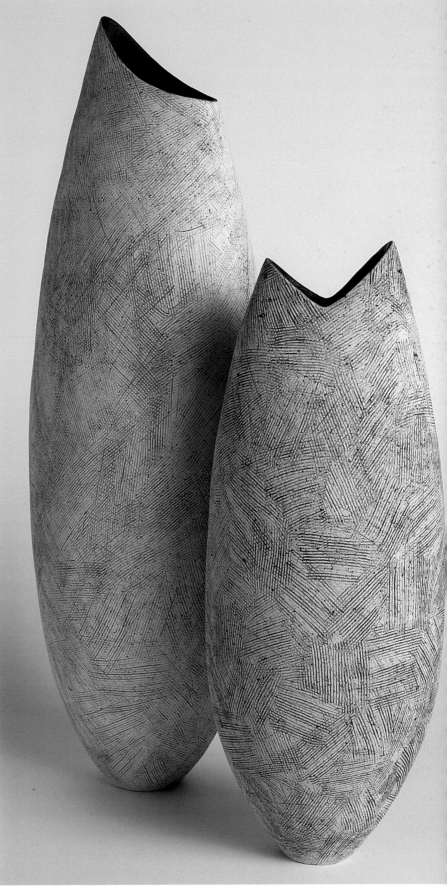

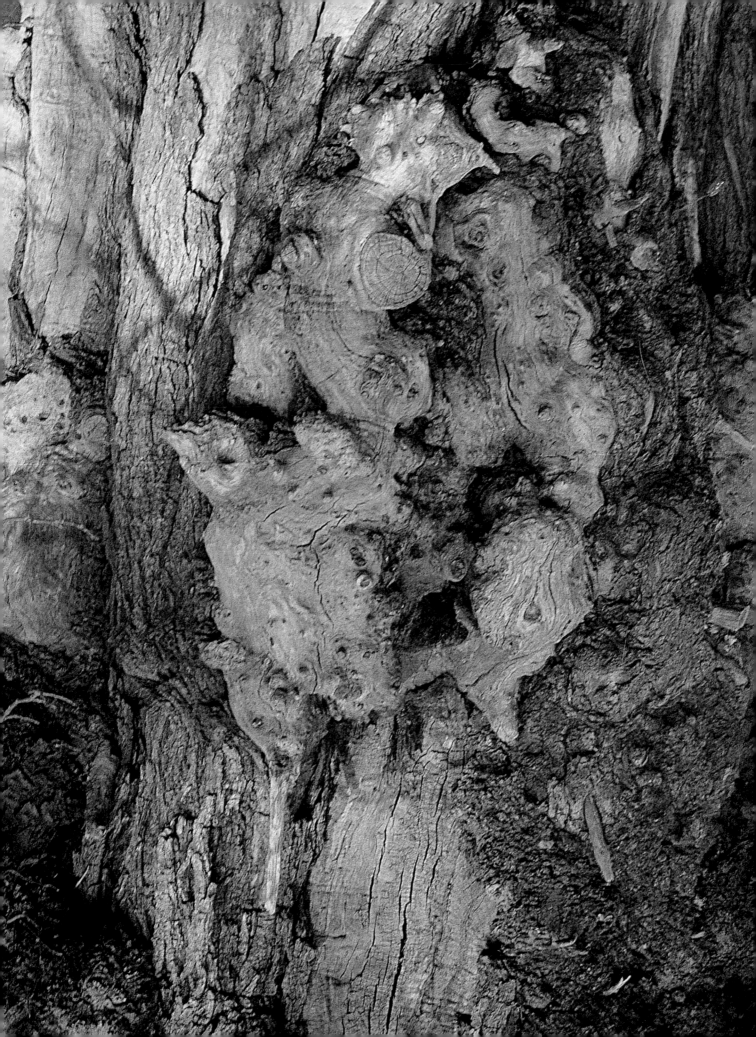

When on walks I always look at the bark of trees. Time and again I am amazed to see the varieties of bark – the smooth silky whiteness of the Silver Birch contrasting with the gnarled corrugation of the Oak. Running my hands over the different surfaces is like touching fired clay. Making rubbings is a tactile way of learning about surface. The texture comes alive on paper as the crayon rubs against the bark and clay impressions made of these surfaces can form part of a visual library of exciting textures that may one day be useful.

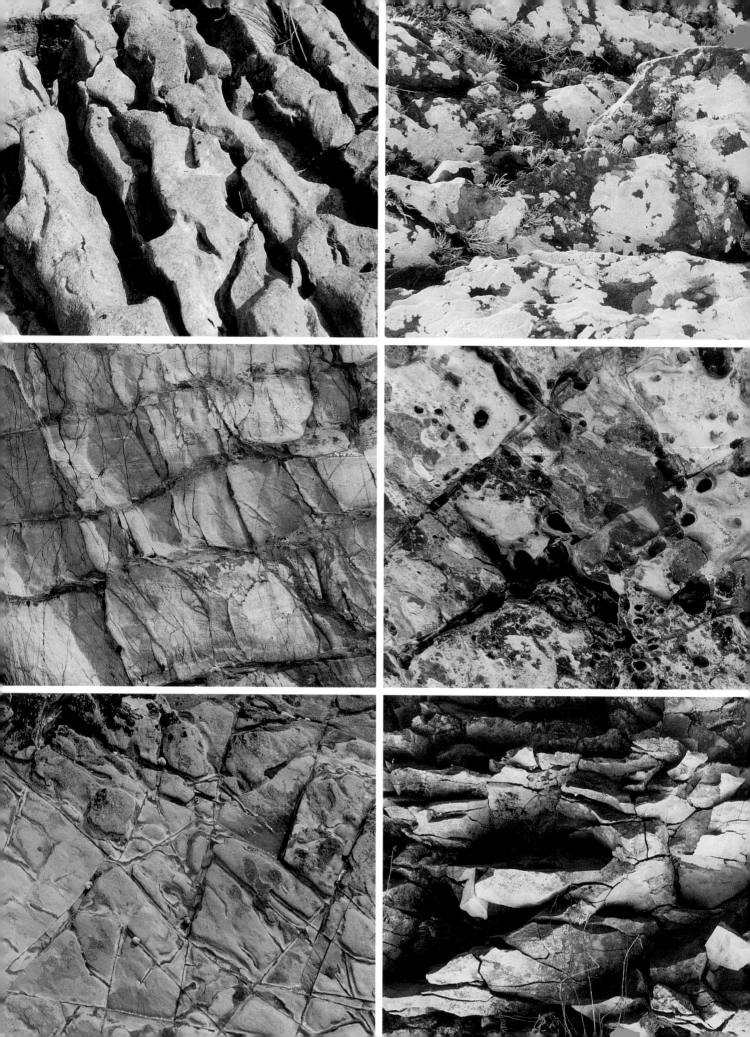

Another source of inspiration for both surface and form are rocks on the beach or inland, as part of a hillside or wall. Continually exposed to the elements, the weathered forms evolve and their history is revealed. Rocks on a beach show signs of salt-water erosion while the rocks of hillsides have cracks and crevices caused by earth movement, their coloured surfaces stained by minerals in the soil. Many textures already have a quality that lends itself to ceramic but I prefer to ignore the obvious seeking to find a new angle to work from.

Attracted to the lichen covered rocks on a beach in Crete with deep fissures and moody colour I explored the weathered stone on paper. I like to draw from life and after sketching the rocks I gained a feel for the structure of the rocks and their spatial relationship to one another. Creating solid blocks of colour to capture individual shapes that became evident as I drew, some lent themselves to construction in clay; powerful slab pots in Crank or delicate rhythmic coiled vessels or softly thrown pots. Watercolour studies followed and by using latex resist I created layers of colour to visually interpret the rock strata. Using a variety of drawing materials suggested ideas for thematic progression. I found that on returning to the original source I was stimulated and enlightened by the understanding I had gained through my research.

Two ceramists whose work, for me, is synonymous with surface and texture are Judy Trim and Duncan Ayscough. Judy Trim uses layers of coloured slip, building up a background for her enigmatic lustre decoration or smoke-marked pots. The surface of Duncan Ayscough's work has an extraordinary patina, achieved by intensive burnishing, the glowing surfaces revealing depths of tone that intensify the rich earth colours of his pots.

OPPOSITE PAGE Rock formations.

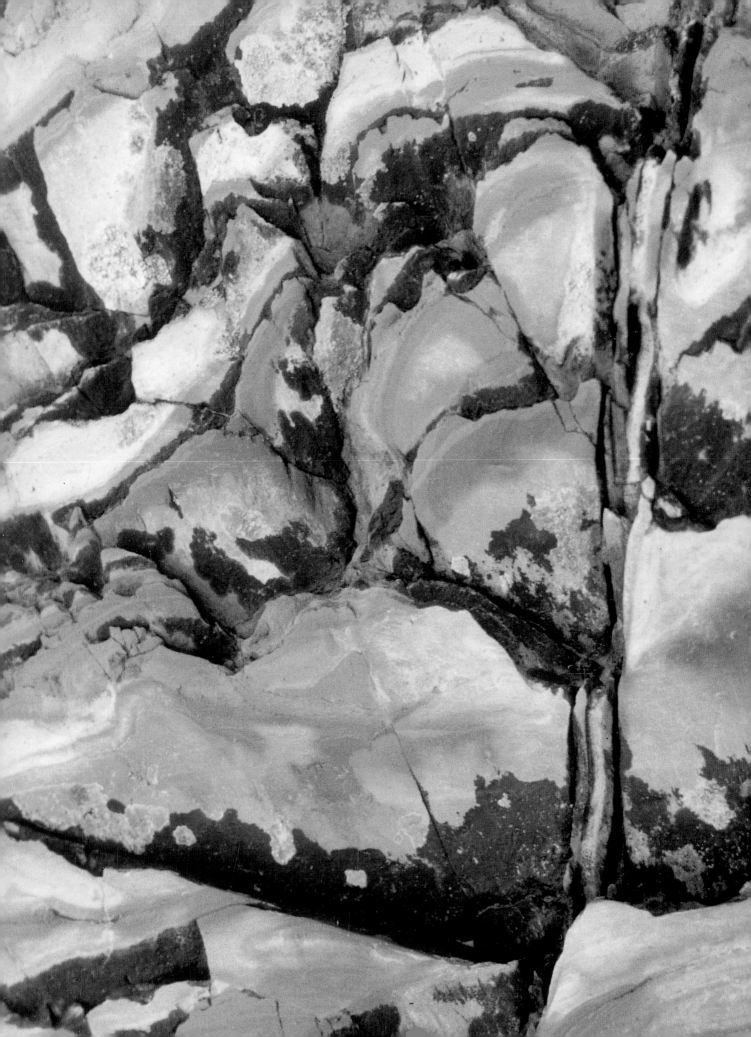

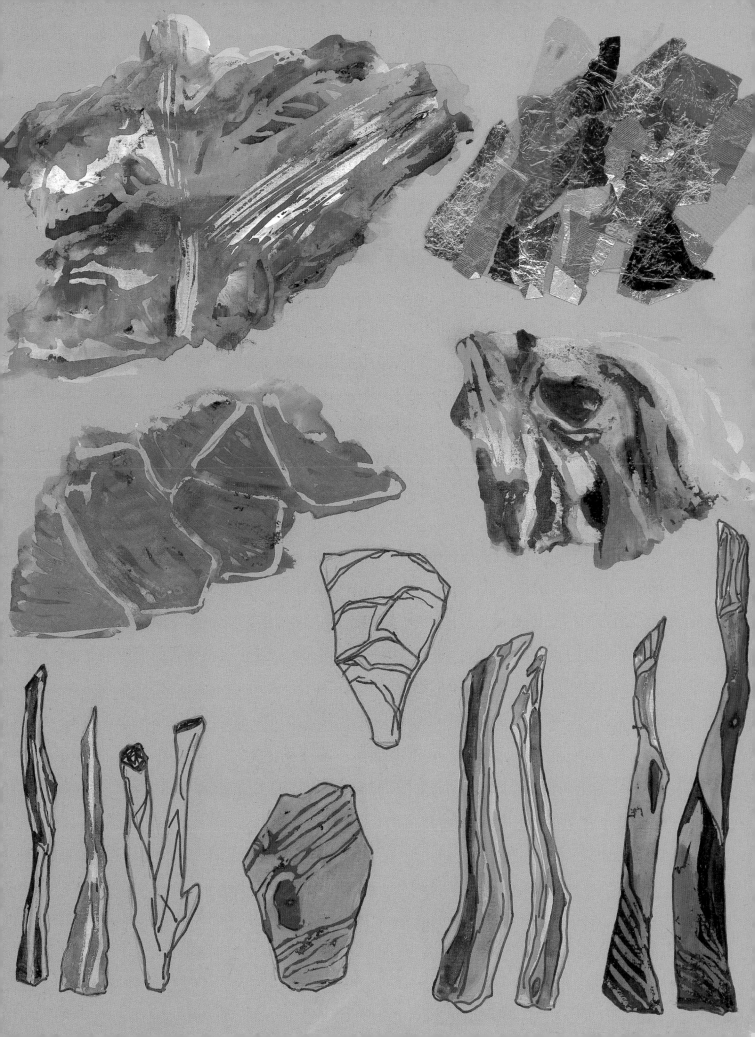

Judy Trim

Standing in Judy Trim's studio, looking at her beautifully crafted, calm, contemplative sawdust fired pots and richly decorated Tear Jars and bowls, it seems surprising that the guiding principle behind everything Judy Trim has made is echoed in this succinct quotation by William Blake, 'Do not pursue skills, technique will follow the idea – the idea will find a technique'. But after a few moments thought, I realise that this makes perfect sense and it is the years of dedicated making, attention to detail and acquired technique that makes her work so arresting.

Trained at Bath Academy of Art in Corsham in the 1960s, she studied painting and ceramics and, with James Tower to inspire her, learnt simple handbuilding techniques and a love of materials. Looking at nature and traditional English work and the work of other ceramists, including Hans Coper, Lucie Rie and Ian Auld, she came to appreciate the value of simplicity and of keeping to certain forms. A vessel to her represented the archetype – basic, timeless and human.

She worked slowly and precisely, building coil pots, smoothing and polishing the surface as she went. She said, 'With each piece I am trying to find a way to express feelings, often all too elusive, of warmth, generosity, calm and hope. I am intrigued by the endless possibilities of interplay offered by the container between the actual and the symbolic. Particularly the strong and obvious analogy with the feminine principle, e.g. holding, preserving, protecting, receiving and giving out'.

On the shelves in her studio are an eclectic collection of objects – a mother of pearl shell, dried stamens of flowers, an iridescent butterfly, a primitive wooden statuette, photos of Delphi, and a few of the tiles she always made, to test combinations

BELOW *Moon Crater*, 67cm diameter, by Judy Trim. OPPOSITE PAGE Tear Jar No. 9, 1990, by Judy Trim.

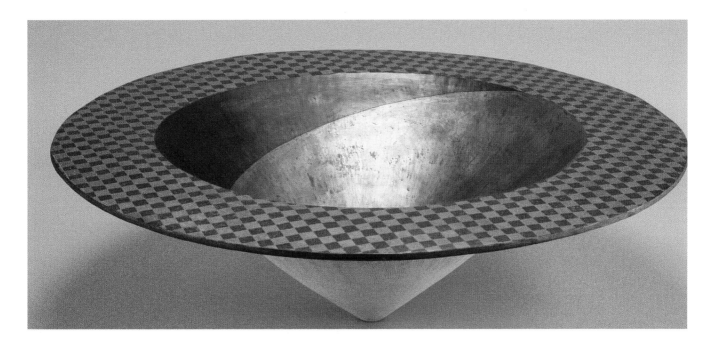

of slip and lustre and variations of design, as a form of relaxation, enjoying the painting and creating of pattern. Sources of inspiration in themselves, running concurrently and echoing her interest in ancient cultures, where she found inspiration in the processional qualities of formal and powerful rituals, including the Egyptian Cosmologies and the American Indian, Peruvian and Cycladic containers, which she thought of as free of the 'well intentioned cant of modernism'. Her preoccupation with building vessels which appear to float or be airborne, 'objects in conflict with gravity', may make others nervous but rather appealed to her. Latterly the arrangement and relationship of groups of pots became as important as the individual pots.

When I saw Judy Trim's work, the contrast of her sawdust smoked pots with simple textures and layers of slip did not seem to me to be at odds with her smoothly burnished, lustre bowls, but rather two sides of the ceramist. The bowls with geometric compositions and magical colour, reflecting light and the pots with random smoke markings were each conceived from a belief in the idea, the technique selected appropriately. Design and surface treatment relating perfectly to form.

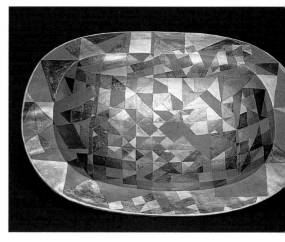

ABOVE *Red Webb*, 1998, lustred bowl, by Judy Trim.
BELOW *Dark Winged*, 67 x 18cm high, by Judy Trim.

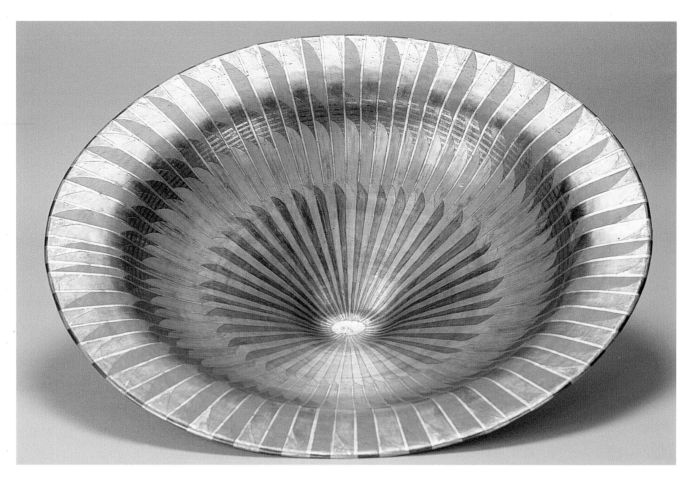

Duncan Ayscough

Duncan Ayscough's principal source of inspiration is the potter's wheel. The fluidity of the process, which transforms a lump of clay into a recognisable object has fascinated him since, at the age of fourteen, he first sat at a potter's wheel.

Obsessed with the notion of 'function' as opposed to 'utility', Duncan sees the function of his own work to be of an allegorical nature, primarily symbolic, its purpose to contain and reflect viewer's contemplation.

Fossils, fragments of ancient pottery and Neolithic stone tools inspire his creativity. Recently, he saw in a museum, a flat round black stone, 20cm in diameter with a 6cm hole in the centre. This 5000-year-old stone was the support of a central post of a tent type construction from sub-Saharan Africa and had the patina that could only have been created by centuries of hard handling. That this beautifully crafted object from natural materials sat at the heart of human activity for hundreds, even thousands of years, a passive witness to the life around it, intrigued Duncan and it is an

BELOW Rounded pot, gold interior, concave 22cm, 2000, by Duncan Ayscough. Photograph by Duncan Ayscough.

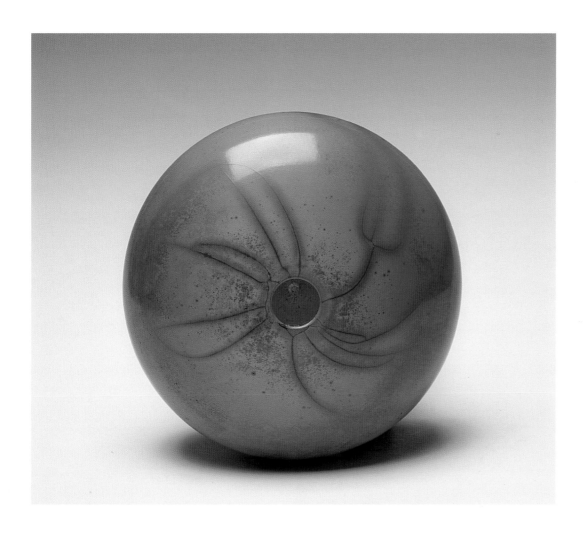

emotional response such as this that inspires so much of his work.

Within the natural world, he finds himself compulsively drawn to objects such as shells and seedpods that at some previous time, were hosts to life that have long since vacated them.

Inspiration is never literal and Duncan does not attempt to imitate but aspires to reflect the organic fluidity of a seedpod or the strength and purposefulness of a neolithic tool. A less obvious influence on his work is the geographical location of where he lives. Working in a village in Wales, his studio window looks towards the Iron Age hill fort of Garn Goch. Used by both the Celts and the Romans, many 5000-year-old artefacts have been found and Duncan feels it is impossible to ignore the sense of history prevalent in his environment.

Source material is documented by photography – sometimes he takes pictures of whole objects, sometimes just details of texture, tone or colour. These photographs are used when developing ideas for the construction of new shapes and forms. Duncan develops his ideas through the making process but occasionally he sketches and refers to his photographic source materials to explore relationships between form as well as contrasts between materials.

Knowing more about Duncan's sources of inspiration and influences, I look at a piece of his work, such as 'Rounded Pot, Gold Interior Concave' with new eyes. The polished surface reminds me of stone implements so important for survival to the people who used them, whilst the sharp contrast of the exterior to the bright gold interior provides a contemporary twist that is wholly of the 21st century. The gold transforms it into something precious, as precious as the tool would have been to primitive man.

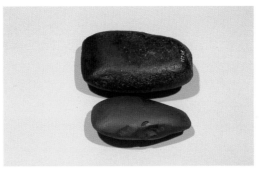

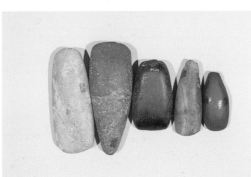
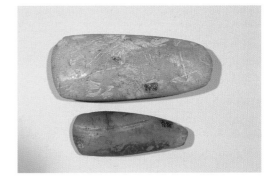

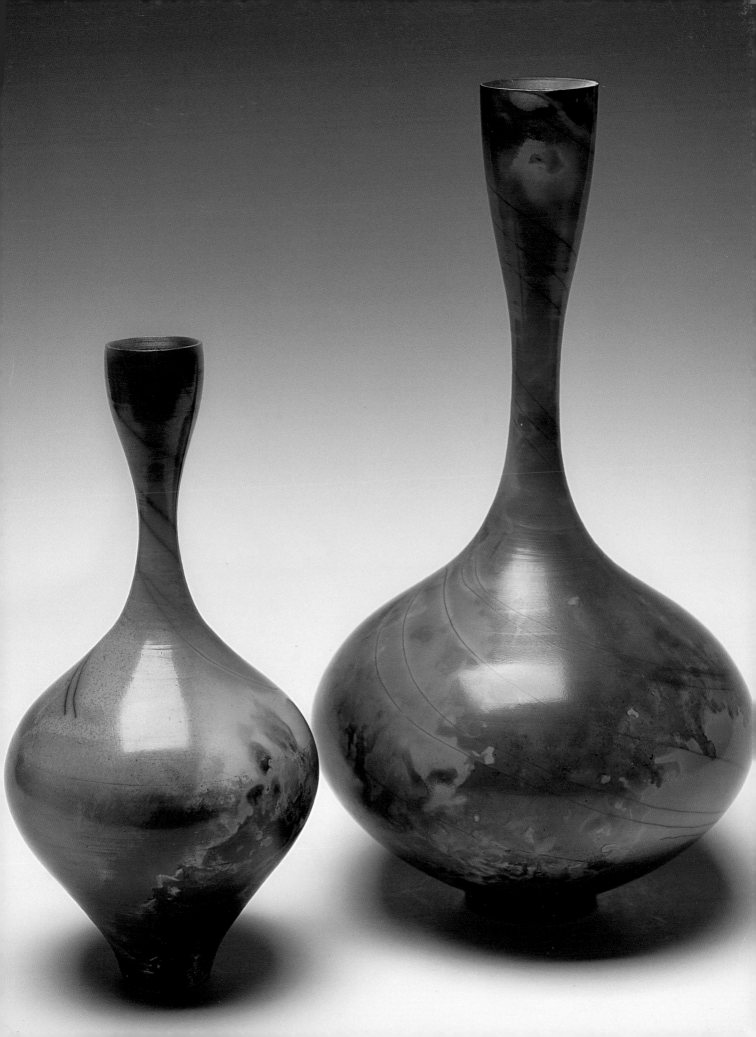

Index